**KOREAN SOCIETY OF
TYPOGRAPHY
LETTERSEED 20**

KB082129

LetterSeed 20 ISBN 978-89-7059-540-5(04600)
 Printed in 13 August 2021
 Published in 20 August 2021

Concept Korean Society of Typography
 Editorial Department
Autho An Mano, Fibi Kung, Ha Hyeongwon,
 Han Sukjin, Jang Sooyoung, Kim Chorong,
 Kim Hyunjin, Kim Youngsun, Ku Jaeun,
 Kwon Joonho, Lee Hwayoung·Hwang
 Sangjoon, Lee Jaemin, Mak Kai Hang,
 Maria Doreuli, Mun Sanghyun, Nam Sunwoo,
 Park Chulhee, Park Jinhyun, Park Shinwoo,
 Park Youngshin, Poe Cheung, Seok Jaewon,
 Syn Gunmo, Yang Soohyun
Translation Hong Khia, Kim Noheul, Son Hyeonjeong
Proofreading Jeon Jaeun, Anneke Coppoolse
Design You Hyunsun

Publisher Ahn Graphics
 125-15 Hoedong-gil, Paju-si,
 Gyeonggi-do 10881, South Korea
 tel. +82-31-955-7766
 fax. +82-31-955-7744
President Ahn Myrrh
Creative Director An Mano
Editing Kim Sowon, Lee Yeonsu
Communication Kim Bom
Marketing Hwang Ari

Printing & Binding N2D Printek
Paper Invercote G 260g/m² (Cover),
 Lynx 100g/m² (Body)
Typeface SM3 Shinshin Myeongjo, Mokoko,
 Rix Dongnim Gothic Pro

Sponsors

DOOSUNG PAPER

Partners
Black

NAVER

kakao

+X

Yoondesign

RixFont

ExtraBold

VINYL ㄷ

Bold

motemote

ㅎ ㄷ ㅣ ㅈ ㅏ ㅇ ㅣ
ㅗ ㄴ
ㅇ

Regular

INNOIㄴ‾

Letterseed 20

KOREAN SOCIETY OF
TYPOGRAPHY
LETTERSEED 20

AHN GRAPHICS, 2021

Notes　The names of foreign individuals, titles of foreign organizations, and imported technical terms were written following the orthographic rules for loanwords by the National Institute of Korean Language and 『Dictionary of Typography』. 『LettreSeed』 follows the following Korean notation: double hook brackets (『 』) for titles of books, periodicals, and dissertations; hook brackets (「 」) for titles of academic articles, news articles, and typefaces; double angle brackets (《 》) for titles of exhibitions and albums; angle brackets (〈 〉) for titles of art works, films, and songs.

Korean Society of Typography
Editorial Board
Lee Byounghak (Seoul National University of Science and Technology, Seoul)
With an interest in the structure and decoration of the interface, his doctoral dissertation titled 『The Study of Decorative Design Based on the History of the Title Page』 has been published in 『LetterSeed』. Currently, he teaches web publishing in the department of Visual Communication Design.

Min Bon (Hongik University, Seoul)
Assistant Professor, Hongik University Visual Communication Design. University of Reading, MA in Typeface Design. University of Barcelona, MFA in Typography: Discipline & Uses. Seoul National University, BFA in Visual Communication Design. Former Designer, Apple Design Team, Apple Inc.. Former Type Designer, Font Team, Apple Inc.. Former Journalist Designer, Hankyoreh Newspaper.

Sim Wujin (Sandoll, Seoul)
He works in education and publishing, focusing on the design methodology of books and types. He is an author of 『Manual of Body Text Typesetting』, 『Hiut』 Magazine issues 6 and 7, 『Easy-to-Find InDesign Dictionary』, and the co-author of 『Microtypography: Punctuation Marks and Numerals』, 『Typography Dictionary』. He published 『Type Trace: A History of Modern Hangeul Type』 and translated 『Hara Hiromu and Modern Typography: Type, Photo, and Print of Japan in the 1930s』. He has been a type director of Sandoll 「Jeongche」, which is the representative body text font of Sandoll since 2017. He is currently the head of Sandoll Type Design Institute.

You Hyunsun (Workroom, Seoul)
She is a graphic designer at Workroom and a member of Filed. She pursues easy, strong, fast work and explores the strange encounter of photography and graphic design. Her work has featured in 《ORGD 2020: Optimal Performance Zone》《Contactless》. Also, she took part in the planning and design of 《PLAANTS》 and 《Filed SS 2020》.

Authors

An Mano (Ahn Graphics, Paju)
A graphic designer who loves letters and posters. A creative director at Ahn Graphics.

Fibi Kung (孔曉晴,
Graphic Designer, Hong Kong)
She graduated from the Hong Kong Polytechnic University with a BA degree in Visual Communication Design. After she received the Hong Kong Young Design Talent Award in 2014, she worked in design agencies and studios in Stockholm, Copenhagen, Rotterdam, and Seoul where she had years of practice and experience working for a wide range of international projects. She has a keen interest in type design and lettering and she likes to travel and experience new cultures through design.

Ha Hyeongwon (BATON, Seoul)
Ha Hyeongwon is working as a brand designer in BATON. She carries out title-lettering or branding projects based on her interest in the form of letters. She conducts lettering classes for students and designers.

Han Sukjin (University of Bristol, Bristol)
He is a professor of economics at the University of Bristol. He received degrees from Yale University and Seoul National University and served as an assistant professor at the University of Texas in Austin. The topic of recent research is to analyze subjects from various angles using text or visual information that has been overlooked in existing economic studies. He is usually interested in art, architecture, and writing, and is continuing to communicate with experts in related fields.

Jang Sooyoung (yang-jang, Seoul)
A Hangeul typeface designer at a type design studio yang-jang.

Kim Chorong (Sandoll, Seoul)
She makes a living by designing, thinking, and talking about fonts and their environment. She studied Visual Communication Design at Kyung Hee University in Korea and ERBA Besançon(ISBA Besançon), and Type Design at ESAD Amiens in France. She worked as a font designer at Cadson Demak, and currently, she is working at Sandoll. She is teaching at the Hangeul Typography School. She participated in 「Thonglor」 of Cadson Demak, 「Neue Frutiger Thai」 of Linotype, Kakao typeface, Naver 「Nanum Square」, and 「Euljiro」 of Baemin, Sandoll 「Jeongche」 family, and 「IBM Plex Sans KR」.

Kim Hyunjin (Type Designer, Seoul)
Typeface & Graphic designer. Loves to explore unusual—yet beautiful—forms of letters. Always trying to create an eccentric typeface. Also working on some client projects.

Kim Youngsun (VCNC, Seoul)
She works on designing printed matters, branding, letterings, and illustrations. She mainly works by bringing interesting forms of characters into various projects. She participated in exhibitions such as 《100 Films 100 Posters》《Big River Poster Festival》《Weltformat Korea》 and 《"THEN TO NOW" Gate way》《TUKATA NEW BLUE CHALLENGE》.

Ku Jaeun (Graphic Designer, Seoul)
A graphic designer and a translator. Studied at Hongik University and Pratt Institute. Currently working at a design studio.

Kwon Joonho (Everyday Practice, Seoul)
He studied Visual Communication at the Royal College of Arts and taught graphic design at the Royal College of Arts for the following year. In 2011, his graduation work 〈Life〉 was selected as the UK Creative Review's "The Annual 2011". In 2012, he was selected as the "Rising Star" by British Design Week and was selected one of as the 20 artists of "New Sensation" by Saatchi Gallery. After working as a graphic designer at London-based Jonathan Barnbrook Studios and Why Not Associates, he has been running the design studio Everyday Practice since 2013. He became an AGI member in 2017 and worked with colleagues on various projects.

Lee Hwayoung·Hwang Sangjoon
(BOWYER, Seoul)
BOWYER is a design studio based in Seoul, Korea. Founded in 2016 by Lee Hwayoung and Hwang Sangjoon. They specialize in brand identities, printed matters, and exhibitions with a wide range of clients.

Lee Jaemin (studio fnt, Seoul)
Graphic designer. He graduated from Seoul National University and founded a graphic design studio fnt in 2006. He worked with clients like the National Museum of Modern and Contemporary Art, Seoul Museum of Art, National Theater of Korea, and Seoul Record Fair Organizing Committee on many cultural events and concerts. He also teaches Visual Communication Design at the University of Seoul. He is an AGI member since 2016 and a full-time dad of two beautiful cats.

Mak Kai Hang (麥緊桁, Mak Kai Hang Design, Hong Kong)
He graduated from HKICC Lee Shau Kee School of Creativity, and started his book design career as an in-house designer at a publisher. Focusing on book design and typographic layout from an experimental point of view, his book designs are with strong and impactful aesthetics. In 2019, he won the Golden Pin Design Award for "Best Design of the Year", and in 2020, he received awards from The One Club New York, D&AD, the TDC Tokyo, the TDC New York, and the ADC New York. His work has been exhibited internationally in Beijing, Moscow, Norway, Taiwan, and the US.

Maria Doreuli (Contrast Foundry, San Fracisco·Moscow)
She is the founder of an independent studio Contrast Foundry. In 2018, craving for new challenges, she relocated to San Francisco. She's open to new opportunities and aims to experiment more to find unexpected forms of expression. Some of her projects have been honored with many international awards from ADC, Communication Arts, Morisawa, Red Dot, and TDC New York.

Mun Sanghyun (Studio Mun, Seoul)
After graduating from the Rhode Island School of Design, he worked at the Walker Art Center on a Design Fellowship, and Hyundai Motor's Creative Works. Some of his works and interviews were published on Google Design, CNN, and in 『Wired』, and in 2012, he was selected as "20 Under 30: New Visual Artists" by 『Print』. His work has been taken up in the permanent collections of the San Francisco Museum of Art, the Philadelphia Museum of Art, and the Musée des Arts Décoratifs, and he is currently pursuing a master's degree at Seoul National University.

Nam Sunwoo (Curator, Seoul)
She studied Aesthetics and worked at Monthly Art, Curatorial Lab Seoul, and Ilmin Museum of Art. She co-curated exhibitions such as《Afterpiece》《mumu》, and《The Face of Theater》, and co-translated 『Gateways to Art』.

Park Chulhee (Sunnystudio, Seoul)
He is a graphic designer of Sunnystudio. He likes to draw letters and to make shapes.

Park Jinhyun (Type Designer, Seoul)
She is a graphic and typeface designer. She also often delivers typography workshops. In 2018, she released a 「Galmetbit」, a typeface exclusively for vertical typeset. Currently, she is drawing the Minburi type family 「Jibaek」, which is composed of three weights. Also, some of her works have been featured in《50 People, 50 Shapes》and《Weltformat Korea》.

Park Shinwoo (Paper Press, Seoul)
Paper press is a graphic design studio located in Seongsu-dong. From arts and culture to collaboration with a variety of brands, paper press carries out all the possibilities for graphics to intervene.

Park Youngshin (IanDesign, Seoul)
She is a book artist, picture book writer, and art director at IanDesign. She has designed numerous illustrated encyclopedias, Korean dictionaries, and picture books since 1983. She tried to create new ways of making artbooks, such as 『Bird & Bird Sound』, which visualized bird sounds in Morse code, and 『God's Garden』, which is composed of imaginary seeds. She received the Design Achievement Award on "Book Day" in 2020 thanks to her creativity.

Poe Cheung (張少寶, Graphic Designer, Hong Kong)
She graduated from the Hong Kong Polytechnic University, majoring in communication design, and started her career in Berlin. She is now a Hong Kong-based designer focusing on visual identities, editorial design,

exhibition design and bilingual typography. She is interested in visualizing concepts in an unconventional way.

Seok Jaewon (Hongik University, Seoul) Graphic Designer ◦ Professor at Hongik University×Director of AABB Group ◦ MFA in Graphic Design from Yale University×BFA in Visual Communication Design from Hongik University

Syn Gunmo (Formula, Seoul) He studied graphic design at Kaywon School of Art and Design. He is particularly interested in letters and handling letters. He enjoys working on paper as his main medium. Since 2013, he has been working on Onyang Folk Museum's museum identity and its publications. In addition, He has collaborated with various cultural and art organizations and institutions in South Korea, including the National Museum of Modern and Contemporary Arts, Seoul Foundation for Arts and Culture, and Architectural Critics Association.

Yang Soohyun (NEWNEEK, Seoul) She studied modern art at Konkuk University and works as a graphic designer. In 2018, she joined NEWNEEK, a newsletter service for the Millennials. She developed a character called "Gosumi" and designed various products and experiences needed for the brand. As a member of FDSC, she is in solidarity with a contemporary female designer. She likes to spread herself thin, and keep humor and sincerity. Also, she pursues a design with a story. She recently gave birth to a daughter and is trying to be a wonderful mother.

Translator
Hong Khia (Translator, Seoul) Jennifer Choi, translator. She translates art (and everything else). khiahong@gmail.com

Kim Noheul (Translator, Samcheok) Graduated from the Graduate School of International Studies at Seoul National University. Actively working in the field of art and science. Recently participated in translating 『LetterSeed』 of the Korean Society of Typography and 『Typojanchi 2017』 of Ahn Graphics.

Sohn Hyeonjeong (Translator, Seoul) Graduated from the Graduate School of Translation & Interpretation at Ewha Womans University and has been actively working as a professional translator for over ten years. Recently participated in translating 『LetterSeed』 of the Korean Society of Typography.

Purpose
These regulations form a framework for
paper submissions to 『LetterSeed』, the
journal published by the Korean Society of
Typography.

Submission Requirements
Only regular or honorary members of the
Society are qualified for paper submission to
『LetterSeed』. Co-authors should equally be
regular or honorary members.

Regulation for Acceptance
In principle, authors should not submit
previously published work. However, if a
paper has been presented at a conference of
the Society, or at symposiums, or if they have
been printed in journals of colleges, research
centers or companies, but never as papers
in any Korean media, it can be published in
『LetterSeed』 as long as the author discloses
the source.

Types of Submissions
The categories for publication are as follows
1 Research papers: papers that describe
either empirical or theoretical studies on
subjects related to typography. Examples:
proof of theory, research into historic events,
redefitions of tradition or culture, redefitions
of past theories or events, new perspectives
or methodologies, analysis of typographic
trends (both local and international).
2 Project reports: full length reports of
which the results are original and logically
delivered. Example: archive of processes and
results of actual large-scale events, archives
of processes and results of related artworks
or projects.

Submission Procedure
Papers can be submitted and published
based on the following procedure:
1 Authors can submit papers at any time,
via e-mail.
2 Authors submit papers following the
guidelines for paper submission.
3 Authors pay a 100,000-won assessment
fee.
4 The Society appoints reviewers according
to the procedure established by the editorial
board.
5 The Society notifies authors about the

result of the assessment (if there is any objection to the result, authors can send a statement of protest to the Society).

6 Authors send the final version of their paper via e-mail and pay a 100,000-won publication fee.

7 Authors receive two volumes of the journal (regular members receive one volume).

8 The journal is published twice a year, on 30 June and 31 December.

Copyright, Publishing Rights, Editing Rights (for Content)

Authors retain their copyright and grant the Society the right to edit and publish their paper in 『LetterSeed』.

[Declaration: 1 October 2009]
[Amendment: 17 April 2020]

Instructions for Authors
Manuscript Preparation

1 The paper should be sent in the form of both TXT/DOC file and PDF file in order for the Society to check errors and edit. INDD files can be submitted in particular cases.

2 Image files should be submitted in a separate folder.

3 In jointly written papers, the name of the main author should be written at the top and the following authors on the next lines.

4 The abstract, approx. 800 Korean characters, should summarize the paper.

5 Three to five keywords should be provided.

6 The paper should contain an introduction, body, conclusion, footnotes and references, all clearly distinguished from each other. Special papers can be written more freely, but footnotes and references cannot be missed.

7 Chinese and other foreign words should be translated into Korean. When the meaning is not delivered clearly in Korean only, the original words or Chinese characters can be placed beside the Korean adaptation, in parenthesis. Foreign words should only feature together with their Korean adaptation the first time they appear. After this, only the Korean adaptation should be used.

8 Symbols and units should be written following international standard practice.

9 Images and figures should be included in high-resolution. Captions should be included either in the body of the paper or on the image or figure.

10 Korean references should be listed first, followed by English references. All references should be arranged in the alphabetical order of their repective language. They should include the name of the author, the title of the work, the name of the journal (not applicable to books), the publisher, and the year of publication.

Page Count
Papers should be at least six pages long, at a 10-point font size, excluding the table of contents and references.

Printing
1 Once a manuscript is typeset, the corresponding authors checks the layout. From this point, the authors are accountable for the published paper and responsible for errors.

2 The size of the journal is 171×240mm (it was 148×200mm before December 2013).

3 The journal is printed in black and white.

[Declaration: 1 October 2009]
[Amendment: 17 April 2020]

Paper Assessment Policy
Purpose
The Korean Society of Typography has defined a framework for the assessment of paper submissions to 『LetterSeed』.

Paper Assessment Principles
Whether or not papers are accepted is decided by the editorial board and is based on the following principles.

1 If two out of three reviewers give a paper a 'pass,' the paper can be published in the journal.

2 If two out of three reviewers consider a paper better than 'acceptable if revised,' the editorial board asks the author for a revision and accepts the revised paper if it meets the requirements.

3 If two out of three reviewers consider the quality of a paper to be less than 'reassessment required after revision,' the paper has to be revised and the reviewers reassess to determine whether it qualifies for publication.

4 If more than two out of three reviewers give a paper a 'fail,' the paper is rejected and will not be published in the journal.

Editorial Board

1 The editor-in-chief of the editorial board is appointed by the president of the Society and makes recommendations for the editorial board, to be approved by the board of directors of the Society. The editor-in-chief and the editorial board serve a two-year term.
2 The editorial board appoints the reviewers for submitted papers, who will make assessments and ask authors for revisions, if necessary. If authors do not resubmit revised papers by the requested date, it is presumed they are no longer interested in publishing their papers. Papers cannot be altered after submission, unless approval is obtained from the editorial board.

Reviewers

1 Papers are assessed and screened by at least three reviewers.
2 Editorial board members appoint reviewers among experts on the subject of submitted papers.
3 There are four assessment results: pass, acceptable after revision, reassessment required after revision, fail.

Assessment Criteria

1 Is the subject of the paper relevant to the tenets of the Society and does it contribe to the advancement of typography?
2 Does the paper make a clear point and does it present academic originality?
3 Is the paper logically written?
4 Is the paper written according to the guidelines provided by the Society?
5 Do the Korean and English summaries exactly correspond to the paper?
6 Does the paper contain references and footnotes?
7 Do the title and keywords correspond with the contents of the paper?

[Declaration: 1 October 2009]

Code of Ethics
Purpose

The code of ethics below forms an ethical framework for members of the Korean Society of Typography in regard to their research and education practice.

Report of Violation of the Code of Ethics

If a member of the Society witnesses another member violating the code of ethics, he or she should endeavor to correct the problem by invoking the code. If the problem is not corrected, or if the case of violation is flagrant, it can be reported to the Society's Ethics Commission. The Ethics Commission should not disclose the identity of the member who reported the case.

Order of Researchers

The order of researchers should be determined based on the extent to which they have contributed to the research, regardless of their relative status.

Plagiarism

Authors should not represent any research results or opinions of others as their own original work in their papers. Results of other researches can be referred to in a paper when their source is clarified, but if any of the results are given as if they are the author's own, it is plagiarism.

Redundant Publication

Work that has been previously published (or will soon be published) elsewhere—domestically or internationally—cannot be published in the journal. An exception can be made for segments of work that previously appeared in foreign publications. In this case, the editorial board can approve publication based on the significance of the contents. However, the author cannot use the publication as additional research achievement.

Citation and References

1 When using existing published research materials, authors should accurately cite them and disclose the source. If data is gained through a personal contact, it can be cited only with prior approval of the person providing the data.
2 Authors should list their sources in footnotes when directly quoting other authors' language and expressions, so that readers can distinguish the original source from the new ideas developed by the authors of the new paper.

Equal Treatment

The editors of the journal should treat the

submitted papers equally regardless of the gender or age of authors, or the institution to which they belong. All papers should be properly assessed, solely based on their quality and on whether they have followed the submission guidelines. The assessment should not be influenced by any prejudice or personal acquaintance with editors.

Appointment of Reviewers

The editorial board should commission reviewers as judges of a paper those who are fair and have expertise. Those who are closely acquainted with, or hostile towards, the author should be avoided to allow fair assessment. However, when assessments of the same paper show remarkable differences, another expert can be consulted.

Fair Assessment

Reviewers should make fair assessments of papers regardless of their personal academic beliefs or of their acquaintance with their authors. They should not reject papers without reason, nor because it counters their opinion. They should not assess a paper before reading it properly.

Respect for the Author

Reviewers should respect the personality and individuality of authors as intellectuals. The assessment should include an evaluation by the reviewers, and elaborate, when necessary, why a certain part of the paper needs revision. The evaluation should be delivered in a respectful manner, free of any contempt or insult.

Confidentiality

The editors and reviewers should keep submitted papers confidential. Aside from possibly necessary consultation, it is not appropriate to show the papers to others or discuss their contents. It is not allowed to cite any part of the submitted papers before they are published in the journal.

Composition of the Ethics Committee and Election

1 The ethics committee is composed of more than five members who are recommended by the editorial board and appointed by the president of the Society.

2 The committee has one chair, who is elected by the committee.

3 The committee makes decisions following a two-thirds majority or more.

Authority of the Ethics Committee

1 The ethics committee conducts investigations into reported cases in which the code of ethics was allegedly violated and reports the results to the president of the Society.

2 If the violation is proved true, the chair of the ethics committee can ask the president to approve sanctions against investigated members.

Investigation and Deliberation of the Ethics Committee

A member who allegedly violated the code of ethics should cooperate with the ethics committee in the investigation. The committee should give the member ample opportunity for self-defense and should not disclose his or her identity until a final decision is made.

Sanctions for Violation of the Code of Ethics

1 The ethics committee can impose the following sanctions upon violation of the code of ethics. Multiple sanctions can be imposed for a single case.

A. If a paper that is subject to violation of the code is not yet published in the journal or presented at a conference, it will not be accepted for publication or presentation.

B. If a paper that is subject to violation of the code is already published in the journal or has already been presented at a conference, it will be retracted.

C. The member is banned from publishing papers and participating in conferences or discussions for three years.

2 Once the ethics committee decides to apply sanctions, it conveys the decision to the institution managing the respective researcher's achievements and announces the decision to the public in a proper way.

[Declaration: 1 October 2009]
[Translation Update: 26 July 2021]

Greetings

Lee Byounghak

Korean Society of Typography
Editor-in-Chief, Paper Section

I am calling for papers for the next 『LetterSeed 21』. No matter what type of paper it is, please feel free to submit it to the editorial board. If you have small seeds, sprout them. Do let me know if you find seeds around you. This may not be a smooth or sophisticated opening for my preface to 『LetterSeed 20』, but I felt I should take the opportunity to make this point first.

Looking through the manuscript of 『LetterSeed 20』, as I am writing this preface, the fruit of the work is beautiful. But why does my mind slowly go blank as if I went back to the days when I was nervous before a presentation at an academic conference? The same might be true for paper submissions. Since I started taking charge of 『LetterSeed 18』, I have simplified the submission process and began accepting papers with free topics, precisely to ease this burden. However, there are still not many voluntary contributions. It must be difficult to decide to submit a paper as it requires going through a review process. Fortunately, the reviewers' responses are more affectionate compliments and advice than they are reviews, so they are a great contribution to the writing process. It's a pity I can't show you. The editorial board was in charge of a total of seven papers, including Mun Sanghyun's 『ZXX』 type design project, which deals with the collection of personal information from a critical perspective, and Seok Jaewon and Ku Jaeun's study, which explores the always ambiguous definition of readability and legibility. I would like to express my deep gratitude to the authors and to all the reviewers who conveyed warm and carefully crafted comments despite their busy schedules. Now, I'll return to preparing the next 『LetterSeed』.

"Paper" is only a small part of 『LetterSeed 20』. Starting with an introduction of the work under the theme of "Re-interpreted Types," there is much to see and read, involving "Archive" "Conversation" "Review" and "Collection." Please turn the page and enjoy this valuable result. In the early planning meeting, I remember some members of the editorial board worried that it would be difficult for designers to make letterings with Hangeul, which can be read even if they are flipped, of "Collection" section. It appears we didn't need to worry.

paper

「ZXX」 Typeface Design to Raise Awareness of Personal Information Protection in the Digital Age

Mun Sanghyun

Keywords: Typography, Type Design, Digital, Surveillance
Received: 26 April 2021
Reviewed: 11 May 2021
Accepted: 6 June 2021

Translation by Hong Khia

Abstract

As linguistic symbols and visual signs utilized in our society, typefaces are the fruit of the zeitgeist. This paper interrogates the social roles and the proactive practicality of type design, revolving around the typeface 「ZXX」 that I developed over the past ten years to protect ourselves from digital surveillance and secure private information.

The study starts with a critical approach towards the physical collection of data and elucidates the process and the results of creating the practical and symbolic type 「ZXX」. The inherently secretive 「ZXX」 has developed sixteen camouflaging variations unreadable by OCR (Optical Character Recognition) artificial intelligence. The ongoing project consistently expands with technology updating OCR software. The objective of this study is not in creating a completely indecipherable typeface but in establishing significance as a symbolic presence that addresses issues surrounding digital surveillance.

The ultimate goal is for the typeface to open up a discussion about current social issues surrounding digital surveillance. This study contemplates the significance of type design as a medium that amplifies the public's voice and raises awareness about the importance of protecting personal data in the digital age.

Preface

A typeface reflects its time and era. It has transformed with civilization, technology and social context, and as the "penetrating thread of civilization"[◆] has served social roles as the fruits of our society with symbolic and temporal values. Then what do today's type designs say about our time? This study seeks the potential of type design from passive service designs to activist designs.

Background

The idea for the 「ZXX」 Project[◆◆] was conceived from personal experiences serving the military[◆◆◆], as a digital defiance against the collection of data. 「ZXX」 was a practical and symbolic call to attention, raising questions and awareness on personal data protection in this highly data-oriented society. New technologies that emerged during the preparation of this project enabled storing and connecting the vast amount of data in a format that can be collected at all times. For example, wearable devices that developed rapidly with Google Glass provided the convenience of recording at all times, but it also meant that a new age of surveillance has arrived where every single piece of data—even data too trivial for human recognition—is tracked at every moment. Such change signifies a dramatic transition from "over the skin" to "under the skin" surveillance.[◆◆◆◆] While new technologies have seeped into the roots of our lives, public awareness about the importance of privacy protection and utilization is still minimal.

This project started with a question: How can the thoughts of humans be concealed from artificial intelligence and those who deploy it? Such thinking was followed by deeper questions: How can design be used politically and socially for the codification and de-codification of people's thoughts? What is a graphic design that is inherently secretive? How can graphic design reinforce privacy? How can the process of design engender a proactive attitude towards the future—and our present for that matter?

As a response, I developed a typeface legible to humans, but undetectable by OCR artificial intelligence. Starting with six families of type [Fig. 2], sixteen cuts [Fig. 3], each with a different camouflage foiling machine intelligence, have been developed as of 2021. While an unreadable typeface would normally be considered useless, the 「ZXX」 types exist to be cryptic, paradoxically.

◆ David Kim, 「Tobias Frere-Jones, Type Designer」, 『Surface Magazine』, Power 100 issue, June/July. New York: Surface Media, 2014.

◆◆ ZXX is the three-letter code used by the Library of Congress when characters are unrecognizable. ZXX indicates "no linguistic content".

◆◆◆ During my service in the Korean military, I worked as special intelligence personnel for the NSA, learning how to extract information from North Korea.

◆◆◆◆ Yuval Noah Harari. 「Yuval Noah Harari: the world after coronavirus」. 『Financial Times』, 20 March 2020.

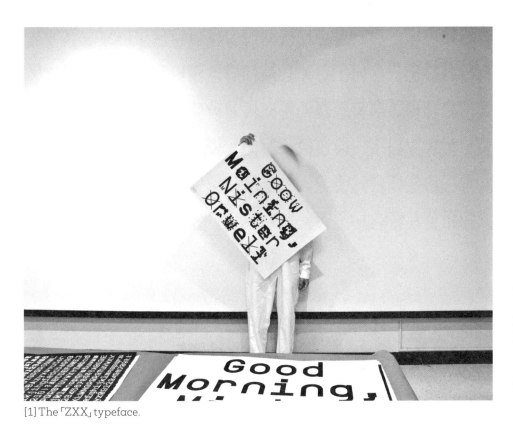

[1] The 「ZXX」typeface.

Examples of Counter-Surveillance Projects

Many activists, artists and designers have, in various forms, demonstrated a critical perspective on privacy protection and the surveillance society through their works. Computer security researcher and hacker Jacob Appelbaum co-developed Tor Project to provide online anonymity and secure privacy. Tor Project's system is structured to bounce around the distributed network of relays, which makes the accumulated metadata dysfunctional. As Tor detours networks of multiple countries before reaching its destination, backtracking is made nearly impossible.✦✦✦✦✦ For this reason, information has been leaked that mere download or use of Tor Project can put the user on NSA's wanted list.

Adam Harvey has created large-scale projects in resistance to our society of surveill-ance and censorship. Harvey's most notable project, CV Dazzle [Fig. 4], responds to surveillance with fashion aesthetics. It is an art of performance-like disguise—a camouflage protecting from face-detection technology such as surveill-ance cameras and drones. Using hairstyling and make-up designs, it obscures humans from computer vision. After developing the disruptive pattern, Harvey launched the

✦✦✦✦✦ For example, instead of going A →Z, the traffic bounces around in the path A →C →B →D →Z to reach its destination. Starting from a server in Korea, it follows a random path to networks in countries like Germany and the United States before reaching the destination server.

ABCDEFGHIJKLMNOPQRSTUVWXYZ
ABCDEFGHIJKLMNOPQRSTUVWXYZ
ABCDEFGHIJKLMNOPQRSTUVWXYZ
ZYXWVUTSRQPONMLKJIHGFEDCBA
ABCDEFGHIJKLMNOPQRSTUVWXYZ
ABCDEFGHIJKLMNOPQRSTUVWXYZ

[2] First type specimen of「ZXX」.

ABCDEFGHIJHLMNOPQRSTUVWXYZ
ABCDEFGHIJHLMNOPQRSTUVWXYZ
ABCDEFGHIJHLMNOPQRSTUVWXYZ
ABCDEFGHIJHLMNOPQRSTUVWXYZ
ABCDEFGHIJHLMNOPQRSTUVWXYZ
ABCDEFGHIJHLMNOPQRSTUVWXYZ
ABCDEFGHIJHLMNOPQRSTUVWXYZ
ABCDEFGHIJHLMNOPQRSTUVWXYZ
ABCDEFGHIJHLMNOPQRSTUVWXYZ
ABCDEFGHIJHLMNOPQRSTUVWXYZ

[3] Second type specimen of「ZXX」.

[4] CV Dazzle.

project Stealth Wear, creating garments unnoticeable to various digital surveillance technologies.

Metahaven, an Amsterdam-based design and research studio, is at the vanguard of critical and social design movements. Through graphic design, they create critical designs and publications that criticize power mechanisms including those of the media and the government. Their practice is an endless search for the role of art in our society. The brand-identity work for WikiLeaks, a non-profit organization known for its whistleblowing platform, highlights the unrivaled approach of Metahaven. Their work exudes a wicked and elusive nature, expressing criticism towards censorship.

「ZXX」 Development Process 1: 2012

Slavoj Žižek once said, "We feel free because we lack the very language to articulate our unfreedom."◆ In raising questions in this context on censorship, surveillance, and freedom of expression, I dedicated myself to "articulating our unfreedom" with a typeface. To visualize the unfreedom, I drew characters indecipherable by OCR software. [Fig. 5] 「ZXX」 intentionally throws different types of noises and distortions onto the alphabet to thwart the software.

「ZXX Camo」 [Fig. 6] cloaks letters in camouflage patterns like an animal camouflaging itself from its predators. The organic vector shapes of the camouflage were borrowed directly from the nature of animals. 「ZXX False」 [Fig. 7], as hinted in its name, sends false information by reversing the order of the twenty-six letters of the alphabet and the ten numerals. An A is hidden inside a Z, a 0 inside a 9. The tiny letter placed within each character has to be found to read it properly. 「ZXX Noise」 [Fig. 8] tests the limits of OCR artificial intelligence by scattering noise blobs around the characters. Most OCR systems process a scan to separate the tones of the text and the background. Letters with more distinctive forms were quickly recognized despite the added noise. A lower case "m" [Fig. 9] required nearly a full-cover of noise to be obscured.

「ZXX Xed」 [Fig. 10] places regular X-patterns over the letters to minimize readability. The patterns invade the corner areas of each character, which elicited the most efficient disruption of the OCR system with the

◆ Slavoj Žižek. Kim Heejin, Lee Hyunwoo. 『Welcome to the Desert of the Real』, Seoul: Jaeum & Moeum, 2011.

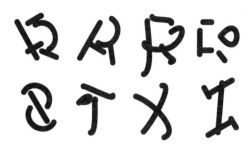

[5] OCR software test.

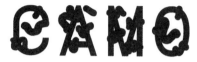

[6] 「ZXX Camo」.

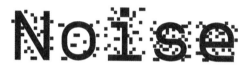

[7] 「ZXX False」.

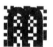

[8] 「ZXX Noise」.

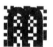

[9] Lower case "m" of 「ZXX Noise」.

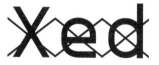

[10] 「ZXX Xed」.

least amount of distortion. Cross-combining the six variations will further confuse the OCR system, with the endless permutations of the typefaces. [Fig. 11]

「ZXX」 Development Process 2: 2020

The second development process of 「ZXX」 started in 2020 while participating in the Carnegie Museum of Art's publication 『Mirror with a Memory』. The 2012 「ZXX」 was put to the test with Google's highly advanced OCR engine, Tesseract.◆ The engine's recognition is constantly enhanced through artificial intelligence training. Tesseract, with the latest being Version 5, easily recognized all characters except 「ZXX False」.

The new variations were validated with Tesseract as the standard software. The OCR engine Tesseract extracts features of the typed images and detects characters. Every distinct feature such as the curvature, corner, angle, and line is dissected and placed in comparison to particular characters. Each feature is outlined and its polygonal approximations are compared to characters of similar form from the database, finding the character with the highest match rate.

I used Tesseract's character recognition architecture to dissect each feature in reverse and create a new cut of types. While maintaining the basic character structure, I made the new typeface with the exaggerated junctions and angular forms for a sharp contrast, and I set this new typeface with the existing typefaces.◆◆ [Fig. 12] Such extreme design was the only way to disrupt

Good Morning, Mister Orwell

[11] An example of a cross-combination of the six cuts.

♦ 『ZXX』went through a test scan with Adobe Acrobat Pro, which provides free OCR service like Google's Tesseract. The software did not succeed in decoding every type of 『ZXX』.

♦♦ With Glyphs's Contextual Alternatives, automated cross-combination of the cuts was made possible, as the process was initially manual.

♦♦♦ Edward Joseph Snowden is a computer technician who worked for the CIA and the NSA. Through 『The Guardian』in 2013, Snowden disclosed confidential NSA documents revealing trackings of telephone calls and the PRISM surveillance program.

♦♦♦♦ 『ZXX』has been featured in multiple exhibitions and interviews by CNN, 『WIRED』, San Francisco Museum of Modern Art, MAD Paris, and Philadelphia Museum of Art, among others.

Tesseract's OCR technology, which continues its training to this day. The heavily cryptic form of the newly developed 『ZXX』acts as a visual measure for the advancement of technology of the current OCR engines.

The project can expand perpetually with time and technology. However, fabricating a perfectly cryptic typeface is not the fundamental ambition of this project. Future OCR engines will be able to recognize the full text and its context rather than single letters. The value of 『ZXX』is rather its symbolic presence in light of digital surveillance awareness, more so than perfecting cryptographic technology.

Circulation of 『ZXX』

Through the exposure♦♦♦ of the NSA's practices in 2013, the world found out about its mass surveillance. Snowden's disclosures shed new light on 『ZXX』's message of defiance against digital surveillance in various media and exhibitions.♦♦♦♦ [Fig. 13]

『ZXX』was released as a free download and used for the book 『Art and Politics Now』 [Fig. 14], designed by British graphic designer Jonathan Barnbrook. With the publication,

TEXHNOLOGY IS NEITHER GOOD NOR BAD, NEITHER IS IG NEUTRAL.

[12] An example of a cross-combination of the sixteen cuts.

「ZXX」spread as a movement proclaiming "digital defiance". Adam Harvey, previously mentioned with his counter-surveillance projects, used 「ZXX」in his project, along with many others in Switzerland, Germany, Russia, the United States, South Korea, and more.

Circulation of the typeface through free distribution allowed users to proactively discuss the phenomena of digital surveillance and demand a forthright change. 「ZXX」is a new form of typeface with both practical and symbolic values; a medium provoking critical thinking and a call to action.

Conclusion

As citizens of this modern society, we are never free from censorship and surveillance. The 「ZXX」project was intended to spark conversations around privacy protection through the visualization of unfreedom and to spread caution about the digital age in which convenience overrides protection of individual rights. It may not be possible to provide actual solutions to social issues with a representation of complex themes of digital surveillance and privacy protection. However, the issues can be addressed effectively through active use of the symbolic typeface. Thus, this project not only suggests a single, complete type but also unravels the evolution process of the design to seek the attitudes we should adopt. Moreover, invisible yet crucial values will be further conveyed, expanding the research of the interrelations between technology, power, and aesthetics, and exploring a broader range of social issues.

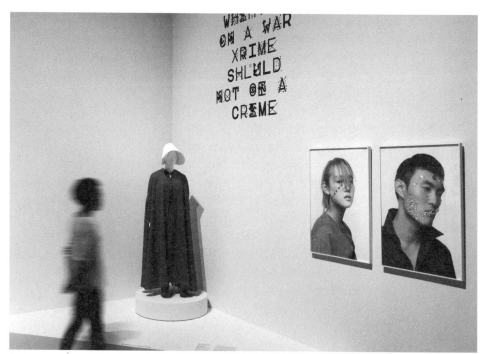

[13] Installation view of「ZXX」. Philadelphia Museum of Art, 2019.

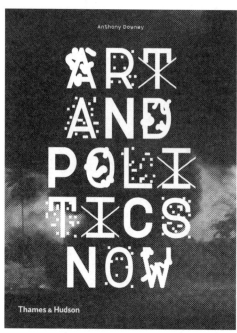

[14]「ZXX」on the cover and pages of『Art and Politics Now』.

Bibliography

Tobias Frere-Jones. 『Surface Magazine』, Power 100 Issue, June/July. New York: Surface Media, 2014.

Yuval Noah Harari. 「Yuval Noah Harari: the world after coronavirus」. 『Financial Times』, 20 March 2020. Accessed: 21 May 2021 www.ft.com/content/19d90308-6858-11ea-a3c9-1fe6fedcca75

Robin Kinross. 『Modern Typography』. Specter Press, 2009

Library of Congress. Accessed: 21 May 2021 www.loc.gov/marc/languages/language_code.html

Yu Jiwon. 『Letter Landscape』. Seoul: Eulyoo Publishing, 2019

Žižek, Slavoj. Kim Heejin, Lee Hyunwoo. 『Welcome to the Desert of the Real』, Seoul: Jaeum & Moeum, 2011.

The Study on Legibility and Readability Definition Usage in Typography

Seok Jaewon, Ku Jaeun

Keywords: Typography, Gadokseong,
Pandokseong, Legibility, Readability
Received: 16 April 2021
Reviewed: 11 May 2021
Accepted: 16 May 2021

Translation by Kim Noheul

Abstract

The term Gadokseong (가독성, a quality of being readable) and Pandokseong (판독성, a quality of being legible or deciphered) are frequently used terms in the field of typography. Nevertheless, their definitions have not been clearly established yet in Korea so they are often confusing or misused. The meanings of legibility and readability are inconsistently matched particularly in translation, which sometimes incurs confusion in communication.

This research aims to identify what causes the confusion and clarify the outline of these terms with unclear use so as to lay the foundation for accurate communication. To this end, this study collected, analyzed and categorized different definitions of Gadokseong, Pandokseong, legibility and readability respectively in the field of typography. The scope of the research covers twenty-three volumes of books either written or translated by noted Korean and foreign typography researchers. This includes ten Korean and thirteen foreign books which provide concrete definitions of Gadokseong, Pandokseong, legibility and readability.

Usage of Gadokseong, Pandokseong, legibility and readability can be classified into three categories as follows. First, Type A covers cases in which readability means perception efficiency of text forms while legibility means perception efficiency of letter forms. Each of the words Gadokseong and Pandokseong is translated as readability and legibility. Second, Type B exhibits cases in which readability means comprehension efficiency of text contents while legibility means perception efficiency of letter and text forms. Each of the words Gadokseong and Pandokseong is translated as readability and legibility. Third, Type C refers to cases in which Gadokseong has extended meanings of with perception efficiency of letter forms, perception efficiency of text forms and text comprehension efficiency all together. The word Gadokseong is translated as legibility in this category.

Thus, a typography researcher is required to make the following efforts in order to avoid confusion of communication. First, be clearly aware that definitions of Gadokseong, Pandokseong, legibility and readability can be interpreted differently from what is intended. Second, elaborate on what is intended when using these terms. Third, annotate a translated version with terms used in the original text as far as possible.

1 Introduction

This research is to review the mixed use of definitions of readability and legibility in the field of typography based on their usage and to categorize the currently used definitions of Gadokseong, Pandokseong, legibility and readability. It aims to identify what causes the confusion of communication and clarify the outline of those terms with unclear use so as to lay the foundation for accurate communication.

The terms readability and legibility are frequently mentioned in the field of typography. They are related to essential functions and goals of typography so their meanings should be carefully considered for use. Nevertheless, the classification criteria of the two are vague even in typography textbooks. The terms have similar meanings but are hard to be regarded as synonyms. However, they are often used inconsistently or without distinction, which incurs confusion of communication.

The main cause of that issue can be attributed to translation of original works. Like many other typography terms, Gadokseong and Pandokseong are commonly explained by quoting original works written in a foreign language. The problem lies in that original works do not have consistent definitions of these terms and consequently cause confusion. In addition, Korean translators adopt different terms in the translation process. Some translators use readability and legibility for Gadokseong and Pandokseong respectively while others use readability for Pandokseong. Other than these cases, analogous terms are also used such as ease of reading, perception degree, distinctness, perspicuity, comprehensibility, visibility, etc.

This confusion has continued over the last five decades but unfortunately, no academic research has been done on that issue. Thus, we tried to examine how Gadokseong, Pandokseong, readability and legibility are defined in books either written or translated by noted Korean and foreign typography researchers, and comprehensively analyze and categorize them.

2 Current Usage
2.1 Dictionaries

According to 『Korean Standard Unabridged Dictionary』 published by National Institute of Korean Language, Gadokseong (可讀性) is defined as described below. Pandokseong (判讀性) is not a headword but both Chinese characters 可 and 判 have the same meaning of telling right from wrong.

■ Gadokseong: the efficiency degree to which a printed

matter can be read easily. It varies depending on
elements such as typeface, type spacing, line spacing,
word spacing, etc.

『Oxford Dictionary』 defines legibility and readability as
follows. It uses 'read' and 'legible' respectively for the notion of
legibility and readability.

Legibility: the quality of being clear enough to read.

Readability: the quality of being legible or decipherable.

『Cambridge Dictionary』 defines both legibility and readability
as 'the degree of being read easily' and visual perspectives of
'clear, printed well' are added to the description of legibility.

Legibility: the degree to which writing or text can be
read easily because the letters are clear, the text is
printed well, etc.

Readability: the quality of being easy and enjoyable
to read.

『Merriam-Webster Dictionary』 defines both legible and
readable as 'the degree of being read' and the expression 'easy'
is added to the description of readable.

Legible: capable of being read or deciphered.

Readable: able to be read easily.

The review on dictionaries above showed no distinctions
between the terms Gadokseong and Pandokseong or legibility
and readability.

2.2 Professional Publications

Dictionary definitions of Gadokseong, Pandokseong, legibility
and readability are hardly distinct and can all be regarded
as synonyms. On the other hand, practical notions in the
typography field may have differences. To figure out their exact
usage and meanings in the typography field, we reviewed
twenty-three volumes of books either written or translated
by noted Korean and foreign typography researchers which
define Gadokseong, Pandokseong, legibility and readability.

Publications used for the analysis consist of ten Korean
and thirteen foreign books which provide concrete definitions
of Gadokseong, Pandokseong, legibility and readability.
Publications have been listed in the order of publishing year
and Korean and foreign books were numbered with K and
F respectively for convenience. In the case of foreign books
with a translated version, we quoted the translation. When a
foreign book did not have a translated version, we translated
it ourselves and put English terms including legibility and
readability in the translation to deliver their meanings
without distortion. When a Korean book was annotated with
an English term, we quoted it as it was.

2.2.1 Korean Books

K01. Song Hyun. 『Hangeul Mechanization Movement』.
Seoul: Inmulyeonguso, 1984.

> Pandokseong and Gadokseong can be seen as similar
> notions but the reason why the author differentiates
> one from the other is that he regards Pandokseong
> as a precedent of Gadokseong, considering their
> sequence and time difference. In other words, he thinks
> Pandokseong comes first as a letter is deciphered first
> among many other letters, followed by a Gadokseong
> phase in which a reader keeps rapid reading deciphered
> letters. Thus, the author intends to separate the notions
> of Pandokseong and Gadokseong; the former is to
> identify a letter from a passage in which different
> letters are all mixed and the latter is to continue to read
> through deciphered letters at a high speed. The author
> regards Pandokseong and Gadokseong as the chief
> primary reason for ideal letters with high practicality
> because the very first function of letters is to convey
> meanings. Letters are supposed to be rapidly read
> and deciphered by readers so high Pandokseong and
> Gadokseong are the primary conditions for ideal letters
> with high practicality.

K02. Lee Soonjong, Cho Youngje, Ahn Sangsoo, Kwon
Myungkwang. 『The Dictionary of Contemporary Design』.
Paju: Ahn Graphics, 1994.

> → Gadokseong: legibility. readability. The term
> Gadokseong can be translated as legibility and
> readability. The former refers to a 'process to identify
> and perceive' each letter form and the latter represents
> 'a success rate of scan-and-perceiving process'. The
> term 'legibility' was used in early discussions about
> factors that affect ease of reading and reading speed
> and some scholars started to use 'readability' around
> 1940, which was to express 'measuring the level of
> mental difficulty of reading material'. That way the two
> terms were separated, incurring confusion. Legibility is
> ultimately associated with reading material connected
> to perceiving a letter or a word. Type form should
> definitely be identified and perceived as a characteristic
> word form; continuous body text should be rapidly,
> accurately and easily read and understood. In other
> words, 'legibility' refers to integration and adjustment of
> essential typographic elements out of letters, symbols,
> words and continuous text materials that affect ease of
> reading and reading speed.

K03. Han Jaejoon, Lee Yongje, Ahn Sangsoo.
『Hangeul Design』. Paju: Ahn Graphics, 1997.

→ Gadokseong: legibility. The degree to which types on a printed matter can be read easily. Gadokseong factors include beauty of type form, harmony of sentence contents and typeface design, appropriate typesetting (spacing between letters and lines, etc). The term ease of reading (易讀性) is a synonym, which means ease of reading contents in a sentence and visibility is also used which explains the degree of how noticeable the text is.

K04. Korean Publishing Research Institute. 『Publication Terminology Dictionary』. Paju: Bumwoosa, 2000.

→ Gadokseong: legibility. readability. The term that refers to how easily the text can be read. Printed matters can be either easily or slowly read depending on typeface to be read, editing, printing method, etc. In addition to formativeness and design originality, Gadokseong of letters is also an important consideration in advertisements and commercial design.

K05. King Sejong the Great Memorial Society Korean Typeface Development Institute. 『Korean Font Dictionary』. Seoul: King Sejong the Great Memorial Society, 2000.

→ Gadokseong: 可讀性. legibility. The term Gadokseong can be translated as legibility and readability. The former refers to a 'process to identify and perceive' each letter form and the latter represents 'a success rate of scan-and-perceiving process'. The term 'legibility' was used in early discussions about factors that affect ease of reading and reading speed and some scholars started to use 'readability' around 1940, which was to express 'measuring the level of mental difficulty of reading material'. That way the two terms were separated, incurring confusion. Legibility is ultimately associated with reading material connected to perceiving a letter or a word. Type form should definitely be identified and perceived as a characteristic word form and; continuous body text should be rapidly, accurately and easily read and understood. In other words, 'legibility' refers to integration and adjustment of essential typographic elements out of letters, symbols, words and continuous text materials that affect ease of reading and reading speed. → Pandokseong: 判讀性. legibility. The term Pandokseong means how noticeable a letter is and refers to a process to identify and perceive each letter form. Sans serif types are known as highly legible. An

analogous notion Gadokseong means how easy it is to read a letter and refers to a success rate of scan-and-perceiving process. Serif types are known as highly readable. The notion of Gadokseong generally incorporates both readability and legibility but if the two should be particularly differentiated, legibility is chosen.

K06. Yu Jeongmi. 『It isn't a tabloid but a magazine』. Paju: Hyohyung Publishing, 2002.

The term Gadokseong in typography is used limitedly for desirable quality of typeface, letter or designed page. Gadokseong in the typography field, therefore, can be accepted as 'easily readable'.

K07. Won Youhong, Suh Seungyoun, Song Myeongmin. 『Typography Arabian Nights』. Paju: Ahn Graphics, 2004.

→ Gadokseong (readability) means efficiency of how easily and rapidly a reader can read lots of heavy text such as news articles, books, annual reports, etc. Pandokseong (legibility), on the other hand, refers to efficiency of how much a reader can perceive and notice from short text such as headline, table of contents, logotype, folio, etc. These two have different functionality but are the same thing as well in that they aim for the same goal, the efficiency of reading. → Gadokseong: readability. The degree of reading efficiency on the body text. Reading efficiency varies depending on font type and typesetting method. Good typography should thoroughly review readability of letters as well as formativeness and originality. → Pandokseong: legibility. The degree to which letters are identified and read easily.

K08. The Korean TEX Society. 『TEX: Beyond the World of Typesetting』. Seoul: Kyungmoon Publishers, 2007.

Ease of reading (mentioned in typography) does not mean 'readability' but 'legibility'. 'Readability' means how readable the text is in terms of language or contents while 'legibility' demonstrates how easy it is to read letter(s) or layout in design context.

K09. Oh Byeongkeun, Kang Sungjoong. 『Textbook of Information Design』. Paju: Ahn Graphics, 2008.

Gadokseong is a visual attribute in typography about whether a large amount of text information can be easily and rapidly read. In other words, it is related to

how much information can be understood in a given time, directly connected to efficiency of information delivery. To enhance Gadokseong, font style, type size, color harmony, letter spacing, length of the line of letters, arrayal and the like should be considered.

K10. Korean Society of Typography. 『A Dictionary of Typography』. Paju: Ahn Graphics, 2012.

→ Gadokseong: readability. The degree to which writing can be read and understood easily. (synonym: ease of reading) It greatly varies based on contents of writing, reader's background knowledge about the contents, reading material and time, typography, etc. Pandokseong which is often mixedly used with Gadokseong refers to the degree to which letter forms are perceived easily. In spite of the high legibility of individual letters, readability may be reduced when arranging multiple letters so the two terms should be distinctively used. → Pandokseong: legibility. The degree to which individual letters or word forms are identified and perceived easily. Pandokseong and Gadokseong are often mixedly used but the former is subject to words or letters while the latter is applied to writing. Thus, these two should be distinctively used.

2.2.2 Foreign Books

F01. Mark S. Sanders, Ernest J. McCormick. 『Human Factors in Engineering and Design』. New York: McGraw Hill, 1957. No translation.

→ visibility: The quality of a character or symbol that makes it separately visible from its surroundings.
→ legibility: The attribute of alphanumeric characters that makes it possible for each one to be identifiable from others. This depends on such features as stroke width, form of characters, contrast, and illumination.
→ readability: A quality that makes possible the recognition of the information content of material when it is represented by alphanumeric characters in meaningful groupings, such as words, sentences, or continuous text. This depends more on the spacing of characters and groups of characters, their combination into sentences or other forms, the spacing between lines, and margins than on the specific features of the individual characters.

F02. Miles A. Tinker. 『The legibility of Print』.
Iowa: The Iowa State University Press, 1964. No translation.

In all earlier discussions of factors affecting ease and
speed of reading, the term 'legibility' was employed.
But since 1940, certain writers have been using the word
"readability" for this purpose. For a time, it appeared
to be a broader term and perhaps more meaningful.
However, with the advent of the "readability formulas,"
devised to measure the level of mental difficulty of
reading material, we have had the same terminology
employed with entirely different meanings. Obviously,
this has led to confusion. To avoid this confusion, this
report confines itself to the term "legibility of print." (…)
Legibility, then, is concerned with perceiving letters
and words, and with the reading of continuous textual
material. The shapes of letters must be discriminated,
the characteristic word forms perceived, and continuous
text read accurately, rapidly, easily, and with under-
standing. In the final analysis, one wants to know what
typographical factors foster ease and speed of reading.
Optimal legibility of print, therefore, is achieved by a
typographical arrangement in which shape of letters
and other symbols, characteristic word forms, and all
other typographical factors such as type size, line width,
leading, etc., are coordinated to produce comfortable
vision and easy and rapid reading with comprehension.

F03. James Craig, Irene Korol Scala. 『Designing with Type』.
New York: Watson-Guptill, 1971.

→ Legibility is the quality of the typeface design
and readability with the design of the printed page.
Designers aim to achieve excellence in both. The
typeface you choose should be legible, that is, it should
be read without effort. Sometimes legibility is simply
a matter of type size; more often, however, it is a matter
of typeface design. Generally speaking, typefaces
that are true to the basic letterforms are more legible
than typefaces that have been condensed, expanded,
embellished, or abstracted. Therefore, always start with
a legible typeface. Keep in mind, however, that even
a legible typeface can become unreadable through poor
setting and placement, just as a less legible typeface
can be made more readable through good design.
→ legibility: The quality in typeface design that affects
the speed of perception: the faster, easier, and more
accurate the perception, the more legible the type.

F04. Sandra Ernst Moriarty. 『The ABC's of Typography』. Stamford: Art Direction Book Co., 1977. No translation.

> Two factors are involved in ease of reading: readability and legibility. Readability describes the understanding of the message. Legibility describes the process of discriminating and recognizing individual letterforms. Generally, we use the term readability when referring to such things as word choice, and sentence length. Legibility more usually applies to size, type and shape of the letterforms.

F05. John Ryder. 『The Case for legibility』. London: The Bodley Head Ltd, 1979. No translation.

> The first factor affecting legibility is the typeface. The next factors are the size of the letter, length of the line of letters, the space between the lines of letters. The next relates to the space between words, the size of page, or format, the printed area of the page, the margins surrounding the printed area on the page, visual or even mechanical aid to continuity of design such as grid, and lastly 'finishing'.

F06. Walter Tracy. 『Letters of Credit: A View of Type Design』. Boston: David R. Godin, 1986. No translation.

> There are two aspects of a type which are fundamental to its effectiveness. Because the common meaning of 'legible' is 'readable' there are those—even some people professionally involved in typography—who think that the term 'legibility' is all that is needed in any discussion on the effectiveness of types. But legibility and readability are separate, though connected, aspects of type. Properly understood, and used in the meanings appropriate to the subject, the two terms can help to describe the character and function of type more precisely than legibility alone.
>
> Legibility, says the dictionary, mindful of the Latin root of the word, means the quality of being easy to read. In typography we need to draw the definition a little closer; we want the word to mean the quality of being decipherable and recognizable – so that we can say, for example, that the lowercase h in a particular old leg makes it look like the letter b; or figure 3 in a classified advertisement type is too similar to the 8. So legibility is the term to use when discussing the clarity of single character. It is a matter for concern in text size, and especially in such special cases as directories, where the

type is quite small. In display sizes legibility ceases to be a serious matter; a character which causes uncertainty at 8 point will be plain enough at 24 point.

Readability is a different thing. The dictionary may say that it, too, means easy to read. In typography we can give the word a localized meaning, this: if the columns of a newspaper or magazine or the pages of a book can be read for many minutes at a time without strain or difficulty, then we can say the type has good readability. The term describes the quality of visual comfort—an important requirement in the comprehension of long stretches of text but, paradoxically, not so important in such things as telephone directories or air-line time-tables, which the reader is not reading continuously but searching for a single item of information.

Legibility, then, refers to perception, and the measure of it is the speed at which a character can be recognized; if the reader hesitates at it the character is badly designed. Readability refers to comprehension, and the measurement of that is the length of time that a reader can give to a stretch of text without strain.

F07. Eric Gill. 『An Essay on Typography』.
Boston: David R. Godine, 1988.

Legibility, in practice, amounts simply to what one is accustomed to. But this is not to say that because we have got used to something demonstrably less legible than something else would be if we could get used to it, we should make no effort to scrap the existing thing. This was done by the Florentines and Romans of the fifteenth century: it requires simply good sense in the originators & good will in the rest of us.

F08. David Collier, Bob Cotton. 『Basic Desktop Design and Layout』. Cincinnati: North Light Books, 1989.

The two words legibility and readability are often confused. Legibility refers to the clarity of the type character—how well each character is defined and easily identified. Readability describes how some typefaces are suitable for long texts meant for continuous reading.

F09. James Craig. 『Basic Typography, A Design Manual』.
New York: Watson-Guptill, 1990. No translation.

Legibility. That quality in type and its spacing and

composition that affects the speed of perception:
the faster, easier, and more accurate the perception,
the more legible the type.

F10. Robert Bringhurst. 『The Element of Typographic Style』.
Vancouver: Hartley & Marks, 1992.

One of the principles of durable typography is always
legibility; another is something more than legibility:
some earned or unearned interest that gives its living
energy to the page.

F11. Gavin Ambrose, Paul Harris. 『Typography (Basic Design)』.
West Sussex: AVA Publishing, 2005. No translation.

→ legibility: The ability to distinguish one character
from another due to qualities inherent in the typeface
design. → readability: The overall visual representation
of the text narrative.

F12. Gordon Ernest Legge. 『Psychophysics of Reading in
Normal and Low Vision』. London: CRC Press, 2006.
No translation.

"legibility" refers to perceptual properties of text
that influence readability. Text which is hard to
read because of obscure vocabulary, or complex
syntax or meaning may be incomprehensible, but
still highly legible. Legibility depends on both local
and global properties of text. Local properties refer to
characteristics of individual letters or pairs of letters
such as font, print size, and letter spacing. Global
properties refer to layout characteristics such as line
length, line spacing, and page format.

F13. Gerard Unger. 『While You're Reading』. New York: Mark
Batty Publisher, 2006.

In Letters of Credit(1986) the type designer Walter Tracy
looks at a matter of English. Whereas Dutch has only
one word (leesbaarheid), English has two: legibility and
readability. Legibility refers to the ease with which letters
can be distinguished from one another: whether, for
example, there is a sufficient difference between a capital
I and a lower-case l. According to Tracy, readability is
a broader term that refers to comfort: if you can read
a newspaper for a long stretch at a time, it is readable.
At the same time, both these levels can be regarded
together as being part of legibility, and readability
then refers to the way the writer uses his language and
makes his text easy to follow and understand. Although

Tracy does not go into what makes typefaces legible or readable, he does show what kinds of types he regards as legible: the designs of Jan van Krimpen, Frederic Goudy, Rudof Koch, William A. Dwiggins, and Stanely Morison's Times New Roman (1932).

	K01	K02	K03	K04	K05	K06	K07	K08	K09	K10
Gadokseong	○	○	○	○	○	○	○		○	○
Pandokseong	○				○		○			○
legibility		○	○	○	○		○	○		○
readability		○	○	○	○		○	○		○

[1] Whether Gadokseong, Pandokseong, readability and legibility are described in Korean books.

	F01	F02	F03	F04	F05	F06	F07	F08	F09	F10	F11	F12	F13
legibility	○	○	○	○	○	○	○	○	○	○	○	○	○
readability	○	○	○	○		○		○			○	○	○

[2] Whether readability and legibility are described in foreign books.

3 Analysis
3.1 Korean Books
Distinctively defined Gadokseong and Pandokseong
Among ten volumes of Korean books, Gadokseong and Pandokseong are distinctively defined in five of them, which are K01, K03, K07, K08 and K10. [Fig. 1] K01 and K07 define Gadokseong as perception efficiency of text forms (the text in this study refers to the lines of letters formed with continuous consonants and vowels, sentences and paragraphs) and; Pandokseong as perception efficiency of letter forms. In K03, Gadokseong is legibility and ease of reading is readability. The former means ease of reading the characters and the latter is that of reading the contents. K08 defines legibility as how easy it is to read letters or layout in design context and readability as how readable the text is in terms of language or contents. In K10, Gadokseong is readability and Pandokseong is legibility. The former means the degree to which writing can be read and understood easily and the latter means the degree to which individual letters or word forms are identified and perceived easily.

Defined Gadokseong only
Among 10 volumes of Korean books, 5 of them describe Gadokseong only, which are K02, K04, K05, K06 and K09. K02, K04 and K05 define Gadokseong as a superordinate concept which covers both legibility and readability. K02

and K05 borrow the definition of readability from F02. In order to differentiate readability from the same term used in psychology, F02 distinctively presents legibility as a comprehensive term for easy perception and comprehension of writing from a typographic perspective. Referring to this F02, the Korean book K02 defines both legibility and readability as Gadokseong and additionally explains that Gadokseong is legibility from a typographic perspective. However, it skips explanation about readability in view of Pandokseong and typography. K05 is a glossary, which includes both Gadokseong and Pandokseong as its headwords. It defines Gadokseong the same as F01 and K02 but it suggests the definition of Pandokseong (legibility) in a different position from that of Gadokseong, which causes confusion. K06 and K09 show brief definitions for Gadokseong, which are the degree of easy reading and; that of easy and rapid reading and consequent comprehension, respectively. No English terms attached.

Defined Pandokseong only

None of the 10 Korean books define Pandokseong only.

3.2 Foreign Books

Distinctively defined legibility and readability

Among 13 volumes of foreign books, legibility and readability are distinctively defined on 9 of them, which are F01, F02, F03, F04, F06, F08, F11, F12 and F13. [Fig. 2] F01, F03, F06, F08, F11, F12 and F13 define legibility as perception efficiency of letter (type) forms and; readability as perception efficiency of text forms. F02 and F04 define legibility as perception efficiency of letter and text forms and; readability as comprehension efficiency of text contents. There is a sentence omitted from the F03 translated version which is "Legibility is the quality of the typeface design and readability with[sic] the design of the printed page. Designers aim to achieve excellence in both."

Defined legibility only

Among 13 volumes of foreign books, 4 of them describe legibility only, which are F05, F07, F09 and F10. F05, F07 and F09 define legibility as perception efficiency of text forms (typesetting, in other words, font, type size, spacing between letters, length of the line of letters, the space between the lines of letters, format, printed area of the page, margin, grid, etc). Though F10 does not suggest concrete scope of legibility, it takes the same position as F05, F07 and F09 in context.

Defined readability only
None of the thirteen foreign books define readability only.

Translations
Five of thirteen foreign books have translations, which are F03, F07, F08, F10 and F13. In the case of F03, legibility was translated as Gadokseong and readability as ease of reading. The term legibility on F07 was translated as Gadokseong. In F08, F10 and F13 translations, legibility=Pandokseong and readability=Gadokseong. Four translations except F07 include English term annotations to deliver accurate meaning.

3.3 Usage Classification
The definitions of Gadokseong, Pandokseong, legibility and readability excerpted from twenty-three Korean and foreign books are organized into three categories. [Fig. 3]

Type A
Gadokseong refers to the perception efficiency of text forms. Readability is the synonym in foreign books. It is affected by text typesetting (type size, spacing between letters, the space between the lines of letters, margin, format, etc). Pandokseong is the perception efficiency of letter forms. Legibility is the synonym in foreign books. It is affected by letter design (serif or sans serif type, x-height size, counter size and shape, stroke width, etc). Gadokseong and Pandokseong are readability and legibility, respectively. K01, K07, F01, F03, F06, F08, F11, F12 and F13 fall under Type A.

Type B
Gadokseong refers to comprehension efficiency of text contents. Readability is the synonym in foreign books. Pandokseong is the perception efficiency of letter and text forms. Legibility is the synonym in foreign books. Gadokseong=readability and Pandokseong=legibility but the usage differs from that of Type A. Pandokseong of Type B encompasses Gadokseong and Pandokseong of Type A. K03, K05, K08, K10, F02 and F04 fall under Type B.

Type C
Gadokseong covers perception efficiency of letter forms, perception efficiency of text forms and text comprehension efficiency all together. Legibility is the synonym in foreign books. Gadokseong of Type C encompasses Gadokseong and Pandokseong of Type A and B. K02, K03, K04, K05, K06, K09, F02, F05, F07, F09, F10 and F11 fall under Type C.

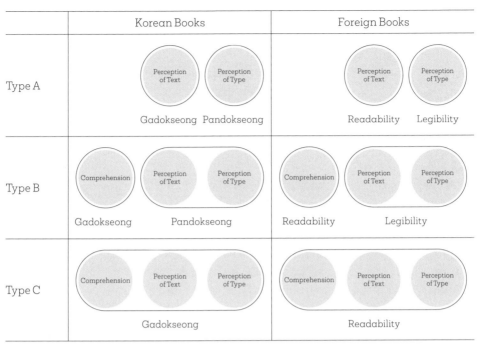

	Korean Books		Foreign Books	
Type A	Perception of Text	Perception of Type	Perception of Text	Perception of Type
	Gadokseong	Pandokseong	Readability	Legibility
Type B	Comprehension · Perception of Text · Perception of Type		Comprehension · Perception of Text · Perception of Type	
	Gadokseong	Pandokseong	Readability	Legibility
Type C	Comprehension · Perception of Text · Perception of Type		Comprehension · Perception of Text · Perception of Type	
	Gadokseong		Readability	

[3] Usage classification of Gadokseong, Pandokseong, readability and legibility.

3.4 Problems

As aforementioned, meanings of Gadokseong, Pandokseong, legibility and readability are defined differently in every book. Problems arising from this issue can be classified into two sorts.

First, the same term is used with multiple definitions. [Fig. 4] In case of Gadokseong, it means perception efficiency of text forms in Type A; comprehension efficiency of text contents in Type B and; encompasses perception efficiency of letter forms, perception efficiency of text forms and text comprehension efficiency all together in Type C. As to Pandokseong, it means perception efficiency of letter forms in Type A; perception efficiency of letter and text forms in Type B but it is not used in Type C. Definitions of Gadokseong and Pandokseong vary in every category so it causes confusion every time we encounter a different category.

Second, the Korean and English terms do not consistently match. [Fig. 5] Type A and B make different definitions for Gadokseong and Pandokseong but both categories still demonstrate that Gadokseong=readability and Pandokseong=legibility. (The only exceptions are K03 and F02 translation, which both state Gadokseong=legibility, ease of reading=readability. It is solely these two books that mention ease of reading.) A problem emerges in Type C. It embraces multiple notions mentioned in Type A and B using a single term Gadokseong, which is translated as legibility in foreign books. In other words, if a reader learned

	Gadokseong	Pandokseong
Type A	Perception of Text	Perception of Type
Type B	Comprehension	Perception of Type + Perception of Text
Type C	Perception of Type + Perception of Text + Comprehension	–

[4] Usage classification of Gadokseong and Pandokseong.

	가독성 = readability	판독성 = legibility
Type A	가독성 = readability	판독성 = legibility
Type B	가독성 = readability	판독성 = legibility
Type C	가독성 = legibility	

[5] Usage classification of Gadokseong and Pandokseong, legibility and readability.

Gadokseong=readability and Pandokseong=legibility through Type A and B, he/she would be confused with the notion of Gadokseong=legibility in Type C. Among twenty-three books reviewed in this research, eleven fall under Type C and legibility in all the foreign books of Type C is translated as Gadokseong in Korean versions.

The reason why foreign books in Type C use the term legibility is thoroughly described in F02. "With the advent of the Readability Formulas devised to measure the level of mental difficulty of reading material, we have had the same terminology employed with entirely different meanings. Obviously, this has led to confusion. To avoid this confusion, this report confines itself to the term Legibility of Print." Miles A. Tinker (1893 –1977), the author, is an American researcher who conducted legibility experiments for thirty-two years at the University of Minnesota and is an internationally recognized scholar in the field of legibility experiments. Tinker's adoption of legibility greatly affected the then American printing industry, which would lead to continuous use of legibility up to now.

Korean books in Type C use the term Gadokseong but no materials were found that explain its specific reason. However, it can be assumed that an extensive term that covers both Type A and B. For example, Pandokseong of letters in K01 is explained as a preceding Gadokseong of the text. This is because perception of letter forms should come first in order to perceive forms of the lines of letters. F12 demonstrates that perception of letter forms (legibility) is a precedent of text comprehension (readability). If Type C should choose an extensive term that covers both Type A and B, the proper answer would be Gadokseong, a concept superior to the rather narrow notion of Pandokseong. If the term readability is available, unlike the case of Tinker, it would be natural to adopt the term readability (Gadokseong)

over legibility (Pandokseong) as a single, all-inclusive term that covers the entire meaning.

This confusion also occurs when a Korean researcher translates Korean into English. For example, thirty-three Korean typography papers (1990–2020) incorporate the term Gadokseong in their title. Among them, fifteen pieces use legibility while the other twenty-two use readability. Taking a closer look at the meaning of Gadokseong adopted in those papers based on preceding research, however, the term covers the entire concept of Gadokseong associated with typography and does not differentiate it from Pandokseong, which means in context all of them fall under Type C. Thus, it would be proper to translate their titles as legibility.

4 Conclusion

This research reviewed confusing definitions of Gadokseong and Pandokseong in the field of typography based on its usage and organized the currently used definitions of Gadokseong, Pandokseong, legibility and readability into three categories.

In Type A, Gadokseong means perception efficiency of text forms while Pandokseong is perception efficiency of letter forms. Gadokseong and Paneokseong are respectively translated as readability and legibility. In Type B, Gadokseong means comprehension efficiency of text contents while Pandokseong refers to perception efficiency of letter and text forms. Gadokseong and Pandokseong are respectively translated as readability and legibility. In Type C, Gadokseong has synthetic meanings with perception efficiency of letter forms, perception efficiency of text forms and text comprehension efficiency all together. Gadokseong is translated as legibility.

As aforementioned, all of Gadokseong, Pandokseong, legibility and readability are similar but are used and defined slightly differently. Thus, a typography researcher is required to make the following efforts in order to avoid confusion of communication. First, be well aware that definitions of Gadokseong, Pandokseong, legibility and readability can be interpreted differently from what is intended. Second, elaborate on what is intended when using the terms to clarify the meanings to be delivered. Third, annotate a translated version with terms used on the original text as much as possible, so that the intentions of the original writer can be clearly represented. However, it is necessary to keep in mind that English and Korean expressions are not always a one-to-one match.

Based on the mixed use of Gadokseong, Pandokseong,

legibility and readability reviewed in this research, it is expected that researchers will have further discussions about typographic terms lead to similar confusion in the future.

Bibliography

David Collier, Bob Cotton. 『Basic Desktop Design and Layout』. Cincinnati: North Light Books, 1989.

David Collier. Translated by Byun Taesik. 『Desk-Top Publishing』. Seoul: Designhouse, 1995.

Eric Gill. 『An Essay on Typography』. Boston: David R. Godine, 1988.

Gordon Ernest Legge. 『Psychophysics of Reading in Normal and Low Vision』. London: CRC Press, 2006.

Eric Gill. Translated by Song Sungjae. 『Eric Gill: An Essay on Typography』. Paju: Ahn Graphics, 2015.

Gavin Ambrose, Paul Harris. 『Typography (Basic Design)』. West Sussex: AVA Publishing, 2005.

Gerard Unger. 『While You're Reading』. New York: Mark Batty Publisher, 2006.

Gerard Unger. Translated by Choi Moonkyung. 『While You're Reading: Font, Font Design, Typography』. Seoul: Workroompress, 2013.

James Craig. 『Basic Typography, A Design Manual』. New York: Watson-Guptill, 1990.

James Craig, Irene Korol Scala. 『Designing with Type』. New York: Watson-Guptill, 1971.

James Craig, William Bevington, Irene Korol Scala. Translated by Moon Jisook, Choi Moonkyung. 『Designing with Type』. Paju: Ahn Graphics, 2002.

John Ryder. 『The Case for legibility』. London: The Bodley Head Ltd, 1979.

King Sejong the Great Memorial Society Korean Typeface Development Institute. 『Korean Font Dictionary』. Seoul: King Sejong the Great Memorial Society, 2000.

Korean Publishing Research Institute. 『Publication Terminology Dictionary』. Paju: Bumwoosa, 2000.

Korean Society of Typography. 『A Dictionary of Typography』. Paju: Ahn Graphics, 2012.

Lee Soonjong, Cho Youngje, Ahn Sangsoo, Kwon Myungkwang. 『The Dictionary of Contemporary Design』. Paju: Ahn Graphics, 1994.

Mark S. Sanders, Ernest J. McCormick. 『Human Factors in Engineering and Design』. New York: McGraw Hill, 1957.

Miles A. Tinker. 『The legibility of Print』. Iowa: The Iowa State University Press, 1964.

Oh Byeongkeun, Kang Sungjoong. 『Textbook of Information Design』. Paju: Ahn Graphics, 2008.

Robert Bringhurst. 『The Element of Typographic Style』. Vancouver: Hartley & Marks, 1992.

Robert Bringhurst. Translated by Park Jaehong, Kim Minkyung.

『The Element of Typographic Style』. Seoul: Mijinsa, 2016.
Sandra Ernst Moriarty. 『The ABC's of Typography』.
	Stamford: Art Direction Book Co, 1977.
The Korean TEX Society. 『TEX: Beyond the World of
	Typesetting』. Seoul: Kyungmoon Publishers, 2007.
Won Youhong, Suh Seungyoun, Song Myeongmin.
	『Typography Arabian Nights』. Paju: Ahn Graphics, 2012.
Yu Jeongmi. 『It isn't a tabloid but a magazine』.
	Paju: Hyohyung Publishing, 2002.

project

Re-interpreted Types

This time, we introduce the work of four designers from Seoul and Hong Kong, in the "Project" section. They all come from very international cities when looked at from a typographic perspective. Also, they use other scripts in addition to their native scripts (母國字)✦ as important components in their design work. However, they use different methodologies to establish hierarchies between these different scripts. In the process of establishing a typographic order based on the designers' own ideas and principles, thet have "reinterpreted" the scripts in relation to each other.

The form of the Latin alphabet's lower and upper cases is reinterpreted as a special character in the Korean font (Kim Chorong), or as paired with Hong Kong's Beiwei calligraphy✦✦ (Poe Cheung). Additionally, the uneven English and Chinese characters on Hong Kong street signs from over 100 years ago are unified into digital types (Fibi Kung). Finally, simplified Chinese, Japanese Ming-style Hanzi, and symbols are reset to harmonize with traditional Chinese (Mak Kai Hang).

It can be said that the designers coordinate the relationship between their inherent "locality" and that of other regions, creating a kind of "internationality." I hope that it can be an opportunity to refresh the locality that was once sacrificed in pursuit of internationality or to observe the internationality that appears to support locality.

Min Bon

✦ It is a word that corresponds to a native language and is used only in this article.
✦✦ It is a font derived from calligraphy that is distinguished from typeface.

Latin Alphabet of Sandoll 「Jeongche」: Better Use, Better Harmony

Kim Chorong

「Jeongche」 is a big type family developed as a body text font with better usability and new impression, upgraded from an existing body text font. Since the first launch of 「530」 and 「530i」 in April 2019, a total of 12 fonts have been released and the whole set will be produced in the long term. 「Jeongche」 supports Hangeul, Latin basic, Latin extended, Greek basic and Cyrillic basic along with italic fonts available for each typeface. [Fig. 1]

The Latin alphabet of 「Jeongche」 started from a question of 'Would there be a way to make a Latin font optimized for the Hangeul typesetting environment, without giving up its essence?' The Latin alphabet included in Hangeul fonts has been regarded as difficult to use and the quality of Latin fonts made by Korean designers has been doubted—I strived to solve this problem above all else. I will not mention every single detail during the work but I would like to share some of my biggest concerns.

Framing and Modeling

「Jeongche」 Hangeul font has several aspects different from those of previous Hangeul Myeongjo◆ fonts; one of them is that the stroke contrast is quite weak and letters are distinct overall. Compared to general Myeongjo fonts, the contrast of thin and thick strokes is weaker. The counter, on the other hand, is smaller than that of other Myeongjo fonts. [Fig. 2] What I worried about regarding the stroke contrast was that it would be very likely that the weak stroke contrast on the Latin alphabet would give it a modernistic impression. It was because the recently released 「Jeongche 930」 or 「030」 Hangeul had a somewhat modernistic impression while 「530」 and 「630」, the very first of the 「Jeongche」 family, were rather classic. To solve this, I tried to make the frame of the Latin alphabet resemble the impression of 「Jeongche」 Hangeul as much as I could. For 「530」 and 「630」, I reflected the framing structure and proportion of a Latin humanist typeface with a classic feel.

◆ The typeface with serif at the end of the stroke. Since it looks similar to the Chinese Myeongjo font (明朝體), it is known to be used under the same name in Korea. In general, horizontal strokes are thinner than vertical strokes.

Jeongche Type Family

Style hierarchy (left to right across column groups):

Type Style	Character	Usage	Length/Role	Groups
Classic Type Style	Classic and Simple	Classical Literature	Short-length Quotes	1, 2
Classic Handwriting Style	Graceful	Classical Literature, Letter	Medium-length Quotes	3, 4
Modern Handwriting Style	Friendly	Modern Literature, Elementary School Textbooks	Medium&Long-length Narration	5
Modern Type Style	Upright	Modern&Contemporary Literature, Humanities	Long-length Narration	6, 7, 8
Contemporary Type Style	General (Literature, Humanities, Practical), Middle&High School Textbooks	Solid / General	General	9, 0

E-book Specialization covers the Modern Type Style and Contemporary Type Style groups.

	1-0	1-8	1-6	2-0	2-8	2-6	3-0	3-8	3-6	4-0	4-8	4-6	5-0	5-8	5-6	6-0	6-8	6-6	7-0	7-8	7-6	8-0	8-8	8-6	9-0	9-8	9-6	0-0	0-8	0-6
1g	110	118	116	210	218	216	310	318	316	410	418	416	510	518	516	610	618	616	710	718	716	810	818	816	910	918	916	010	018	016
3g	130	138	136	230	238	236	330	338	336	430	438	436	530	538	536	630	638	636	730	738	736	830	838	836	930	938	936	030	038	036
(v)	130v			230v			330v			430v			530v			630v			730v			830v			930v			030v		
(i)							330i			430i			530i			630i			730i			830i			930i			030i		
4g	140	148	146	240	248	246	340	348	346	440	448	446	540	548	546	640	648	646	740	748	746	840	848	846	940	948	946	040	048	046
(v)	140v			240v			340v			440v			540v			640v			740v			840v			940v			040v		
(i)							340i			440i			540i			640i			740i			840i			940i			040i		
9g	190	198	196	290	298	296	390	398	396	490	498	496	590	598	596	690	698	696	790	798	796	890	898	896	990	998	996	090	098	096
(v)	190v			290v			390v			490v			590v			690v			790v			890v			990v			090v		

[1] 「Jeongche」 family tree.

LATIN ALPHABET OF SANDOLL 「JEONGCHE」: BETTER USE, BETTER HARMONY

획 대비와 속공간

획 대비와 속공간

[2] Comparison of stroke
contrast and counter.
Above: 「Jeongche 630」.
Below: Sandoll 「Myeongjo
Neo」.

ein ein

[3] Comparison of dot,
stroke and structure.
Left: 「Jeongche 630」.
Right: 「Jeongche 030」.

As shown in the serif bracket of 「630」, the horizontal stroke of
'e' and the dot of 'i', I drew the outline of letters by emphasizing
asymmetry and organic impressions of curves, injecting
a natural touch out of handwriting. For 「930」 and 「030」,
however, I made the x-height larger for Hangeul in which
the letter counter was made a little bigger. I also pursued
symmetry for the letter contour as much as possible. [Fig. 3]
In addition, I tried to make letter widths even so that they
could get a flatter texture on the whole. There was a restriction
that the glyph width could not be freely changed, which is to
be covered in the 'Width' section.

Size and Arrayal

In case of mixed typesetting with Hangeul and the Latin
alphabet, the size and location are as influential as the
shape of individual letters. Unlike Hangeul, the Latin
alphabet consists of uppercase and lowercase letters. When
an uppercase Latin character is used in a Hangeul-typeset
sentence or a paragraph, that Latin letter looks bigger than
other letters and consequently it tends to disturb the flow of
passage. Considering this aspect, I deliberately designed the
uppercase Latin letters of 「Jeongche」 on a slightly smaller
scale. This would make the physical vertical length of the
Latin alphabet seem shorter than that of Hangeul but it is a
choice made in consideration of the Hangeul counter. [Fig. 4]
In addition, lowercase letters have ascenders and descenders,
in which a passage sometimes looks ascending or descending
at other times for different combinations with Hangeul.
As circumstances may vary greatly, I adjusted the height in
Hangeul to allow harmony of the centroidal axis in a range
which would be safe for any situation.

문장 속 대문자Upper Case 크기는
독서를 방해하지 않도록 한다.

문장 속 대문자Upper Case 크기는
독서를 방해하지 않도록 한다.

[4] Comparison of Latin alphabets size in a Hangeul sentence.
Above: 「Jeongche 630」. Below: Sandoll 「Myeongjo Neo」.

Width

The most important characteristic of the 「Jeongche」 Latin alphabet is that the letter width of every letter across the entire type family is the same. For example, the width of 'n' in the serif typeface 「630」 is the same as that of 'n' in the sans serif typeface 「930」. Unlike Hangeul, the horizontal space between letters in the Latin alphabet (hereafter right-left space) is generally determined on the basis of letters. A serif letter requires more right-left space while a sans serif one needs less. When changing a text typeset with a serif font into a sans serif font in the same type family, the passage often decreases in length. This does not happen when typesetting solely with Hangeul, even when changing a style or stroke width in the same type family. In most cases, however, the difference in width of punctuation marks and spacing used for Hangeul lead to disruption. All of the Latin alphabet, and the numbers, spacing and punctuation marks of 「Jeongche」 have been designed to maintain the original typesetting even when changing to different font. Thus, any article typeset only with 「Jeongche」 can keep its original typesetting without passage expansion or shrinkage even if a user switches to another font in the 「Jeongche」 family. [Fig. 5]

To this end, the entire Latin alphabet of the entire 「Jeongche」 font family was oriented towards space rather than strokes, which was quite a challenge, for two reasons. First, the letter counter and inter-character space are very important as the Latin alphabet is based on a phonemic writing system. When zooming in at the middle part of a passage typeset with the Latin alphabet, it shows a more regular crossing pattern with vertical strokes and space than a Hangeul passage. [Fig. 6] As demonstrated above, the role

정체는 하나의 정체성을 유지하며 다양한 분위기를 내도록
뼈대skeleton, 너비width, 무게weight를 축으로 자족이
확장됩니다. 정체로 조판된 글은 530부터 030까지 어떤
구성원으로 변경해도 조판이 그대로 유지됩니다.

정체는 하나의 정체성을 유지하며 다양한 분위기를 내도록
뼈대skeleton, 너비width, 무게weight를 축으로 자족이
확장됩니다. 정체로 조판된 글은 530부터 030까지 어떤
구성원으로 변경해도 조판이 그대로 유지됩니다.

[5] Typesetting stay put even
with different typefaces.
Above: 「Jeongche 630」.
Below: 「Jeongche 930」.

latin type

[6] Space pattern of Latin
script with repeated vertical
strokes and space.

AENhisw

AENhisw

[7] Jeongche Latin script
with the same width
regardless of whether to be
a serif or a sans serif type.
Above: 「Jeongche 630」.
Below: 「Jeongche 930」.

åçñķōỳ

åçñķōỳ

[8] Latin script with
diacritical sign.
Above: 「Jeongche 630」.
Below: 「Jeongche」930」.

of inter-character space is as significant as the shape and space of individual letters and it greatly affects typographic readability as well. Thus, it was a huge obstacle that the right-left space could not be minutely adjusted.

Second, this work was hard because the width of individual letters and the relationship of those widths are also an important factor in determining the overall impression of a Latin font. Among the same sans serif fonts, 「Helvetica」 feels modernistic for the width of individual letters is generally similar and even; 「Gill Sans」 or 「Syntax」 feel more humane and antique for the distinct difference of the width of individual letters. It cannot be a decisive criterion as there are cases like 「Futura」. (Most of the uppercase letters of 「Futura」 follow the width of humanist style fonts.) Nevertheless, the impression of widths is never negligible, so it should be taken into account in the design phase. Compared to 「530」 「630」 「730」 and 「830」, 「930」 and 「030」 in the Latin alphabet were in the early stage designed to have similar width for individual letters in order to achieve a modernistic impression and thus, the proportion of the Latin alphabet and letter widths were made different from those of existing 「Jeongche」. However, testing them in various situations while working on this project, I finally reached the conclusion that it would be better to reinforce the features of 「Jeongche」 as a family and so I modified the work. [Fig. 7] In conclusion, it was a kind of experiment to adjust the Latin alphabet to the fixed width of the Hangeul typesetting environment, putting aside the optimal way for the Latin alphabet. I feel both content and frustration about the creation of the Latin alphabet for 「Jeongche」.

Usability

One of the reasons why it was hard to insert a Latin alphabet into a Hangeul typeface was poor usability. In most cases, Latin letters with diacritical signs, which are generally used in European language groups were hardly available and even if they were, the designed shape was often not in uniformity with the basic Latin alphabet. However, the demand for a body text font which can cover letters of more diverse language groups is increasing so 「Jeongche」 has been designed to facilitate writing characters of different languages such as extended Latin, Greek basic and Cyrillic basic along with Hangeul. I did not simply add the diacritical signs but rather regarded them as a part of typeface upon design. Looking into the shapes of diacritical signs, you can see they share features of 「Jeongche」 letters. [Fig. 8]

I also added a set of punctuation marks for Latin

The "Set of punctuations" for (Latin) is offered, as an opentype-feature?

The "Set of punctuations" for (Latin) is offered, as an opentype–feature?

[9] Punctuation mark sets for 「Jeongche 630」. Above: One for Latin letters and typesetting. Below: Another for Hangeul and typesetting.

Title Swash

Title Swash

[10] Before (above) and after (below) applying 「Jeongche 830i」 swash capitals.

alphabets. Location and width of basic punctuation marks set were designed to fit Hangeul; the set for Latin alphabets was newly created to be more harmonious in case of typesetting purely with Latin alphabets and its location and width were also adjusted. [Fig. 9]

Last but not least are the italics. When both roman and italic are required for editing, a Latin font composed with Hangeul may be used but it is still tiresome to choose an italic that matches both in terms of form and context. In typesetting, Latin type families end up getting mixed, to provide both roman and italic fonts. To solve this problem, 「Jeongche」 also offers italics for each Latin typeface. These italics were made in harmony with every roman type. Each typeface includes swash capitals◆ which can be used as initial capitals for italic-only typesetting, which enriches the typography. [Fig. 10]

Conclusion

Anyone who works on the Latin alphabet as part of a Hangeul typeface would have thought about the above issues. However, there still is a lot to be uncovered. Other problems, such as changes in style, weight and width of 「Jeongche」 that is yet to be produced, will arise as new projects develop. If we keep working on, and solve these problems, and share them with many others, wouldn't it be possible for the Latin script of the Hangeul typeface to be referred to as the best Latin typeface to use with Hangeul? Some would call it a dream. However, I won't stop dreaming and will continue to observe, design and talk about it.

Who made Sandoll 「Jeongche」
Direction: Sim Wujin
Hangeul Typeface: Song Mieon (「530」「730」),
Park Soohyun (「630」「830」「930」「030」)
Latin Typeface: Kim Chorong

◆ Letters with decorative serif, originating from an italic font in Italian Renaissance. First used at 『La Operina』 by Ludovico Vicentino degli Arrighi.

「ST-RD」:
A Hidden Typeface Lost in the Concrete Jungle

Fibi Kung

Hong Kong Typographic Scene

Walking down the streets of Hong Kong, seeing the signages from street signs to shop names to maps, you can feel the British colonial vibe in the bilingual scripts and lettering. Since the Handover of Hong Kong in 1997, a trilingual system of English, Traditional and Simplified Chinese scripts can be found in one design.* In my opinion, among them, the most heterogeneous pair of scripts would be English and Traditional Chinese because of their vast differences in origin, language structure, calligraphic tools, and overall complexity. As a Hong Kong-based designer, it is a gift to be able to understand how to work with these two vastly different but challenging scripts in the context of design. With limited choices in Chinese typefaces, it's always challenging to find something to complement the Latin typeface. At the same time, because of the Chinese character's pictorial nature, it opens up many opportunities for designers like myself to create bespoke Chinese lettering that is unique and fresh, illustrating the meaning of the character itself.

As for typesetting, it can be challenging to achieve harmony and equal importance with two or three scripts together in one design. There is always going to be a more dominant script, so I always ask myself which should be the lead script in a bilingual project. Although it has never been easy to find the right balance, there are many examples in our daily lives in this illustrious city that show how multi-script designs can create and achieve an interesting and unique visual impact on society. [Fig. 1–3]

T-shaped Signage

Most people look at the content when they see a sign because that is a sign's purpose. It indicates direction or the name of the street. It provides information to its audience. And this applied to me as well, when I was living in Hong Kong. I have never given the "design" of signages as a second thought until I started

* Traditional Chinese characters are complex Hanzi which have many strokes. Simplified Chinese characters are standardized Hanzi used in Mainland China.

[1] English letters and Chinese characters typeset in triangle form in the hazard signage.

[2] Bilingual script design for the public housing estate in Hong Kong.

[3] Bilingual script design for Holland Hostel in Hong Kong.

[4] Signage in Rådmansgatan metro (tunnelbana) station in Stockholm.

[5] Signage in Knebckar (Киевская) metro station in Moscow.

[6] The T-shaped signage of Hollywood Road at Tai Kwun, Hong Kong. Photography by Hidden Hong Kong.

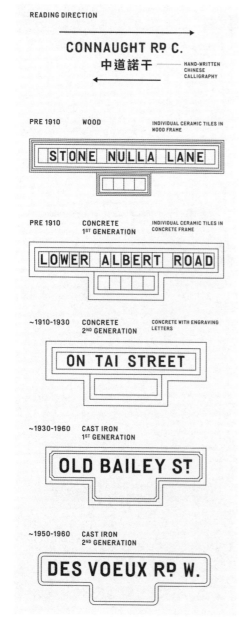

[7] Different types of T-shaped signage.

living abroad. Having graduated with a BA in Visual Communication Design from the Hong Kong Polytechnic University in 2014, I had the opportunity to work for agencies and design studios in Seoul, Rotterdam, Copenhagen, and Stockholm for the past 5 years. In these places with foreign languages, I would notice that I no longer understood the content in the signs, but I would start to observe the letterforms, the shapes, and how the color blends in with the colors of its urban habitat, reflecting the natural visual language of the city. [Fig. 4–5]

In 2019, I decided to move back to Hong Kong with a new set of eyes; a new perspective. I kept up the habit of observing signages with the eyes of a designer. One day, a particular street sign caught my attention—the T-shaped signage of "Hollywood Road" at Tai Kwun, the former Central Police Station compound which underwent heritage revitalization in 2018. [Fig. 6] The English letters in a bold sans serif typeface paired with hand-written Chinese calligraphy center aligned, creating an interesting contrast within the multiscript design, which took me down the rabbit hole of exploring the story of T-shaped signages in Hong Kong.

The T-shaped signage was one of the earliest street and road signs in Hong Kong, designed with capitalized English letters on top and Traditional Chinese characters below written from right to left. The positioning of the English might imply its superiority over Traditional Chinese at the time. I have often wondered why the signages were T-shaped? It could have been

designed in a rectangular format but it was specifically cut into a T-shape, perhaps to save materials? While I could not find a specific reason, I believe there are no other signages in the world similar to this.

ST. STREET
RD. ROAD

[8] The words 'Road' and 'Street' feature in the form of contractions as 'Rd.' and 'St.', in these T-shaped signages.

There are three main types of T-shaped signages that have remained in the city. The first type dates back to the early 1910s and was made with individual ceramic tiles placed in a wooden or concrete frame. The second type was made of concrete with engraved letters during approximately the 1910s–1930s. The third type, which was in use between the 1930s–1960s was made with cast iron plates that were hand-crafted and can weigh up to 30kg. [Fig. 7]

「ST-RD」

In typical fashion, the words 'road' and 'street' in these T-shaped signages feature in the form of contractions, as 'Rd.' and 'St.' respectively. [Fig. 8] As sign painter John Downer put it, they are seen as "word logos" usually used in signwriting to save space. It is common to see these word logos for words like number (No.) or company (Co.). But for me, it was fascinating to see it was used in these street signages in Hong Kong and

[9] A hidden typeface lost in the concrete jungle. The T-shaped signage of "Sai On Lane," the only T-shaped signage with white text on black background remaining in Hong Kong. Photography: Burton Lam. http://www.facebook.com/hkhistory.org

[10] Full alphabet and number set of 「Transport Medium」, designed by Jock Kinneir and Margaret Calvert. Font file was produced by Nathaniel Porter.

[11] Full alphabet and number set of 「Old Road Sign」. Font file was produced by Tom Sutch.

[12] Full alphabet and number set of 「AES Ministry」. Font file was produced by Harry Blackett.

ABCDEFGHI
JKLMNOPQ
RSTUVWXYZ
1234567890
&꜏Ṭ.,"""!?/-()

[13] The full character set of 「ST-RD」.

hence, I started my exploration of, and research into the type design of these signages, giving birth to this project.

Today, there are less than 200 uniquely T-shaped signages remaining in Hong Kong, hidden throughout the urban landscape. [Fig. 9] My objective for this project is to research, preserve, and re-interpret the letterforms on the T-shaped signages from the 1930s–1960s as they are gradually disappearing from this city. I think it is vital for us as designers to not only preserve but also retain the origin and uniqueness of these signages, from their physical form into a digitized form, for the purpose of research and education of and by our future generations.

I kick-started this project by researching the typefaces that have been used on these signages. British road sign lettering and typefaces like 「Transport」 [Fig. 10], 「Old Road Sign」 [Fig. 11], and 「AES Ministry」 [Fig. 12] (The two types of lettering used on British road sign before the Worboys Report♦ introduced the current road sign designs and lettering in 1964) have been carefully studied during my research, but at closer inspection, none of these typefaces look like the ones that were used in the T-shaped signages. It was at this point that I asked "who created these letterforms?"

When I could not find the original typeface, I decided to create my own as a replica of the original and as a tribute to its creator. As the signages were exposed to weathering and erosion

♦ The final report of the Worboys Committee which was formed by the British government to review signage on all British roads.

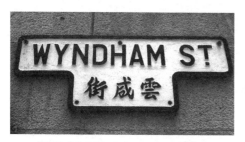

WYNDHAM ST

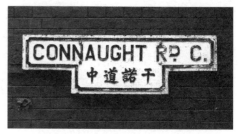

CONNAUGHT RD C.

[14] T-shaped signage of Wyndham Street. Photography by Benny Lai. http://www.facebook.com/hkhistory.org

[15] T-shaped signage of Connaught Road Central. Photography by Hong Kong Road Signs. http://www.facebook.com/hkhistory.org

KENNEDY RD JUBILEE ST
JAFFE RD PEDDER ST
WHITFIELD RD GOUGH ST
STEWART RD RUMSEY ST
DES VOEUX RD ELGIN ST
O'BRIEN RD APLJU ST
NATHAN RD CLEVERLY ST
WILSON RD COCHRANE ST
CHATER RD D'AGUILAR ST

[16] Different Hong Kong road and street names typeset in 「ST-RD」.

R R

[17] The letter 'R' with different angles of the diagonal stroke (tail).

KOWLOON
(W) & (E) [1]

↓ **25 MINS**
 19 MINS

[19] Mini specimen of the 「ST-RD」.

[18] The Work-in-Progress of the letter 'W'.

for more than 60 years, and despite multiple site visits to study the T-shaped signages and strenuous data collection on online platforms, it was impossible to recreate the exact lettering. However, the typeface, 「ST-RD」was designed to appear as close as possible to what was still preserved until now.

One of the most challenging but rewarding parts of this project was the creation of letterforms that were not clear or non-existent as all references together could not assemble the full alphabet. Some letters I had to design from scratch, like completing a missing piece of a puzzle. It was fulfilling as I got closer and closer to finishing the typeface.

Other than the distinctive glyphs for 'Rd.' and 'St.', the 'R' and 'W' are letters that are of significant as well. There were multiple letterforms of the 'R' used in the signages, some appeared to have a wider diagonal stroke (tail), others did not. While I could have created alternatives in the OpenType, I decided to go with just the wider tail version to retain the uniqueness of the original. [Fig. 17] 'W' was the most challenging to design, as the form has a heavy yet narrow aesthetics to it. It is almost as if it came from another typeface so the goal was to find a balance that would keep the integrity of the letterform but would also allow consistency in relation to the other characters of the typeface. [Fig. 18]

Future Plans

It is certainly sad to witness a city with so much history and tradition getting torn down bit by bit without a hint of attention paid to it. These T-shaped signages that were once part of our daily lives are now living in the shadows of our busy lives, and I am afraid they will one day also be destroyed and dismantled; disappear along with the buildings they are attached to. While I don't completely agree with the traditional heritage conservation methods of the past, we can definitely do more than just photography our heritage and display it in museums. As a local, the first step I would initiate is to record and share the type design via a new website or in physical form such as in an exhibition, so that the history of our city can be passed down to our future generations. But more importantly, as a designer, I think this typeface has a classical Hong Kong elegance that is timeless no matter in which era it is being used. Even after it has served its purpose on these T-shaped signages, it can continue to serve other purposes in other places and through other possible applications by future designers like ourselves. [Fig. 19] I will continue to refine and perfect this typeface and hopefully in the near future, release this piece of tribute to the public.

Mak Kai-hang

「KuMincho」&
『LOLOSOSO』:
Building With Details

Cultural Texture Created by Multiple Scripts

Immersed in the typography and design scene since my high-school period, I have always been fascinated by the unique cultural texture of Hong Kong as well as its charming historical context that differentiates us from the rest of the world. Being a British colony for more than one and a half centuries has shaped Hong Kong's bilingual culture by treating Chinese and English equally in our daily life. Compared with other cities, I think the most unique possession of a Hong Kong designer is that we are all equipped with the ability to handle various scripts, hence being able to reach a wider range of clients from across the globe.

In most of my design projects, I need to deal with bilingual, or even trilingual contexts. I would say that there was not a more heterogeneous pair of a scripts for me, yet striking a balance between two distinct typefaces and achieving visual harmony were the tasks that took up most of my effort during my design process. Among all the scripts I have been working with, Chinese is undoubtedly my favorite as it was derived from hieroglyphs that hold an imaginative and charismatic touch that enables me to go wild when designing, unlike other scripts that are bound by letter structures.

Recalling my first encounter with design and culture, it was an awakening moment during my studies, majoring in Film, at an art college. At the time, my film lecturer Long Tin, a prominent film critic in Hong Kong, showed us black-and-white movies from the 1950s–1970s a few times a week on a regular basis. As the films he selected were filmed way before any technological advancement, emphasis was placed on how the director presents abstract ideas to the audience through anthropomorphism and materialization, using simple colors, that turn their work into timeless classics. I believe these movies have had a great impact on my work as I always tend to look for a bigger narrative from a tiny little design element.

[1] 「KuMincho」

「KuMincho」

Around five years ago, I joined my best friend Julius Hui (許瀚文), a former senior type designer at Monotype, in his new typeface design project, 「KuMincho」, learning and practicing my type design skills. [Fig. 1] Among the variety of existing Chinese typefaces, Mincho♦ is always my pick as its structure and strokes can best show the classical rhyme and humanistic touch of Chinese characters. Also, as Mincho originated from traditional Chinese calligraphy, its soft and emotional stroke can convey much more than the message itself. Yet choices of traditional Chinese typefaces are limited in the current typeface market, maybe that is also a reason why designers would sometimes go for Japanese typefaces as a substitute, as high-quality Kanji typefaces are in continuous supply in Japan.

♦ It is the character style made during the Ming Dynasty, but is actually closer to the style of Song Ti, the character style of the Song Dynasty, so it is called Song Ti in China.

『LOLOSOSO』

In 2019, I was invited by anothermountainman, a prominent
designer in Hong Kong, to design his biography 『LOLOSOSO』.
"LOLOSOSO" means nagging or talking a lot in Cantonese,
therefore words can be found all over the book. The design is
also inspired by one of the artworks of Tsang Tsou Choi (曾灶財),
also known as "The King of Kowloon (九龍龍皇帝)". [Fig. 2]
Tsang's artwork could be found on every corner of the city
when I was a child, and coincidently anothermountainman
had also created an artwork based on Tsang's creation. So,
I found the concept a perfect match with the book identity
and eventually created an "architecture" with densely
packed typography. Every book is an entrance designed
by a designer; an entrance to a reading journey that has a
predetermined reading flow. However, this time, I had chosen
to put it another way, where the book is designed to let readers
choose where to start by using various sizes and font weights,
allowing exploration of ones reading order, as well as allowing
readers their own rhythm through the journey. [Fig. 3]

[2] Tsang Tsou Choi's work.

[3] 『LOLOSOSO』.

Design Building With Delicate Details

Only focusing on the big picture may lead to negligence of little details in one's design, but I would say my designs are created as an assembly of intricate details. [Fig. 4–5] I would always generically match fonts from Chinese, Hiragana & Katakana, and the Latin alphabet that I found suitable, fine-tuning would be the next step. In the pursuit of perfection, I have once used seven different fonts in a paragraph yet it is barely noticeable by other designers or readers. Sometimes I have to spend more than two weeks on finetuning, testing the prepositions in order to master the desired reading flow, greyscale, and reading rhythm. Trial and error is the only way we, as Hong Kong designers, can polish our Chinese typesetting skills. Given there are limited resources focusing on this area, learning from past experiences and exchanging ideas with people around you is always the fastest way to grow.

[4] Details of 「Ku Mincho」.

[5] Details of 「Mechanical Mincho」.

Poe Cheung

「Hoko」: Typography in the Bilingual City

Typographic Harmonization in the Bilingual City

English has been an official language in Hong Kong since 1842 after Hong Kong was ceded to the British as a colony. Until 1974, Chinese was elevated to the status of a co-official language along with English after some anti-colonial riots. Today, English and Chinese remain our official languages. The Chinese language is written in Hanzi. The majority of the population in Hong Kong speaks Cantonese and we have been taught to write in a way that closely resembles Putonghua.◆ But the difference is that traditional Chinese is the official script used in Hong Kong, while simplified Chinese is the official script in mainland China.

As a designer in Hong Kong, most of the time I have to work with Chinese-English bilingualism. As you know, the Hanzi and Latin alphabet are very different from the linguistic and visual points of view. Hanzi is much more complex in form and construction, especially for traditional Chinese, while the Latin alphabet is simple with modular strokes and shapes. I always find it is difficult to balance the two scripts visually as Chinese always looks "stronger than" the Latin alphabet in the same layout. This is because Hanzi characters occupy the em square fully with complicated structure. For example, "key" in Chinese is "鑰匙". When you have to put them into a poster,

[1] Poster for《柔和之光 Softened》, considering the balance between Chinese and Latin characters.

you may have to test how to harmonize them by changing color, weight, size, typeface, or use of graphic devices. It may be a time-consuming process but sometimes you may create something unexpected in the end.

I always have to design the priorities among multiple scripts in my design, like I have to decide which scripts come first when readers read. Most of the time they are not equally treated. It depends on the target linguistic groups then you will know which script is more important. However, no matter if readers are monolinguals or bilinguals, they would be influenced by the graphic presentation of content in the other language. Therefore, I think the two scripts should look relevant or harmonize when they are in the same layout in order to avoid distraction while reading.

A poster I recently designed for an artist's exhibition is a good example:《柔和之光 Softened》. Apparently, the target groups of this exhibition are Hong Kong locals. When I have to put the four Chinese characters together with a single English vocabulary, I may have to think about how to harmonize them while the Chinese characters have to be large. And how can the Chinese character "柔和之光" look "Softened". Graphical treatments were applied to balance the two scripts. I customized the Chinese type for this project. The horizontal strokes of the Chinese are super thin. Some strokes of the letters 之 and 光 are disconnected to widen the space among the character. The terminal of the characters is rounded in order to match with the Latin font. Also kerning between characters is large. [Fig. 1]

「Hoko」

I designed 「Hoko」 in a summer program, TypeParis.♦♦ It is an experimental humanist typeface inspired by Hong Kong Beiwei Kaishu. Since the 1950s–1960s, Beiwei has been commonly used on large-scale signboards in Hong Kong. If you have been to Hong Kong, you can easily find a Beiwei style sign at a traditional store. [Fig. 2] It is bold, strong for people to see from a far distance. It is very exuberant and recognizable. However, Beiwei Kaishu is endangered now as fewer new businesses choose to use calligraphy for their signs.

According to Keith Tam (譚智恒), a typographer in Hong Kong, "The Qing Dynasty saw a revival of the study of epigraphy, and calligraphers were divided into two schools: the 'ink-on-paper' school in the north, and the

♦ Putonghua, also called Mandarin, uses simplified Chinese characters and is widely spoken in China. Cantonese is considered a dialect and uses traditional Chinese characters. It is mainly used in Guangdong, Hong Kong, and Macau, and has nine intonations, unlike Putonghua.

♦♦ Launched by the Typo-fonderie team in 2015, TypeParis is a type design education program including weekly talks which are open to the public.

epigraphy school in the south. But there is a particular style of Kaishu called Beiwei (or Northern Wei) that can be considered indigenous to Hong Kong." Beiwei Kaishu originated in the Northern Wei Dynasty (386–534 AD) and was inscribed on stones to document historical events. Influenced by the marks made by a chisel, Beiwei Kaishu has sharp strokes, dynamic forms, and slightly asymmetrical constructions.

[2] A Hong Kong tea house with Beiwei calligraphy style sign.

I like Beiwei calligraphy because it is a very familiar but special calligraphy style. It can be found around every corner in my hometown. It can be found in a Chinese medicine stall, Chinese tea house, restaurant, old printing store, clinic, industrial building, and so on. Sometimes it displays alone, sometimes it displays with English translation.

While choosing a topic for my type design project at my summer school in Paris, as a foreigner, I decided to create something related to my hometown. It should be experimental and fun. I thought of Beiwei calligraphy and it all started with my imagination: How would Latin letters look if they were in Beiwei style? This is an interesting question that was hard to imagine at that moment. Meanwhile at that period of time, there were type designers in Hong Kong trying to digitise Beiwei style calligraphy into a set of Chinese display types. I wished to design a Latin typeface working with this style of font.

After studying about Beiwei Kaishu, some explorations were done before I decided the shape and details of the type. At the very beginning, by referencing the letter shapes that calligraphers inscribed on stones with a chisel, the first draft of「Hoko」had very pointy and sharp strokes. You can see that the serif of the letter 'n' 'p' and 'f' are close to a parallelogram. The terminal of the letter 'p' is sharp like a triangle. The set of letters seems somewhat symmetrical. [Fig. 4] I am not very happy with the first draft as I think the letters look too serious and lack sensibility. It couldn't relate to Beiwei Calligraphy.

After the first attempt, I explored another direction. Depending on the result I sought, I had to make a choice between the different mediums. I brought some Chinese calligraphy brushes and ink and started to write to see if there are any insights. [Fig. 5] By using a soft brush to write, more dynamic forms can be created. Apparently, It created a thick part at the start of the stroke and pointy terminal. These

HONG KONG BEIWEI KAISHU

北 d 風 j 港 K

Hong Kong Beiwei Calligraphy Type designed by TREBEKA.

香 HOKO 港

TYPEFACE INSPIRED BY

Hong Kong Beiwei Kaishu Calligraphy.
Beiwei Kaishu in fact performs very well at
largescales and viewed from fair distances.
The beginning, endings and turns of strokes are very sharp
and exaggerated, making the shapes of the characters very distinctive
and easy to recognise.

[3]「Hoko」specimen.

[4] Initial Sketch of「Hoko」.

[5] Latin alphabet written with a calligraphy brush.

[6] The second sketch of「Hoko」with calligraphy rhythm.

[7] The final sketch of「Hoko」, identifying and reinterpreting the characteristics of Chinese characters and applied them to the structure of the Latin alphabet.

strokes are closer to the sensibility of calligraphy. Then I applied what I had discovered from the lettering to my second draft. Now, the letters seem lively. They have a calligraphy rhythm in themselves and they look energetic. [Fig. 6]

However, how to strike balance between the two scripts was one of the main tasks for this project. One of the mistakes that I made was that I tried to copy the stroke from Chinese calligraphy directly to the Latin form. This was a wrong approach. The letters are too asymmetric. As I was designing body texts, the form of the letter should also look stabler visually in order to create a better reading experience. From the visual point of view, the structure of the Latin alphabet and Hanzi are at the polar opposite of the spectrum. What I had to do was to apply the characteristics of Chinese calligraphy to the Latin system but not to copy the strokes directly. In the final sketch of「Hoko」, you can see that the letters look steadier after reducing the curve in the letters. [Fig. 7] The stems and bar at the letter 'e' are now all straight. The shape of the serifs is close to a parallelogram but remains slightly curved which is a distinctive serif system.

「Hoko」is designed in two weights, a regular weight for texts and a heavy weight for titles. [Fig. 8] The form of the letters is dynamic. Influenced by the tool of the brush, the strokes of the letter are sharp and with a slightly asymmetrical structure.「Hoko Heavy」is a bold and strong display type for large scales and could be viewed from far distances. It features narrow

HOKO Regular

abcdefghijklmn
opqrstuvwxyz fifl
ABCDEFGHIJKLMN
OPQRSTUVWXYZ
0123456789
€$@[(*)]?!-–—/.,:;·."""'«»&
æœ àåçëíıñôü ÆŒ
ÀÅÇÉÎÑÔÜ

Hoko Regular Features:
Dynamic form, sharp stroke, asymmetrical structure

HOKO Heavy

abcdefghijklmn
opqrstuvwxyz
ABCDEFGHIJKLMN
OPQRSTUVWXYZ

Hoko Heavy Features:
Super bold stroke, narrow counter spaces, asymmetrical structure

[8]「Hoko Heavy」&「Hoko Regular」.

[9]「Hoko Heavy」Production Process.

[10] Weight Test of 'n', drawing from extra light to heavy.

counter spaces, super bold strokes, and a slightly asymmetrical structure. The development of the heavy weight is very fun for me as well. In fact, I think「Hoko Heavy」matches the Beiwei calligraphy sign better as it is super strong and eye-catching. [Fig. 9–10]

「Hoko」is an experiment, not a completed project. For me, the project is a learning process and is a starting point for my typography exploration. I hope to explore more in the future and be open to cooperation. At the same time, I am now finding other interesting material for my upcoming project.

[11]「Hoko」in use in TANK Shanghai, He Xiangyu's exhibition.

archive

Typojanchi saisai 2020–2021: International Typography Biennale

Workshop: 14–22 December 2020
Talk: 1 May 2021

Director in General: Lee Jaemin
Curator: Park Eerang, Jo Hyojoon

Hosted by
Ministry of Culture, Sports and Tourism

Organized by
Korea Craft & Design Foundation
International Typography Biennale Organizing Commitee

In cooperation with
National Hangeul Museum
Korean Society of Typography

Supported by
Doosung Paper
Design Press

Translation by Kim Noheul

타이포잔치 사이사이 2020–2021:
국제 타이포그래피 비엔날레
Typojanchi saisai 2020–2021:
International Typography Biennale

토크 Talk

2021년 5월 1일 토요일 오후 2시, 온라인 스트리밍
Saturday, May 1, 2021, 2PM, online streaming

Talk Poster for 《Typojanchi saisai 2020–2021: International Typograhy Biennale》.
Illustration: Lee Hongmin. Design: Typojanchi Planning Team.

Me and You and
Typography We Know

INTERNATIONAL TYPOGRAPHY BIENNALE TYPOJANCHI SAISAI 2020-2021: INTERNATIONAL TYPOGRAPHY BIENNALE

Lee Jaemin

《Typojanchi saisai 2020–2021: International Typography
Biennale》(hereafter 《saisai》) is a pre-biennale to explore its
themes and present expectancy and possibilities prior to the
main event. It consists of diverse channels such as symposia,
workshops and exhibitions at the discretion of the art director.
《saisai》this time had workshops on 14–22 December 2020
and a talk on 1 May 2021. The theme 'Typography and Life'
decided by the International Typography Biennale organizing
committee seems to imply the timeliness of the current
pandemic to some degree. To present the theme, however, we
did not want to deliver any serious message or give guidance
to viewers tired of extended social distancing. We did not even
have a detailed plan for expressing the theme. Therefore,
《saisai》had to be considered as a chance to sketch out how
far and in what direction the theme could be expanded
beyond a sneak peek or preview. The workshop and the talk
are the result of attempting to search for diverse possibilities
that can be expressed with the combined two words of letter
and life.

Workshop 1 ⟨Letters Brought to Life—Life.js⟩. Photography: Park Jaeyong.

The ⟪saisai⟫ workshop boldly started with Jeonghyo's ⟨Letters Brought to Life—Life.js⟩ to make 'life on digital space' through text-based programming, it did not deal with traditional typography or visual design. It was followed by Just Project's ⟨Reviving再生 Letters—My Face, My Use⟩ that revives obsolete letters to develop ones with totally different uses or functions and; O Hezin's ⟨Mutated變異 Letters—Mutation⟩ in which participants make drawing tools through arbitrary aesthetic sense and work on drawings under certain conditions. Considering COVID-19 prevention, the events were carried out six times on a very small scale with 7–15 people. We wanted participants to enjoy the process rather than the result and imagine and explore letters and life together. On the other hand, the exhibition ⟪Contactless⟫ held online by the Korean Society of Typography had an opportunity for offline exhibition at RTO, Culture Station Seoul 284 where we had the ⟪saisai⟫ workshops. It strengthened the relations of Society and ⟪Typojanchi⟫, offering workshop participants to see the exhibition as well.

Screenshot of online talk. From the left to right: Yang Soohyun, Park Youngshin, and Erich Brechbühl.

At 《saisai》 talk which sought for more varied possibilities regarding the theme, we invited six designers and activists from home and abroad, who had studied design, life, environment and letters in different ways and asked them to share case studies and their own insight. The talk was designed in an online, contactless form due to the pandemic, to give more people the chance to participate in comparison to the workshop sessions. Yang Soohyun told us a story of new service operation and design styles such as developing characters and forming fandom through her branding experience of NEWNEEK, a newsletter platform for younger generations. Starting with a question 'Would there possibly be a cafe without disposable cups?', Chung Dawoon promoted active interests and changes of environment and life through her experience of creating and running a platform which suggests sustainable everyday lives. Sofia Østerhus from Byggstudio shared her process of turning an ordinary, listless space into an active one; she applied craft techniques with traditional and regional colors to public projects and made up signage based on a plant native to a particular region.

Based on 'activity as information', Hagiwara Shunya
(萩原 俊矢) told us how he made drastic twists of familiar
notions on the Internet, the primary media of his actions,
or within 'stuff like the Net' as its extension and broke out of
limits and stereotypes about media. We also listened to
Park Youngshin and Erich Brechbühl. Park Youngshin thinks
every living thing develops their own senses and intelligence
and sends and receives information to/from the outside world
and considers 'sending out' the most predominant aspect
of living things. She looked back on her diverse works and
ideas surrounding that theme which she has worked on since
1995. Erich Brechbühl demonstrated the process to be a
world-famous graphic designer by utilizing letters as a tool for
expression and introduced his major works. A total of 2,201
people signed up for the 《saisai》 talk in advance and given
that the event was free of charge, 1,577 participants actually
logged into the event, which enabled communication with a
lot more people than offline events had done so far.

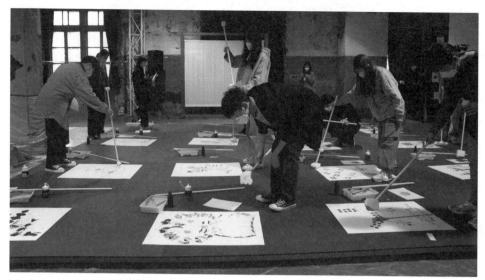

Workshop 3 〈Mutated變異 Letters—Mutation〉. Photography: Park Jaeyong.

Some may have found 《saisai》 somewhat confusing this time as it stressed stories with keywords such as millennials, environmental issues, the Internet, media art and living things, rather than dealing with letters and traditional methodology. Typography is a tool and methodology generally used by graphic designers. As the term janchi means a party, 《Typojanchi》 is naturally considered as a 'typography feast' and it also tends to be perceived as a feast that graphic designers organize and enjoy themselves at. Typographic activities are to beautify and make letters and information more legible on mobile messengers or email, and everyone is doing this in their own way—designers as well as non-designers. Today it is undeniable that new factors have come to be frequently used in this process, such as emojis and animations, which can be regarded as part of typography. We did not want to restrict the scope of visitors to this feast to graphic or typeface designers only, and supposed that it would need to reflect the broadening horizons of 《Typojanchi》. The poster of this 《saisai》 features stuff which looks like disassembled or recombined bodies. A subject matter like 'bone and flesh' symbolically displays typographic notions even though it does not directly handle types or layout. We wished to share that idea through the poster series that headline a picture, not a character, stirring the imagination; web pages for event information and registration and; many different designs on the video screen as well.

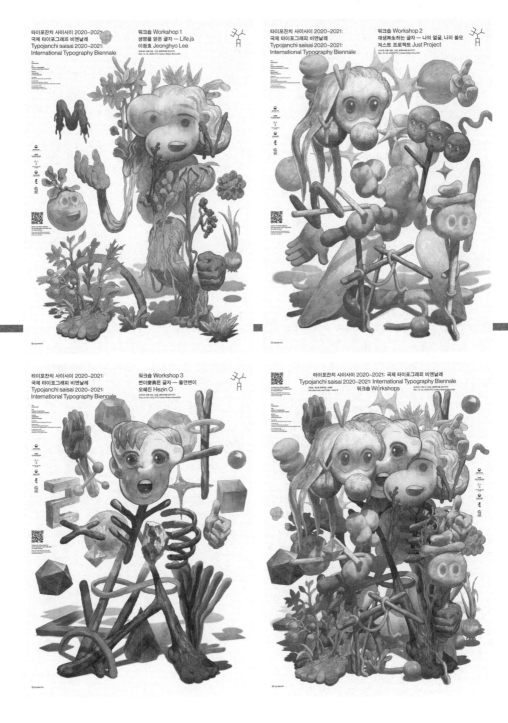

Workshop poster for《Typojanchi saisai 2020–2021: International Typograhy Biennale》.
Illustration: Lee Hongmin. Design: Typojanchi Planning Team.

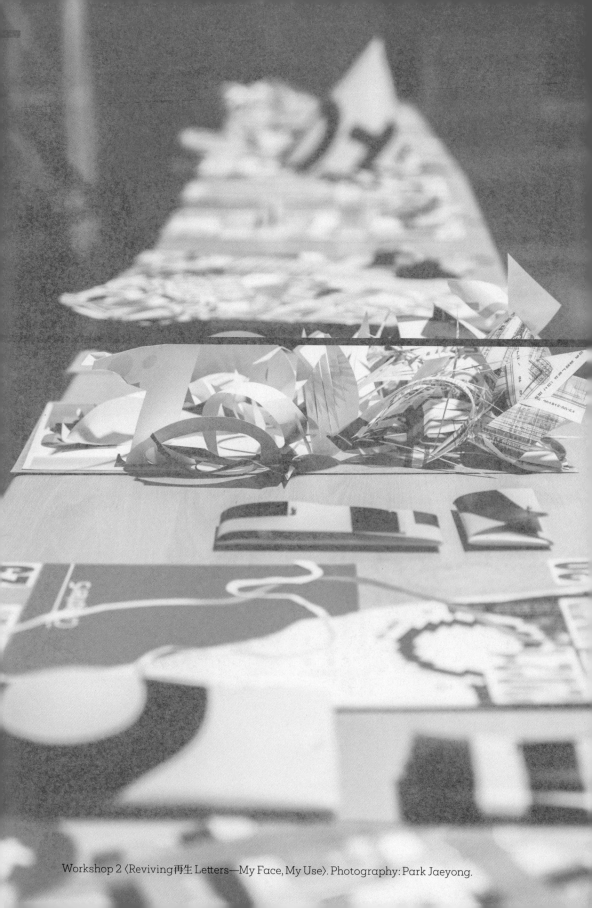

Workshop 2 〈Reviving再生 Letters—My Face, My Use〉. Photography: Park Jaeyong.

How NEWNEEK
Breathes Life into News

Yang Soohyun

Designer Yang Soohyun

Please introduce yourself and say hello to 『LetterSeed』 readers.
I'm in charge of branding at NEWNEEK, a newsletter service for millennials about domestic and international affairs, as a graphic designer. I'm called Gosumi mom for making the character 'Gosumi', our mascot created out of a hedgehog, and now I'm a real mother of a newborn baby.

I was told that you've worked for NewNeek from its early days as a graphic designer. Please tell me what you've been working on to establish a brand and how you are involved in this brand as a designer.
I first met Kim Soyoun and Bhin Daeun, co-founders of NEWNEEK, in the summer of 2018 and they told me "We want to make a hip, fun and authentic brand. This service deals with news but we want it to be recognized as a brand, not media. There are a number of brands which are either hip or fun or stress authenticity but there seems to be none of all three. Let's make one together." It was a vague and difficult request but I could figure it out. It is because I had, like them, a thirts that could not be quenched by legacy media.

Before making the brand 'NEWNEEK', I did some research. Everybody said 'youngsters do not watch the news', but I wondered if they really didn't. Interviewing potential readers, I understood that they couldn't relate to issues covered by legacy media and that the dry and

NEWNEEK

NEWNEEK's Logo

difficult terms used did not seem to be directed at them. In spite of that, they were still curious about the world. NEWNEEK was born out of their needs.

Beginning my design work, I imagined "I read NEWNEEK" had to mean something different. I tried to create a space where news is not stuffy but fun; everyone can get smart and diverse opinions can be respected and; we can discuss issues that we are currently curious about and should be aware of. One of my efforts for that goal was the speaker 'Gosumi' who gives easy explanations about main issues each day. Given that this brand is a newsletter, I wanted to give readers the experience of exchanging emails with a close friend. Working on Gosumi's design, I made him not simply a visual character, but one concerned with every contact point, where he meets subscribers under the name of NEWNEEK. In addition, as a designer, I strive to think of whether Gosumi's personality and way of speaking would hurt anyone and I care about how Gosumi would relate with NEWNEEKERS (nickname for NEWNEEK subscribers) in terms of SNS management, goods production, marketing plan, issue selection, etc. To give you another interesting example, I check the founder's outfit before an interview or lecture. I don't want her to look old-fashioned. Sometimes I nag her not to dress like a model student and her bleached hair seems not enough for me.

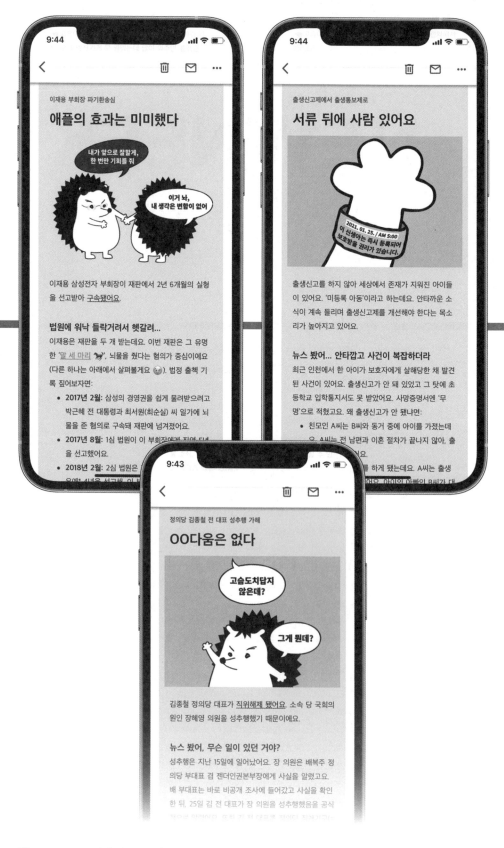

The amount and the layout that can be captured with a single screenshot.

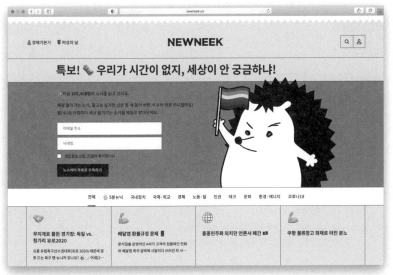

NEWNEEK's website.

Breathing Life into News

Figuring out why generation MZ doesn't read much news, you tried to solve their discomfort via NEWNEEK. Do you have a typographic strategy for the newsletter to that end?

First of all, I've been adjusting the amount of text in consideration of mobile readability and sharing. NEWNEEKERS read our newsletter more in a mobile environment than in a web setting. NEWNEEK went viral at first and the amount of subscribers increased without advertisements. Through FGIs (Focus Group Interviews), we found out they were sharing screenshots through messenger apps like KakaoTalk. Thus, an editor and I studied the amount that can be captured with a single screenshot on a smartphone and would not distract their focus.

Fonts and colors also matter. Our service is a forum for the news so I excluded fonts and colors used by a certain political party or media. 「Noto Sans」 is used for the text and orange is the primary color. (Now there is a political party using the color orange, specifically the People's Party which was established in 2020.)

We should take note of using emojis as well. Each emoji has a different margin and it breaks the layout so unless they are used as a bullet at the initial point of an article, we put them at the end of a sentence. To represent human beings, we put the man and woman emojis together, and their order is alternated every time they

뉴닉의 여성용어 가이드

뉴스레터를 만들 때 뉴닉은 이런 단어를 사용합니다 ✍

그

- 🚫 뉴닉은 안 쓰는 단어: 그/그녀
- 🚫 뉴닉은 안 쓰는 단어: '여'를 접두어로 쓰는 단어들
 ex. 여비서, 여장부, 여의사, 여검사, 여걸, 여대생, 여기자 등

Screenshot of the 'NEWNEEK Female Terms Guide'.

appear. For skin color, we use yellow as default without racial classification.

One of NEWNEEK's distinct features is its quick reflection on reader feedback. Maybe that's the driving force that makes NEWNEEK feel like a platform that is actually alive. That is how the 'NEWNEEK Female Terms Guide' was born. I'd like to hear about the process of reflecting reader feedback into the terms guide in detail along with another case in which reader feedback made a change in NEWNEEK.

Kim Bokdong, a human rights activist who was a victim of Japanese sex slavery concerning 'comfort women', passed away on 28 January 2019. Reporting that news, we used the term 'Halmoni (grandmother in Korean language)' and received a lot of sharp criticism, which involved the question why a male human rights activist is called an 'activist' or 'sir' but a female one 'Halmoni'. The word Halmoni is a respectful expression but considering her status or activities performed, we concluded that the status had to be reflected. We immediately admitted the mistake and notified our readers that the expression would be corrected in the next letter. This inspired the archiving of words that the NEWNEEK team would not use and their substitutes, which led to the development of the 'NEWNEEK Female Terms Guide'. The guide was created for the team when writing a newsletter but we felt that it should be shared with NEWNEEKERS. So, we've made it public and keep it updated. Words mirror

- **좋았어요** 😊 : "쿠팡 물류창고 화재에 대해 깊이 다뤄줘서 좋았다", "전기세(X)와 전기료(O) 중에 뭐가 맞는 표현인지 알게 됐다"는 의견 있었어요.
- **아쉬워요** 🥲 : "박성민 청년비서관 임명에 대한 논란을 더 자세히 알고 싶다", "전기료 안 올라서 좋아하는 사람도 많을 텐데 비판적인 내용이 많아서 아쉬웠다"는 의견 있었어요.

오늘 레터는 어땠나요? 어디가 좋고 어디가 아쉬웠는지, 다음에 알고 싶은 이슈가 무엇인지 아래 버튼을 눌러 알려주세요!

> 좋았어요 😊

> 아쉬워요 🥲

NEWNEEK always summarizes feedback on the last newspaper.

our time. If a word is wrongly used unconsciously, it should be corrected and replaced with the right one, step by step. The NEWNEEK team and the NEWNEEKERS are constantly developing their new common sense and self-censoring in this way.

NEWNEEK always asks what the letter was like that day at the end of the letter. We sometimes get feedback from as many as a thousand readers. Team members carefully check all feedback; it gives us a hint about whether we made a mistake, whether the letter was easy to read or what issues NEWNEEKERS are currently curious about. We sometimes plan the next contents based on this hint.

NEWNEEKERS' feedback has led to quite diverse changes. The policy and standard for advertisements in the newsletter were established with NEWNEEKERS' feedback. We mostly cooperate with brands that respect every member of society; do not reinforce any wrong stereotypes about gender, appearance or race and; are capable of introducing new information or fields to NEWNEEKERS. Not all feedback requires changes, though. We receive words of encouragement, too. Many readers left me congratulations and encouraging words when I took maternity leave. I feel there are people behind the lettes in times like these.

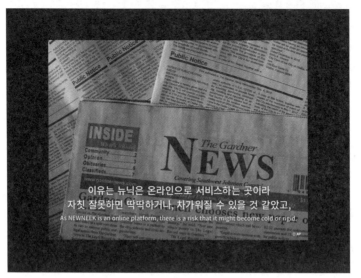

The zigzag edge of the hard copy newspaper has inspired Gosumi.

Breathing Life into Gosumi

Your choice to use a hedgehog as the NEWNEEK speaker fits well with the characteristics of the media outlet. You reportedly came up with that idea based on the rotary press trim line of hard copy newspapers. What is the reason you applied a feature of traditional media to the mascot and what's the effect?

The hard copy newspaper we've read for a long time has a classic feel, I think. Though NEWNEEK suggested an alternative for legacy media, it exists only in the online setting so I didn't want it to feel cold or unfriendly. Legacy media has its own charm—people freshly start their days with newspapers delivered at dawn; the thin paper smells like ink; the layout varies in the preset frame depending on the hierarchy of articles, etc. I wanted to translate this charm to NEWNEEK. The zigzag pattern shown only on a rotary press reminded me of the spikes of a hedgehog. That's how Gosumi, a lovely but daring mascot, was born who is soft on the inside but able to shed those spikes when he has something to say.

We did an MBTI test within the team to make Gosumi feel more vital. The two-hour test in which each of us assumed the propensity of Gosumi showed that Gosumi is an ENFP. A liberal and witty activist type with a high level of empathy seemed right. NEWNEEKERS also replied that they feel close to Gosumi when Gosumi says something on behalf and when Gosumi talks to

Initial sketches of Gosumi.

Gosumi's doljanchi.

them and asks about their thoughts. Receiving replies starting with "Hi Gosumi", we feel like Gosumi is now a dear friend in the mailbox on Monday, Wednesday and Friday mornings.

I've seen that you keep opening Gosumi-related events to communicate and build closeness with NEWNEEKERS. What is your focus on design when planning such an event?
I'm kind of a person who likes to keep myself busy. I am a big party person and like to gather people, having more than a hundred housewarming parties. I take two things into account when planning NEWNEEK events. First, participants should feel a sense of belonging. Second, they should be deeply impressed so that they can remember it for a long time.

We had a first-birthday party for Gosumi to celebrate the first anniversary of the company. I'd like to congratulate our work as Gosumi had grown up with NEWNEEKERS so I prepared a feast table with a rice cake made out of Gosumi's face and with doljabi◆ as well. We've celebrated Gosumi's birthday every year with NEWNEEKERS around our foundation day in summer. The event was done in a contactless way in 2020 due to COVID-19. We established the Gosumi fanclub on his birthday and broadcast the inauguration ceremony live

◆ In Korea, when a child turns one year old, there is a first-birthday party called 'doljanchi'. At the doljanchi, there is a custom called 'doljabi', in which certain items symbolize certain talents. The tiems, such as rice, brushes, bows, money, and threads, are arranged in front of the child, who will then grab one of them, for the baby's good fortune.

Gosumi goods.

through YouTube Live. NEWNEEKERS even sponsored a subway advertisement which had been possible only for idols before. We did an online signing event as well. Besides email, we meet NEWNEEKERS in person and talk to them, which tells us a lot about who we've sent letters to. We plan to have events frequently to meet subscribers on a large or small scale.

Do you have any standard you particularly pay attention to when designing Gosumi goods? Recently, quite a lot of goods are designed in awareness of environmental issues. Tell me your views about it.

I'm making goods but sometimes feel tired to see them pile up at my place. When I do my work, I have a craving to develop as many goods as possible but eventually decided that I would only make really useful ones. When producing our goods, team members as well as I struggle to find a way that does not harm the earth. We're looking for boxes which do not use tape or recyclable wrapping.

I sometimes have to make a choice between design and environment, which gives me a headache. If I should protect the earth, it diminishes the design concept and; for the sake of the best design, the environmental issue bothers me. To be honest, it depends because I'm not Superman saving the earth but rather a greedy designer. However, I'm really trying to find a way that allows me to feel less sorry for the earth.

《Typojanchi saisai 2020–2021: International Typograhy Biennale》. Photography: Park Jaeyong.

Life Radiates

INTERNATIONAL TYPOGRAPHY BIENNALE TYPOJANCHI SAISAI 2020-2021:

Park Youngshin

Designer Park Youngshin

Please introduce yourself and say hello to 『LetterSeed』 readers.
　　　Hello. I am Park Youngshin, the Ian Design art director.
　　　I worked for 『Saemikipunmul (Deep Spring Water)』
　　　as a founding member. After that, I've been designing
　　　illustrated books, Korean dictionaries and children's
　　　books at ianDesign. Other than that, I am a picture
　　　book author and book artist as well. I participated in
　　　the Biennial of Illustrations Bratislava (BIB) with two
　　　volumes of my picture books. And I won the design
　　　achievement award at 《Korean Book Day》 last year,
　　　from the Korean Publishers Association.

You are engaged in several activities as an editing designer,
picture book author and book artist, and 『Saemikipunmul』
was the starting point. It is a meaningful book in the history of
Korean graphic design but it must be more special to you. Tell
me about your experiences as a 『Saemikipunmul』 designer
and about the book's impact on your career as of 2021.
　　　『Saemikipunmul』 claimed to be a 'people's magazine',
　　　set values and the direction of the time, and laid the
　　　standard of thought for me too. Building up the beauty
　　　of, it was a pioneer in the design field as well. Particularly
　　　memorable was the combining of consonants and
　　　vowels using the 「Saemikipunmulche」 module, to make
　　　a de-squared typeface and to work on the magazine's
　　　typeface manual. 『Saemikipunmul』 also took a lead
　　　in introducing new tools. 『Saemi-gipeunmul』 adopted
　　　the newspaper font to Macintosh, a representative

『Saemikipunmul』 May 1988 Cover.

platform for DTP (Desktop Publishing) in 1990, which was soon followed by QuarkXpress 2.04, and the magazine was entirely made using computers in 1991. The process of making the magzine was to print out letters and graphics on a single sheet of black-and-white photographic paper; separately scan photos and pictures and attach them to that paper and; order colors. Most of the typesetting of early DTP was visually unstable. In spite of the early adoption of DTP, 『Saemikipunmul』's font application was relatively smooth. After I left the company, I used Fontographer (FOG) to make Korean typefaces by utilizing Kong Pyongu 3-set keyboard. I've used various graphic software in this way since Photoshop did not yet have layers. I feel grateful for 『Saemikipunmul』 and my early experience with its DTP which surely did pave the way for my career until today.

Your picture book 『Little Lady & Fox』 was published in 2019. What is the reason you make picture books, what is the process, and what are your plans for future publication?

As 『LetterSeed』 started from a single seed, I think everyone would appreciate the importance and possibility of a seed. Children are the seed indeed. Charles Dantzig said, "Reading a book is a tattoo in one's mind." Books from one's childhood in particular are the most influential. If children regard books and learning as 'pleasure', that memory is carried with them into their lives. Children should be provided with a

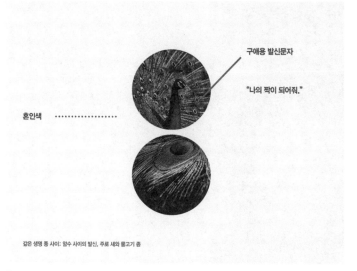

구애용 발신문자

"나의 짝이 되어줘."

혼인색 ····················

같은 생명 종 사이: 암수 사이의 발신, 주로 새와 물고기 종

Communication systems on various living things.

variety of quality content, I think. The perspective that I can give children is a 'vista' bigger than their daily experiences.

『The Maid and the Fox』 is my third picture book, which is made solely using tangram pieces. The mere seven pieces of triangles, squares and parallelograms meet up and produce diverse shapes, which seems to give an idea of how all things in the world are working. All things are made only with a limited number of elements, as shown on the periodic table; tangram pieces also show us an interesting structure to shift to a complex world based on how fundamental figures are joined together. Considering the pieces give a meaningful implication of connection, relationship, parts and the whole, I figured they had mathematical and design values. Publication plans have not been arranged but I'm incompactly putting flesh on several volumes. I'm mapping out tangram series versions easier and harder than 『The Maid and the Fox』, along with a picture book made up of with geometrical figures. In addition, I'm working on another picture book about nature and life and; a folk painting picture book with embroidery which can embody Korean aesthetic sense and vitality. I should also make time to continue the 'life' series.

〈Gaia〉.

Letters of Life

The title 'Life Radiates' for the 《saisai》 talk is impressive.
You took examples from communication systems of various
living things and talked about possibilities as letters.
What does the letter mean to you?

Citing protective coloration, aposematic coloration
and nuptial coloration as communication systems
of living things at the 《saisai》 talk, I mentioned their
potential to be letters sending out messages. But I guess
living organisms have more developed languages
than written ones. When a plant damaged by insects
emits chemicals, a neighboring plant detects it and
produces defensive substances to reduce damage.
It is a typical example of how plants communicate.
Living things detect their surrounding circumstances
and accumulate related data to express their will to
survive and reproduce. Spirama retorta is a moth that
can make a Taegeuk pattern, which means it has the
spontaneity to form the pattern. That's why I put more
stress on 'sending' than 'receiving' and set life as a
subject of 'letter'. The title 'Life Radiates' is the result of
the aforementioned stages. Maybe none of the forms
or patterns or life need meaning attached to them,
and if any meaning is wrongly added, it may cause
errors. When information flows between a sender and
a recipient, however, they understand what each of
them sent out to each other. If the recipient can share
or interpret information from the sender, there is a
communication protocol between the two. So, I think

〈Diva: Apple Diva〉. 〈Diva: Earth Mother〉.

that regardless of whether or not letters are compatible, a 'protocol of sharing and resonance' exist, connecting the sender to the recipient.

Looking at your work introduced at the talk, you seem to understand and observe the principle of life first and then create a work based on that observation. What is your priority in this process? And tell us about the works you're attached to.

The principles vary slightly for each series. 〈Gaia〉, from 1995, serves as a foundation for the entire series. 〈Gaia〉 divides the earth's spheres into light, the sun, land, wind, water and biosphere. I put several ideas together in this work: (i) each sphere is a part of the earth's organic relationship, (ii) nonliving things and living things are not separated but coexist in this huge communal sphere and (iii) life and substance are symmetrical but also connected, etc. Gaia is the goddess of the earth as well as earth itself, with magnanimity, upliftment and vitality. 〈Homo Ludens〉 is the result of expansive thinking about life at the vertex. In this work, my thoughts moved from cyborg to culture and play. 〈Diva〉 is about reasoning about all life's uniqueness and sanctity and the plays this life creates. For the main character, I looked at materials that we see around us and that always work as backgrounds, such as apple trees, pine trees, chestnut trees and rain. I closed the gap between 'abstract attributes' and 'cartoon attributes' and placed my ideas about life and play in its foundation. It is because every life creates play.

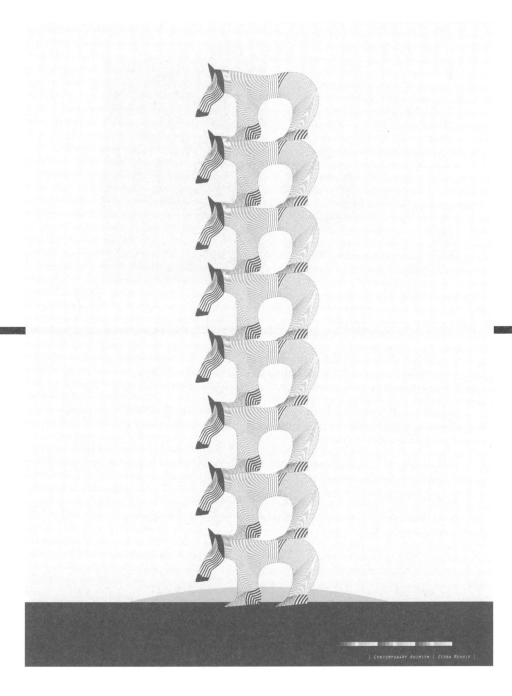

| Contemporary Animism | Zebra Menhir |

⟨Contemporary Animism: Zebra Menhir⟩

Poster for ⟨Contemporary Animism⟩.

I was told not only human beings but also dolphins, crocodiles, lizards and paramecia have been seen to enjoy playing. ⟨Contemporary Animism⟩ involves the greatest number of images of life. The earth has gone through mass extinction many times. 'The past of life' and 'the present of life' are both different and the same. Rewinding the clock to the origin of life, in this work, I explored the 'location where life happens'. Determining my subject matter as an amoeba, polyp, starfish and centipede, I tried to find a space where life was conceived and hidden power did not move yet still did. ⟨Particle⟩ and ⟨Nature's Pattern⟩ are the products of an examination of what is common and different among living and nonliving things. Living and nonliving things sometimes use similar rules to form shapes and patterns. I've sent out and studied visual images from ⟨Gaia⟩ to ⟨Theater of the Flora⟩. There is still a great deal to learn and I still have a long way to go, but in this journey, I do appreciate the chance to enjoy my own work with all of you.

⟨Contemporary Animism: Aquatic Plant & Fish⟩.

Life of Letters

The term 'environmental protection' itself feels otherizing, you said. It involves a form of otherization of the subject and creates prejudices. Can it be prevented in terms of letters and typography?

A term does not simply point out an object but delivers a psychological idea so we should carefully examine whether the term incorporates any discriminative or rejecting elements. To lessen otherization, we should cautiously choose our terms and expand ourselves into a bigger ego. There is a nuance difference between 'other people' and 'others'. If cell membranes don't carry substances or send signals back and forth, an essential activity of life, they will soon wither away. 'Other people' refers to the condition where 'I' am within the cell membrane but even though the membrane is a border line I still exchange signals with 'other people' outside of the membrane. 'Others' means that I shut my membrane off and block the inflow of information entirely. In this case, I would be exhausted quicker than the 'others'. Otherization will stop only if we think about the 'right to life' of other creatures and look at social and cultural phenomena from other parts of the world with an open mind. Recently typographic forms have become more diverse, which will lead to the prevention of otherization itself. We can discover coexistence in vernacular fonts that collect letters from regional cultures and put them in literation along with 「Gilbert」 and 「Gilbeot typeface」. Although it is not an example

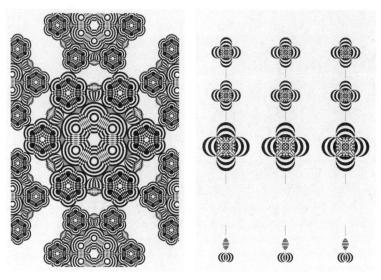

〈Particle〉.

of letters, I was so impressed by the online queer parade 'We Make a Way From Scratch'. At the 『Khmer Alphabet Journey』, letters also served as a bridge not to see the Khmer people as others. No matter how hard the Khmers try to send their message across, if there isn't any media or book that interprets their alphabets, it would not reach us recipients. These works that expand borders are good precedents, I think.

What does the letter mean to you? Can it be seen as life? Please tell me why.

As the human body has a structure of 'atom–molecule–cell–tissue–organ', letters also have a similar organizational order of 'alphabet–syllable–word–phrase–sentence–paragraph' along with harmony, balance and rhythm. Letters deliver meanings, feelings and energy to recipients, which is similar to life's energy exchange process. Letters, like life, maintain homeostasis of their form and, at the same time, they change according to the time or environment. And typefaces grow and develop over and over again and then get enriched as life does. Types also have families as living things reproduce; they expand from conventional writing systems or can be classified into groups based on similar figures. Letters thrive and dissipate according to the time and their surroundings. The most predominant feature is that letters resist entropy and have letter power just as life is a being which goes against entropy. They also have uniqueness

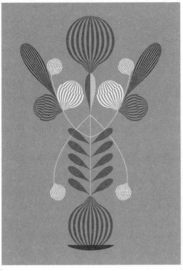
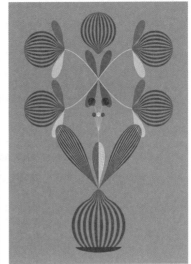

〈Theater of the Flora〉.

as a typeface and a border differentiating them from
other letters just like cell membranes of a living thing.
These features are what life and letters have in common.
Except that letters do not have proteins, carbohydrates,
lipids or nucleic acids that living things have.

conver
sation

Font Market Analysis from an Economic Perspective

Han Sukjin

This interview is an easier version of the ⟨Font Market Analysis
from an Economic Perspective⟩ lecture by Han Sukjin
at T/SCHOOL on 19 February 2021, for readers of 『LetterSeed』.

Translation by Kim Noheul

Please introduce yourself. Hello. I am Han Sukjin, an economics professor at the University of Bristol, England. My research field is 'econometrics', a branch of economics which develops statistical techniques necessary for economic analysis using data.

Other than my major, I've always been interested in delivering my thoughts through objects with physical properties or in a visual form. That's why I've collaborated with installation artists, designers and composers for the last few years and worked on my own pieces. To provide an example, when it comes to developing a statistical technique, we deal with mathematics a lot, in which there is a notion of dimensions. I thought of how to realize that transdimensional experience in daily life and at the same time, I wanted to make a space where we could have such an experience. I wondered if we could feel a sense of awe when experiencing the fourth dimension or above because we live in a 3D space. But it is impossible to make a 4D space in a 3D one. Thus I came up with an idea of lowering a dimension that a human perceives into 1D or 2D and then giving him a 3D experience. For example, connecting a narrow and low tunnel abruptly

to a high, open space. Contemplating that kind of principle, I received help from an architect and applied it to various architectural structures and made up a video. A composer also helped me to develop some music in order to maximize that experience. I found out later that my idea was a kind of way that was actually used a lot for church architecture.

Please tell me about your research topic.

As I said earlier, I am also deeply interested in design, architecture and art. Seeking a research topic at the intersection of my major and those fields, I got interested in the font market. It actually started from an idea that I'd like to do an economic analysis by using visual data. Economic analysis needs market study and market study requires research into industry or goods manufactured in the industry. So I tried to think of a product which visual information matters. Then I happened to see fonts on a website. I had never thought about the font before as it was so familiar. Taking a close look at it, however, I realized a font is one of the visually simplest products and chose it as my research target.

As I looked into the font market, a number of questions arose. What I wondered first was which factors would affect decision makers at each level. I tried to identify factors affecting a font designer's multiple decisions in the designing process and; those affecting a font consumer's choice of purchase. The second question as important as the first one was regarding legal protections. It takes a long time and a great deal of labor to make a font so legal protection procedures are important. I assumed if an economic or mathematical model could be established, a legal mechanism would also be possible which would benefit both font producer and consumer.

Would you tell me your research progress?

This research starts from seeing a designer as an economic subject. Various people seen in society can be referred to as economic subjects and an important prerequisite in economics is that economic subjects make choices with scarce and restricted resources. Then what kind of restrictions would lie in a designer's choice? The restrictions would be the time limit to make a font, whether there is a similar font in the market, consumer's purchasing pattern, etc. My research has been done based on this, considering a designer an economic subject.

The research is titled 'form as a choice'. The 'choice' here is that of a designer and the 'form' refers to the calligraphic form created out of the choice. When preparing my research

proposal, I asked for help from professor Seok Jaewon from visual communication design at Hongik University because I was not familiar with this field. Professor Seok recommended me a font company called MyFonts◆ and I sent my proposal there immediately. I received a reply a month later that MyFonts would like to do the research together. MyFonts is the world's biggest font platform, owned by Monotype. MyFonts sells fonts in a way that a foundry◆◆ owned by Monotype sells its fonts or external foundries pay service charge to sell theirs.

Data provided by MyFonts includes font image, foundry information and purchase information. Among those data sets, items such as price, foundry information, when a font was produced, when a font was purchased, the number of glyphs and language support are 'structured data' which is frequently handled in existing economic research. On the other hand, font preview images, the most important element in font marketing, are 'unstructured data'. The first step of this research was to decide how to structure this unstructured data. Assuming that market participants would be attracted to pangram◆◆◆ images more than individual alphabet images, we digitized them. And among machine learning◆◆◆◆ algorithms, I borrowed the facial recognition algorithm developed by a Google researcher. To digitize a font image means to train a machine to recognize the font image. It is called 'classification' issue to tell handwritten 2 and 3 in machine learning. My research needed a much more elaborate algorithm because each letter form had to be distinguished. That's why I applied the facial recognition algorithm. Kristen Grauman, the coauthor of the paper and a machine learning expert, greatly helped me with this process.

The facial recognition algorithm is a neural network algorithm. This algorithm is to make a mathematical model similar to the structure of the brain's neural network; input a pangram image's pixel values and then process them as digit string in a way that human eyes receive visual data and the brain consequently processes that information. That digit string is called embedding, a term to frequently appear in this study. To put it simply, it is to give coordinate values of space to each font. We can calculate the distance between fonts with the coordinate values. The notion of distance here played an important role in the following research. [Fig. 1]

Two sets of research followed. The first one is a trend analysis. I wanted to see coordinate values of new fonts uploaded to MyFonts for the last decade in the producer-side trend

◆ A digital font distributor founded in 1999, merged into Monotype in 2012. https://www.myfonts.com/
◆◆ Font manufacturers, a term used since lead type casting.
◆◆◆ Sentences made by using every alphabet from 'a' to 'z'. Used to identify impressions of a font.
◆◆◆◆ A field to develop and study computer algorithms trained through experience.

[1] Font map using embedding.

research. It was hard to figure out the trend with coordinate space itself for its abstractness so I devised a 'design differentiation index'. When an index value is small, that font is of a general form; if another index value is big, the font is a rather experimental one. I marked differentiation indices of newly made fonts in time sequence. Comparing the mean differentiation value of entire fonts made before 2000 and that of new fonts, interestingly I found new fonts had a higher mean differentiation value. It demonstrates that designers strived to make brand-new fonts as market competition had been fierce already. [Fig. 2]

I looked into font forms that people bought a lot in the consumer-side trend research but I couldn't find any intriguing trend at first. So I sorted out the trend with font purchase licenses. MyFonts has two categories of font purchase licenses—desktop and web. Regardless of the time, fonts with the desktop license had a higher level of differentiation. Ones with the web license were much closer to the mean. Fonts under the desktop license are mostly used for work with a high degree of design freedom such as posters, invitations, etc., while those under the web license are generally applied to

[2] Producer-side trend research.

work which readability counts like websites, UX designs and the like. So I reached a conclusion that people purchased less adventurous fonts in the latter case. [Fig. 3]

The second research is an in-depth producer-side study. An interesting event happened in the 2014 font market. FontFont, a large foundry that Erik Spiekermann and Neville Brody founded in 1990, was merged into Monotype. In other words, FontFont was one of the foundries paying service charge to MyFonts but it became MyFonts itself. I was curious about whether FontFont changed its font styles after this huge change in the market.

Simply put, it would be to see the variation of differentiation index value before and after the merger. So I tried marking index values of fonts released before and after 2014 respectively. Comparison of those values showed a drastic increase of differentiation index immediately after 2014, which lasted about two years. However, the merger could not entirely account for this phenomenon because some event other than the merger could have affected the trend. Thus I needed another control for comparison. The criteria that another foundry had to meet to serve as a proper control were that it would not be merged into another company and had design patterns similar to those of FontFont. The problem was, however, that it was almost impossible to find another foundry satisfying the criteria. So I applied the 'synthetic control method', a statistical technique recently developed in economics. Features of existing foundries were properly mixed up in order to make their differentiation index values move similarly to those of FontFont prior to 2014. And then I observed how those index values varied after 2014. The control synthesized this way showed what would have happened if FontFont had not been merged. In conclusion, the index value of FontFont and the synthesized control greatly varied as of 2014. The difference between these two demonstrates the gap made with the merger. [Fig. 4]

As FontFont was merged into MyFonts and became a part of a big company, resources available to designers expanded. More resources were secured, which offered favorable conditions for attempting diverse experiments. It deepened the level of differentiation, that's my first interpretation. And before the merger, FontFont and MyFonts were competitors. They had made a similar sort of font before 2014 and competed with each other but after the 2014 merger, they came up with distinct fonts as intracompany competition was inefficient. That is the second interpretation.

[3] Consumer-side trend research.

How is image embedding related to word embedding? According to my research, fonts that seem similar to a designer should have similar coordinate values as well. I wanted to verify it. To this end, images with similar coordinate values should be grouped and then I had to ask a designer whether they were actually similar. However, this was impracticable. So I used hashtags. Fortunately, each font on MyFonts is hashtagged with 30–100 adjectives added by its users. Those tags are words and reflections of feelings that an economic subject has when seeing that font. Thus I tried comparing whether coordinate values were related which were marked with images by using information from that word and machine learning. So I applied a neural network algorithm to text data. When coordinate value made out of image embedding and that out of word embedding has a similar distribution, they can be regarded as sharing similar information. In that case, the image embedding covered by my research can be seen as related to the impression which a designer has about a font.

Would it be possible to provide users with some search or recommendation tools via embedding? The methodology for making search tools or recommendation tools depends on which data is available. MyFonts has used hashtagging on every font for a long time so that data is available now. As image embedding and word embedding had a similar distribution in my research, those two could be woven together. Searching for a single adjective shows every font in that group altogether. If hashtagging has not been used before, each font should be hashtagged one by one. That's what Adobe actually did. They recruited designers and have them add attributes to every font in the form of crowdsourcing♦. Systematization of this method enables searching. I've once presented a paper on related research at Adobe. As to recommendation tools, they can be produced through machine learning methods. For example, an experimenter keeps showing a machine some fonts generally used respectively for title and text. When a user inputs a circumstance to use a font, that machine can recommend a proper one.

♦ A way by which the producer involves consumers in the production process, to get ideas and utilize those ideas for service.

Treated
Synthetic

0.8
0.7
0.6
0.5
0.4
0.3

2004 2006 2008 2010 2012 2014 2016

[4] Comparison of the index value of FontFont and the synthesized.

Design is relatively microscopic work. To think of users, market and competitors, however, it sometimes needs a macroscopic view. What do you see in this as an economist?

The answer may vary depending on the designer's situation. From a designer's personal perspective, it would not necessarily be desirable to see this market from an economic point of view. It is because too much focus on the market may hinder the designer from being creative. And I also assume a designer should pioneer a market, not follow it. It requires independent thinking out of an economic perspective to lead a market, I guess. However, it's a shame that people in the design field lack a good understanding and experience about the market and overall economy so they often cannot exercise their rights granted such as proper payment or copyright fees. It is important to have some economic viewpoints and knowledge in order to prevent unfair treatment. A design company should be fully equipped with an economic perspective. The company should ensure the rights of designers as their members. I think it is an ideal structure that designers exert their capability with freedom and the company gives them business support based on economic knowledge.

Why did you extract data from bitmap instead of directly utilizing numerical data of a font produced with vectors?

From the standpoint of a researcher, bitmaps can be directly dataficated on a website but vector datafication requires buying a font software followed by reverse engineering process, which is obviously more complex. Other than this matter, a font is a designer's property so legal issues can occur as well to load vector values. That's why I used bitmap data. If a font company does the same work using their own font, the vector approach would also be accessible.

From Today, We: The Graphic Designers' Way of Writing Time and Reading Objects

Nam Sunwoo

Hong Eunjoo Kim Hyungjae
《On Your Mark》
17 February –10 March 2021
AVP Lab

Translation by Hong Khia

Attached to the glass door—the main entrance of the exhibition as well as its starting point—is the bus route of the Namsan Shuttle Bus No. 2. Beyond the glass lies the exhibition space in all white. Looking through the door with the bus route as a frame, the first to grab attention are the objects of various heights which form mountain-like shapes, similar to the Audio Visual Pavilion (AVP) logo which Hong Eunjoo and Kim Hyungjae designed. Unidentifiable objects on a wide pedestal and walls with numbers occupy the exhibition space.

Those that may have expected a showcase of the two designers' past projects could be met with confusion, but eventually the exhibited objects will drag the viewers in with curiosity. For instance, one can find joy in discovering unfamiliar objects such as DIY Matryoshka dolls or coloring sets, and the two-pan balance and weights bring back memories of carefully balancing the weights in Science class. Between the shoehorn and white vase used in funeral homes and the double-sided miniature folding screen may come to mind certain memories from the past.

Only those who are quick to read the handouts and the catalog text upon entrance will notice the fact that the chronological numbers on the wall, the objects on the table, and the text they are reading are somewhat related to each other: The numbers on the wall are time stamps of when the objects were purchased, the catalog text a record of the purchases. Texts on white background may be messages from the vendor or bank, while a gray background may signify messages from delivery. In other words, the objects, numbers, and the text are all part of a single work.

The objects laid out in the namesake work 〈On Your Mark〉 (2021) are objects that inspired the visual characteristics or motions of Hong and Kim's projects. Though the connections may be vague, one can assume that each object is associated with a certain project. However, even with the keenest eye it would be close to impossible to identify which project the leathercraft roller indicates or which the chalk line marker inspired. On the other hand, detailed text elucidating the connections would also not help in convincing the viewers of the associations between the objects and the projects. As if the graphics entered into flat paper and screens were spit back out into the real world, such a scene looks to be a sort of "business secret" written in Hong and Kim's code. The secret, although laid out like a "stolen letter," cannot be decoded. However, this secret document allows viewers to make their own connections. Just pure appreciation is, of course, also possible. The stools around the table seem to welcome it.

Another main component of the exhibition is the

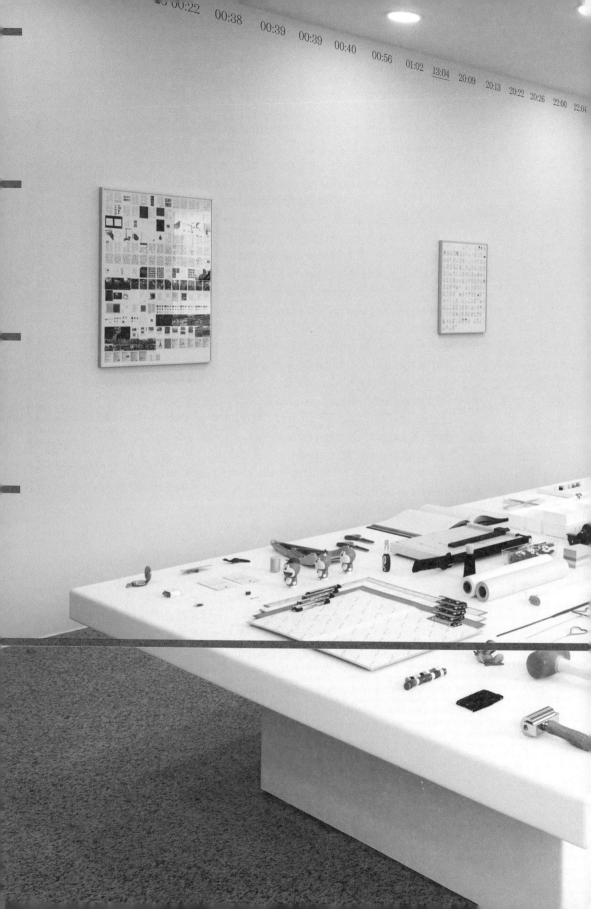

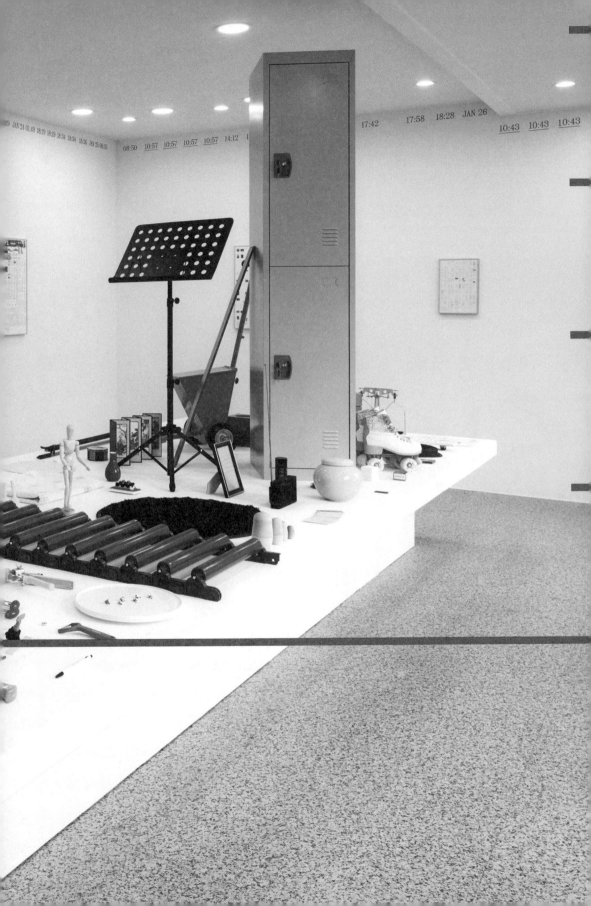

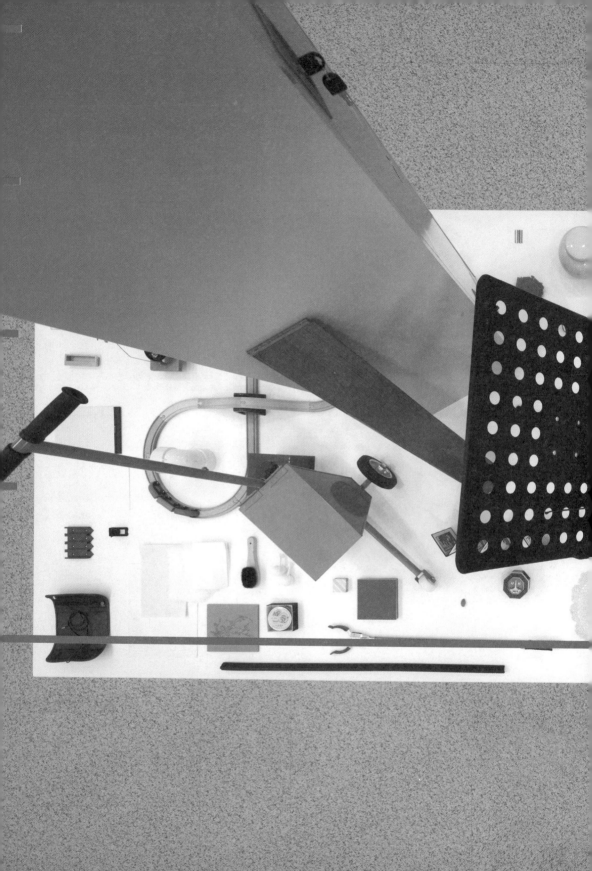

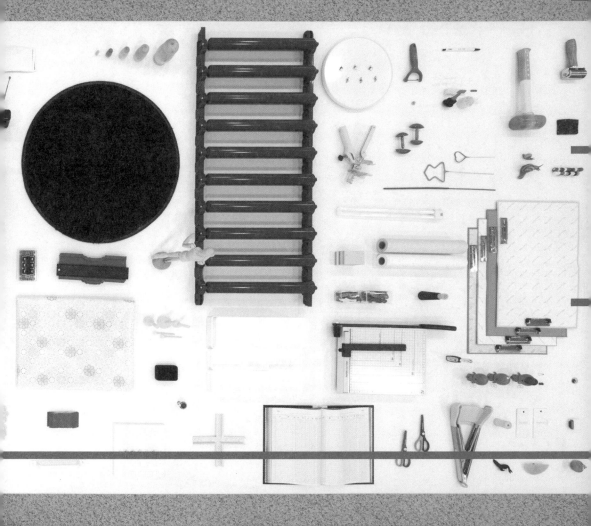

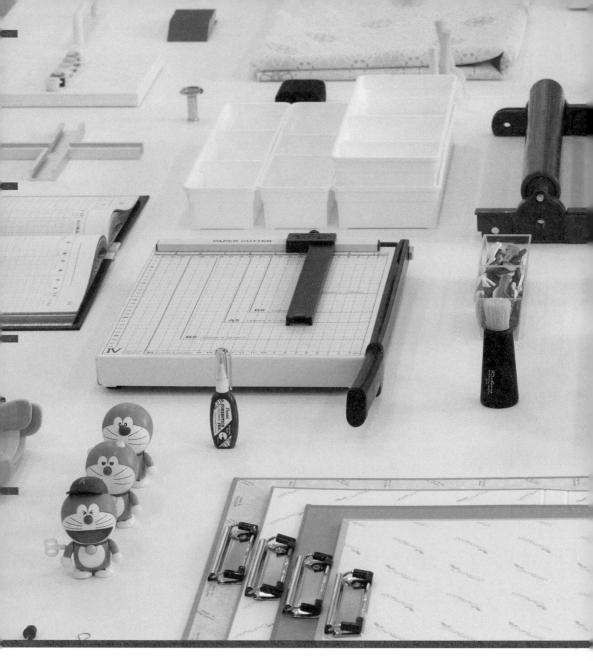

collection of frames hanging on the wall. An important part of
an exhibition celebrating ten years would be assumed to be a
compilation and a list of past works. Yet, a ten-year record of
576 works is placed, not at the place of honor but at the very end
of the exhibition and in the back of the complimentary posters,
printed in the size of a tiny thumbnail. Their major publications,
likewise, are reduced to about 20% of their original size and
framed together on a single sheet of paper. Their concise
approach of wanting to avoid a retrospective manner and their
perception of time are reflected in the frames—like how they
spent mere three weeks to prepare (and order the objects) for the
exhibition that reviews their past ten years.

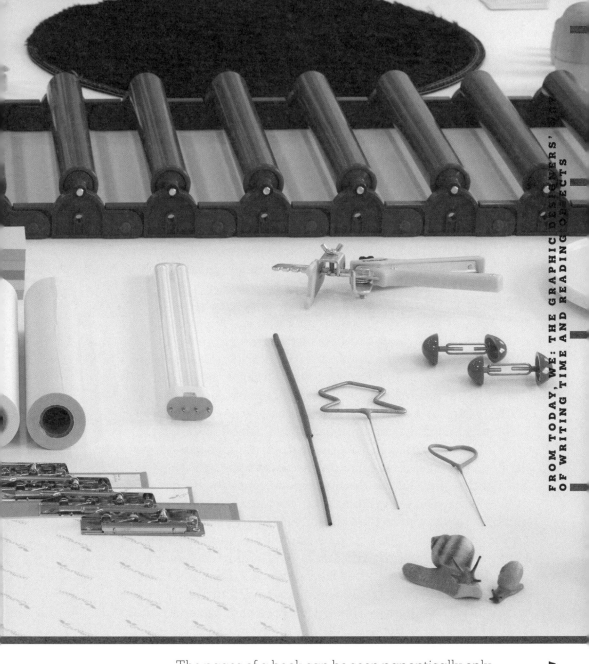

The pages of a book can be seen panoptically only
when the book is not yet published and instead exists only
as data. In this respect, the images on the frames seem to
share the scene that only the designers had the opportunity
to see, in the stages before the physical book is published.
These unmonumental monuments, moreover, generate new
meaning and give life to their work. Seeing every page of
artist Koo Donghee's exhibition catalog 『Night Theft』 (AVP,
2014) laid out next to each other, new discoveries can be
made: the sun and the moon that seemed to be randomly
printed in pages form a line of path, and a simultaneous view
of the illustrations of 『Insecta Erectus』 (G&Press, 2010),

a book on mysterious insects, is an unfamiliar sight.

This exhibition is less a retrospective of Hong Eunjoo and Kim Hyungjae but more a methodology laid out like reminiscences, of the two who have transformed and connected the goals of the collaborators and the ideas and themes of the projects into an articulate visual language, and an experiment of corresponding the route of calling in the objects referenced in their works into reality with the passage they have followed over the past ten years. If ⟨On Your Mark⟩ is a glimpse into the way the two designers read objects, the dense texts and images framed in order, as if to preview the past, might appear to be an analogy for their perception of time.

Let's take a look at the exhibition space. Audio Visual Pavilion, a U-shaped Hanok exhibition space in Jongno which opened in 2013 when new independent art spaces started to emerge, has moved to Yongsan after eight years and is now AVP Lab, an office-styled exhibition space. When many galleries sought to move artworks further away from reality by building a white cube sanctuary, AVP added as little as possible to the Hanok which was formerly a living space so that both the visitors and the artworks could place their feet on the ground. A rectangular space with perfect white walls, AVP Lab also left the windows, lights, and glass door as they were and present projects that apply the conditions to the exhibition. Hong Eunjoo and Kim Hyungjae have been the graphic designers for the identity, website, and exhibitions of AVP from its very beginning. 《On Your Mark》, the first exhibition of the duo on the year of their 10th anniversary, can also come across as an expanded collaboration between long-time partners Hong and Kim and AVP from a different angle. If Hong and Kim turned Hyun Seewon's thoughts on the connection between ordinary objects and thinking and its way of expanding into a book (Hyun Seewon, 『Objects Excursion』, Hyunsil Books, 2014), this time it appears Hong and Kim's way of reading visual characteristics from objects was transformed into the shape of an exhibition in collaboration with Hyun.

On Hong and Kim's website, the menu of the archive of their past projects is titled "(From Today, we…)". Titling the archive with the word "today," the two designers' perception of time is in line with their cyclical and ordinary attitude to be ready to sprint "on their mark" as soon as they have finished their cycle of ten years. The shape of the free-formed but closed path of the bus route on every window adds to this sentiment. The bus that has finished its round stops to take a breath, and on its mark, starts for another.

tat*—
Cutting, Licking, Sticking

Kwon Joonho

Andy Altmann
『tat*–Inspirational Graphic Ephemera』
London: CIRCA
2021

Translation by Hong Khia

Design and Visual Communications I learned in college was an art of producing images, by a business's demand to advertise their products in the industrial society, attractive enough to make customers pay. Instead of "creating"—which is more a romantic word, "producing" was the better word to describe it, and the results were flat and uninteresting graphics that exist only within the boundaries of the analysis of market research and customer preference. Looking back, I realize now that the projects for clients were very much dull and boring because there was no place for my life and my personal experiences to intervene in the work process. Having approached design as a "means" to achieve the demands of the clients rather than as a complete piece of "work", such belief dismissed the attempt to reflect personal experiences into design as immature and romantic.

Stumbling upon Why Not Associates in the school library, however, their experimental works seeming completely ignorant of their clients' demands made me doubt what I had believed. They were complicated and loud, throwing controversial subjects on the table, and had much manual work put in, which seemed far away from the sleek impression of the term "design". I was fascinated with the wild and rough images, growing more curious of the people who created them.

Away from the ever-changing Korean society that replaces history with modern culture, my five years in the UK where posters on buildings and subways are still glued in the old-fashioned way, helped me understand the context of their work. Luckily, after earning my MA, I got to work as an intern at Why Not Associates. I still remember my first impression of Andy Altmann on my first day of work—trying out several designs prior to a photo shoot with a small paper alphabet, giggling and playing around like a kid in design class. Andy was then in the last stages of the project ⟨Comedy Carpet⟩, an installation at the beachfront of Blackpool with typography in various historic styles of Britain's 1,000 most beloved comedians and their jokes. He had a big affection for the project, and from the conversation I had with him near the end of my internship, I could get a sense of his perspective on design.

"Before, I was interested in making artistic posters and images, but now I'm more interested in ordinary objects. I feel it's a shame that the most famous designs are the furthest away from our life. Those may have a nice 'design', but they can only be consumed as products, not something that connects life with design. And that's why ⟨Comedy Carpet⟩ means a lot to me. People can have conversations, eat, drink,

and just have a nice time on the installation. The work is not
a mere art or design piece; it becomes a part of life. That
energy lies in the contexts, not the appearance. The text on
the carpet are jokes that any British would have a laugh with.
I really liked that, so I used every means to make the best out
of it. It's a project for my client, but also for myself."

『tat*–Inspirational Graphic Ephemera』 (hereafter
『tat*』) is a book by Andy Altmann of the graphic ephemera
he found and collected. His scenes of childhood—filled with
excitement on a summer day that Christmas has come early
seeing the colorful smoke coming out of the chimney of a soap
factory, hanging up posters of popular wrestlers and football

players from the 1960s–1970s and doing their impressions, collecting stamps about space, watching Neil Armstrong setting foot on the moon, being fascinated with the design of the typefaces on the textbooks his mother used to teach— are spread out across pages of carefully positioned images and typography.

『tat*』 provides an experience through the beautiful visuals of Altmann's endless love for graphic design in the ordinary. As mentioned in the title of the book, however, the images on 『tat*』 are not works of art by famous designers. "Tat" is used as a derogatory term for low-quality advertisements printed on cheap paper. It is astounding that while

most people would simply throw away tat, for Altmann it is his device for experiencing magic in the mundane. The book argues that depending on which angle you view it from, unexpected beauty can be discovered from the stories of life in the "bad designs". Andy Altmann seems to suggest through this book that designers are not only people who make pretty images for clients but are also those who find beauty in the ordinary, and that perhaps we should pay more attention to the delicate details in life.

A year ago, Altmann closed down Why Not Associates after 33 years of work. I read his interview on preparing for the next step in his life and wanting to do something different and personal. Then it dawned on me that it is natural for 『tat*』, a trace of his passage, to be the starting point of his new journey. Back when I had finished my internship and was struggling to figure out how to make it as a designer back in Korea, Andy told me a story of one of his favorite comedians, Spike Milligan. "We never had a plan, so nothing could go wrong."

He talked about how when he first started out as a designer he worked solely for his own satisfaction, but as he started his studio he was freed from the compulsion of forcing himself to do everything by himself. Now, as designer Andy Altmann, not Why Not Associates, 『tat*』 shows the cultural contexts which became the influence of his works. Andy is my biggest influence as a designer and is steps ahead of me in this journey called life; I wait once again with excitement, wondering where his eyes will set next.

Upside Down

Lee Jaemin, Maria Doreuli, Ha Hyeongwon,
Lee Hwayoung·Hwang Sangjoon, Park Jinhyun,
Kim Youngsun, Jang Sooyoung, Syn Gunmo,
Park Shinwoo, Kim Hyunjin, Park Chulhee, An Mano

New Man's logo, designed in 1969 by Raymond Loewy, is an "ambigram"♦ that is read in the same letter when flipped up and down. He created an exquisite structure by applying the principle of point symmetry to the geometric shapes of 'N' 'W' and 'a' 'e'. New Man's logo was used unchanged for about 50 years until 2020, giving the impression of a "new" brand with the act of reading upside down.

In addition to Raymond Loewy, many creators have experimented with the possibility of form through changes in gaze. As an extension of the experiment, the "Collection" planned a 〈Upside Down〉. It contains twelve character experiments, including letters that are read in the same or different meaning when upside down, letters that organically combine the strokes of the Hangeul and Latin alphabets, and letters that express the shape of sounds spreading in all directions. I would like to share the visual pleasure of flipping and thinking with the letters that contain clues that the change of gaze can expand to the change of thinking.

♦ Ambigram is a letter design that can be read in many ways depending on the direction of view. Since Douglas Hofstadter, an American cognitive scientist, first mentioned it, it has been tried and applied in various logos and graphic designs.

Lee Jaemin
(the Quick and the Dead)

Quick not only means "fast", but as a noun, it also has the meaning of raw flesh (under nails or light skin) and the most emotionally sensitive part. It is also a dead word meaning "living people" in a similar context. "And sitteth on the right hand of God the Father Almighty; From thence he shall come to judge the quick and the dead." It is a phrase from the Apostles' Creed. There is a movie with the same name. Directed by Sam Raimi, Sharon Stone, Gean Hackman, Russell Crowe, and (young) Leonardo Dicaprio appeared. I liked the title with the word Quick, which has more ambiguous meanings, than the movie itself. I briefly thought of using this phrase as the title of the ⟪Typojanchi⟫, which is about 'Typography and Life', but the idea was discarded for many other reasons. I think it's a little waste to just throw it away, so I use it through this page.

Maria Doreuli
(Wow & Mom)

「FlicFlac」is an organic, soft and rhythmic typeface. The main element of the typeface may remind you of water drops and it performs in the same organic way as water naturally flows. The elements tighten and come together in the middle of each letterform, without touching. Maintaining FlicFlac's character throughout means pushing the limits of legibility. Maybe sometimes you would have to guess a letter from the context.

Ha Hyeongwon
(Digda! (디그다))

Digda! Digda! Even if you flip it upside down, it is still Digda. The cute Pokemon Digda is expressed in ambigrams.

Lee Hwayoung·
Hwang Sangjoon
(옹네아어 (Yes Yes Yes Yes))

Yes? Yes! Yes? Yes! Yes? Yes! Yes? Yes!

Park Jinhyun
(「Knowledge (앎)」 & 「Unknowingness (모름)」)

It seems that "knowledge" is clear and "unknowingness" is an unclear concept. However, if you look upside down, there is a solid "unknowingness" in the "knowledge". It becomes clear when you know what you don't know. "When you know a thing, to hold that you know it; and when you do not know

a thing, to allow that you do not know it; this is knowledge. —『the Analects of Confucius』"

Kim Youngsun
⟨BRAVE⟩

I worked on the phrase "BRAVE!" in an ambigram so that I could be encouraged in any difficult situation. Through solid strokes and tilting, it expressed the desire to be courageous with a firm heart without bending despite unfavorable and unreasonable situations.

Jang Sooyoung
⟨Moneari (모내리)⟩

Designed a Hangeul ambigram as cursive writing. "Moneari" is the name of the Ssambab restaurant located in Dongducheon.

Syn Gunmo
(Cicada's Singing)

The sound of cicada's singing(맴 맴) along the river(강가) in summer. Just as the direction of the river viewed from this side and the other side is different, this work also differs according to the viewing direction.

Park Shinwoo
⟨LOVE & 사랑⟩

The ambigram full of love.

Kim Hyunjin
(Joke & 장난)

It took three weeks to come up with this joke. Do you get it?

Park Chulhee
(Victim Mentality (피해의식))

⟨Victim Mentality⟩ is a logo-type for the namesake metal band. In 2013, I was a student who was able to develop a long-term work. After four weeks of drawing the four letters of "피해의식" throughout two practice books, the strokes were later connected in my head and became an ambigram. I love the memory of that time.

An Mano
(Long-awaited (아기다리 고기다리))

Long-awaited. (아기다리 고기다리). It is a joke my mother used to tell me when I was young.

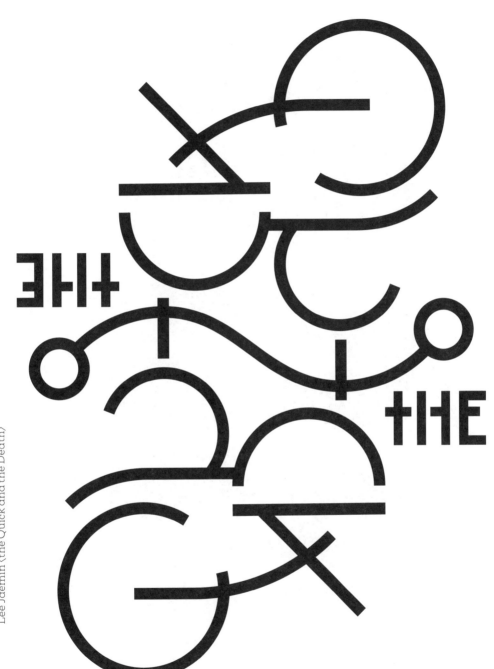

Lee Jaemin 〈the Quick and the Death〉

Ha Hyeongwon 〈Digda:(디그다)〉

〈디그다:〉 하형원

¿아!
¿ ¡아! ¡
¿ ¡네! ¡
¿ ¡응 ¡

〈웅·네아어(Yes Yes Yes Yes)〉Lee Hwayoung·Hwang Sangjoon

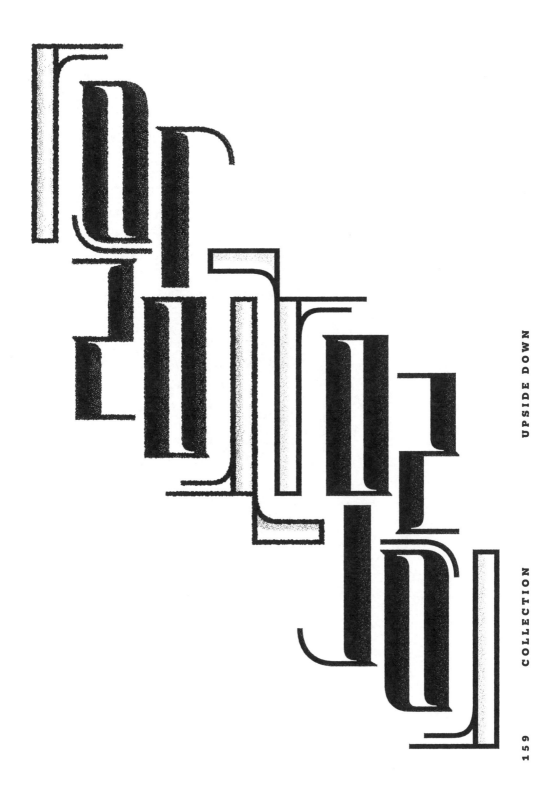

박진현 ⟨「앎」과「모름」⟩

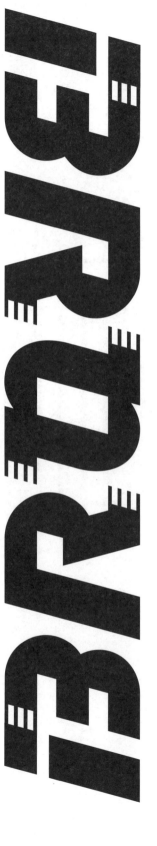

김영선 〈BRAVE〉

Kim Youngsun 〈BRAVE〉

수필 뒤틀어 보기

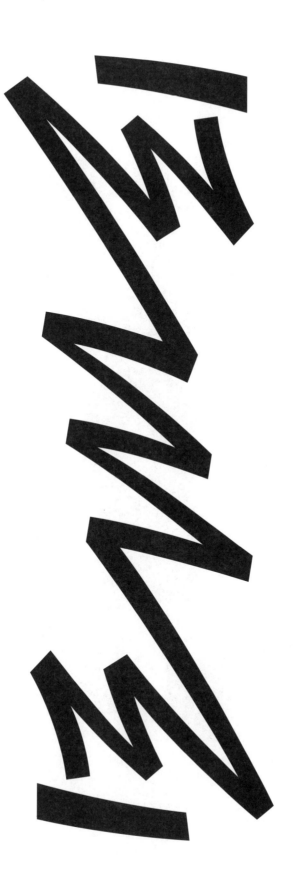

Jang Sooyoung 〈Monaeri〈모내리〉〉

김현진 〈장난과 Joke〉

Park Chulhee 〈Victim Mentality (피해 의식)〉

UPSIDE DOWN

COLLECTION

An Mano 〈Long-awaited〈아기다리 고기다리〉〉

안마노
〈아기다리 고기다리〉
아 기다리고 기다리(던 그대). 어렸을 적 어머니가
던지시던 농담이다.

박철희
〈피해의식〉
〈피해의식〉은 동명의 메탈밴드를 위한 로고
타입 작업이다. 작업을 했던 2013년 당시에
학생이었기 때문에 해당 작업을 길게 발전시킬
여력이 있었다. 4주 동안 '피해의식'이라는
네 글자를 연습장 두 권에 걸쳐 주욱 그리다
보니 나중엔 머릿속에서 획들이 연결되면서
앰비그램이 되었다. 그때의 기억을 참 좋아한다.

김현진
〈장난과 Joke〉
이 농담을 떠올리는 데 걸린 시간 3주.

박신우
〈사랑과 LOVE〉
사랑으로 꽉 찬 앰비그램.

신건모
〈맴맴〉
여름철 강가에 울려 퍼지는 매미 울음소리.
이편과 저편에서 바라보는 강물의 방향이 다르듯이,
이 작업도 보는 방향에 따라 차이가 있다.

장수영
〈모내리〉
흘림체 한글 앰비그램을 제작했다. '모내리'는
동두천에 있는 쌈밥집 이름이다.

김영선
〈BRAVE〉
어떤 힘든 상황에서든 용기를 낼 수 있도록
'BRAVE!'라는 문구를 앰비그램으로 작업했다.
단단한 획과 기울기를 통해 불리하고 불합리한
상황에도 굽히지 않고 단단한 마음으로 용기를
내길 바라는 마음을 담았다.

박진현
「「앎」과 「모름」」
'앎'은 분명하고, '모름'은 불명확한 것처럼
보이지만, 뒤집어보면 '앎'에는 견고한 '모름'이
존재한다. '모르는 것'을 확실하게 인지할 때,
'앎'도 비로소 명료해진다. "안다는 것을 안다고
하고, 모르는 것을 모른다고 하면, 이것이 아는
것이다." —『논어』

이화영·황상준
〈응네아어〉
응? 응! 네? 네! 아? 아! 어? 어!

하형원
〈디그다!〉
디그다! 디그다! 거꾸로 뒤집어도 디그다.
귀여운 포켓몬 디그다를 앰비그램으로 표현했다.

마리아 도렐리
(Mom & Wow)
「플릭플락(FlicFlac)」은 유기적이고 리듬감
있는 글자체이다. 글자체의 형태는 물방울을
연상시키며, 각 문자의 중간에서 간격을 두고
함께 모인다. 「플릭플락」은 가독성의 한계를
실험한다. 아마도 가끔은 문맥으로 의미를
추측해야 할 수도 있다.

이재민
(the Quick and the Dead)
Quick은 '빠른'이라는 뜻뿐 아니라, 명사로서
(손톱 밑이나 연한 피부, 상처 등의) 생살,
감정적으로 가장 민감한 부분, 급소 등의 뜻도
갖고 있으며, 비슷한 맥락으로 '살아 있는
사람들'을 의미하는 고어이기도 하다. "하늘에
오르사 전능하신 하나님 우편에 앉아 계시다가
저리로써 산 자와 죽은 자를 심판하러 오시리라."
사도신경에 나오는 구절이다. 영문에서는 이
'산 자와 죽은 자'를 the Quick and the Dead
라고 표현한다. 같은 이름을 가진 영화도 있다.
샘 레이미가 감독하고 샤론 스톤, 진 핵크만,
러셀 크로우, 그리고 (앳된 시절의) 레오나르도
디카프리오 등이 출연했다. 영화 자체보다도
Quick이라는 단어의 중의적인 의미가 잘 담긴
제목이 좋았다. 여러 가지 이유로 이 구절을
문자와 생명을 주제로 하는 이번 《타이포잔치》
의 전시 제목으로 사용할 생각을 잠시 했었는데,
뒤집어 보아도 같은 글자로 읽히는 앰비그램을
만들기에도 좋은 재료인 것 같다.

레이먼드 로위(Raymond Loewy)가 1969년에 디자인한 뉴맨 (New Man)의 로고는 뒤집어 보아도 같은 글자로 읽히는 '앰비그램 (Ambigram)'*이다. 그는 'N' 'W'와 'α' 'e'의 기하학적 형태에 점대칭의 원리를 적용해 절묘한 구조를 만들었다. 뉴맨의 로고는 뒤집어 읽는 행위를 더해 '새로운' 브랜드의 인상을 풍기며 2020년까지 약 50년간 변함없이 사용되었다.

　　　레이먼드 로위 이외에도 많은 창작자는 시선의 변화를 통해 형태의 가능성을 실험해왔다. 그 실험의 연장으로 이번 '수집'에서는 〈뒤집어 보기〉를 기획했다. 위아래로 뒤집었을 때 같은 또는 다른 뜻으로 읽히는 글자, 한글과 라틴 문자의 획을 유기적으로 결합한 글자, 사방에서 울리는 소리의 형태를 배열로 표현한 글자 등을 포함해 열두 개의 글자 실험을 담았다. 시선의 변화가 사고의 변화로 확장될 수 있는 실마리를 담은 글자와 함께 뒤집어 보고 생각하는 시각적 쾌감을 나눠보고자 한다.

◆ 앰비그램은 보는 방향에 따라 여러 가지 방식으로 읽을 수 있는 글자 디자인이다. 미국의 인지과학자 더글러스 호프스테터(Douglas Hofstadter)가 처음 언급한 이래 각종 로고와 그래픽 디자인에서 다양하게 시도되고 적용되어 왔다.

뒤집어 보기

안마노, 박철희, 김현진, 박신우, 신건모,
장수영, 김영선, 박진현, 이화영·황상준,
하형원, 마리아 도렐리, 이재민

섬세하게 배치된 이미지와 타이포그래피를 통해 펼쳐진다.

『tat*』은 일상 속에 녹아든 디자인에 대한 그의 무한한 애정을
황홀할 정도로 아름다운 시각물을 통해 경험할 수 있는 책이다.
재미있는 사실은, 책의 제목과 부제에서 밝히고 있듯, 『tat*』에 실린
이미지는 유명한 디자이너가 만들어낸 '디자인적' 완성도를 지닌
작품이 아니라는 것이다. 'tat'을 번역하자면 '찌라시' 정도가 될 텐데,
'찌'라는 된소리가 주는 어감과 함께 싸구려 종이에 인쇄된 낮은
수준의 광고물을 폄하하는 용도로 사용되는 단어다. 누군가에는
일회용으로 쓰이고 버림받는 그 지라시가, 그의 눈에는 일상 속의
마법을 경험할 수 있게 해주는 도구로 보여질 수 있다는 것이 놀랍다.
이 책은 '나쁜 디자인' 안에 담겨 있는 일상의 이야기를 어떤 시선으로
바라보는가에 따라, 생각지 못한 아름다움을 발견할 수 있다는 것을
보여주고 있다. 디자이너는 누군가의 의뢰를 받아 아름다운 이미지를
만들어 내는 사람이기도 하지만, 아무도 관심 갖지 않는 버려지는
것들에서 아름다움을 발견해 내는 사람이기도 하다는 것을, 좀 더
세심하게 일상의 아름다움을 관찰하는 시선을 가질 것을 그는 『tat*』을
통해 제안하고 있는 것 같다.

그는 작년에 삼십삼 년 동안 이끌어 오던 와이낫어소시에이츠의
운영을 중단했다. 이제는 삶의 마지막을 준비하며 새롭고 개인적인
것을 해보고 싶다는 그의 인터뷰를 봤다. 그가 새롭게 준비하는 여정의
시작이 그의 디자인의 궤적을 돌아보는 『tat*』인 것은 어쩌면 당연한
일이라는 생각이 들었다. 인턴을 마치고 한국으로 돌아가 디자이너로서
어떻게 살아야 할지 막막해하던 나에게 그는 자신이 가장 좋아하는
코미디언 중 한 명인 스파이크 밀리건(Spike Milligan)의 이야기를
들려주었다. "우리는 한번도 계획한 적이 없다. 때문에 계획이 틀어질
일도 없었다. (We never had a plan, so nothing could go wrong.)"

앤디 알트만은 디자이너로 처음 경력을 시작하며 온전히 자기
자신의 만족을 위한 작업을 했지만, 스튜디오를 운영하며 모든 작업을
스스로 해내야 한다는 강박에서 조금은 자유로워졌다고 말했다.
이제 다시 와이낫어소시에이츠가 아닌 디자이너 앤디 알트만으로서
그는 『tat*』을 통해 그의 작업이 어떤 문화적 맥락으로 만들어졌는지
보여준다. 그에게 가장 큰 영향을 받은 디자이너이자 삶이라는
길고도 짧은 여행의 후배로서 일상을 바라보는 그의 시선이 어디에서
머무르게 될지 다시 한번 설레는 마음으로 기다리게 된다.

위해 경험과 기술을 모두 동원했어요. 클라이언트를 위한 작업인
동시에 개인 작업이기도 해요."

　　　『tat*-Inspirational Graphic Ephemera』(이하 『tat*』)는
앤디 알트만이 수집하고 발견한 아름다운 시각물로 쓰인 그의
자서전과도 같은 책이다. 어느 여름날 비누 공장의 굴뚝에서
뿜어내는 형형색색의 향기로운 조각을 보며 크리스마스가 빨리
왔다며 좋아하던, 1960-1970년대 인기 있던 레슬러와 축구 선수의
포스터를 방문에 붙여 놓고 그들을 따라 하던, 닐 암스트롱의 달
착륙을 보며 우주에 관련된 엽서를 모으던, 교사였던 엄마의 수업
교재에 사용된 글자의 조형미에 매료되었던 그의 유년기 풍경이

물건에 더 관심이 많아요. 유명하고 좋은 디자인일수록 일상과
디자인의 거리를 더 벌려 놓는 것 같아 안타까워요. '디자인적'으로
멋진 작업은 상품으로 소비될 뿐, 삶과 디자인을 연결하지 못했어요.
그래서 저에게는 최근에 작업했던 〈코미디 카펫〉이 큰 의미가
있어요. 사람들이 그 설치물 위에서 대화를 나누고, 먹고, 마시면서
즐거운 시간을 보낼 수 있거든요. 그 작업은 단순히 예술 혹은 디자인
작업으로 분리되어 존재하는 것이 아니라, 일상의 한 부분이 될 수
있다고 생각해요. 그런 힘은 외형보다 내용에서 온다고 할 수 있어요.
그 카펫에 설치된 텍스트는 영국인이라면 모두가 웃으면서 즐길 수
있는 농담입니다. 저는 그 내용이 너무 좋았고, 작업에 잘 담아내기

대학에서 배운 시각 디자인이란 산업사회에서 상품을 홍보하기 위해
기업의 요구에 따라 소비자의 지갑을 열 수 있는 매력적인 이미지를
만들어 내는 작업이었다. 창작이라는 괜스레 마음을 설레게 하는
낭만적인 단어보다는, 생산이라는 기계적인 단어가 더 어울렸던
그 작업의 결과물들은 시장조사와 고객의 취향 분석에 근거한 도표
안에서만 존재하는 딱딱하고 재미없는 도식이었다. 이제 와 돌이켜
보자면 클라이언트를 위한 작업이 그토록 지루하고 재미없던
이유는 그 작업의 모든 과정에 '나'라는 개인이 살아온 궤적과 경험이
반영될 조금의 틈도 없었기 때문이었다. 디자인을 그 자체로 하나의
완결성을 갖는 '작업'으로 보기보다는 클라이언트가 추구하고자 하는
목적을 이루어줄 '수단'으로 보는, 그 신념과도 같은 믿음이 개인의
경험을 디자인에 반영하고자 하는 움직임을 철없고 낭만적인 시도로
치부했던 근거였을 것이다.

우연히 학교 도서관에서 만난 '와이낫어소시에이츠(Why Not
Associates)'가 만들어낸, 마치 고객의 요구를 철저히 무시한 것만
같은 실험적인 작업은 그런 믿음의 근간을 뒤흔들기에 충분했다.
그들의 작업은 복잡하고 시끄러웠으며, 논쟁적인 주제를 지면 위에
무심하게 툭 던져 놓고 있었고, '디자인'이라는 매끈한 단어와는
어울리지 않을 것 같은 수작업의 흔적을 그대로 품고 있었다.
그 거칠고 투박한 이미지에 깊게 매료됐고, 그 작업을 만들어낸
사람에 대한 궁금증 역시 커졌다.

과거의 유산을 현대의 문화로 대체해 하루가 다르게 변화하는
한국 사회를 떠나, 여전히 대형 포스터를 풀칠해서 건물 외벽과
지하철 통로에 도배하듯 붙이는 영국에서의 5년간의 경험은 그들의
작업 맥락을 조금은 이해할 수 있게 해주었다. 대학원 졸업 후 운이
좋게도 와이낫어소시에이츠에서 인턴으로 일하게 되었다. 첫 출근
날, 어느 프로젝트의 촬영을 앞두고 종이로 접은 작은 알파벳 모형을
바퀴가 달린 의자를 밀면서 화면을 구상해보는, 그리고 그 과정이
너무 재미있는지 키득거리며 장난을 치는 모습이 디자인을 공부하는
학생 같았던 앤디 알트만의 첫인상이 아직도 기억난다. 그때는 앤디
알트만이 영국인이 사랑하는 천 명의 코미디언과 그들의 유머를
시대적 특징을 가득 담은 타이포그래피로 블랙풀(Blackpool)의
해안가에 설치한 〈코미디 카펫〉 프로젝트를 마무리하고 있는
시점이었다. 그는 이 작업에 많은 애착을 가지고 있었는데, 인턴을
마치며 그와 나누었던 대화에서 그가 디자인을 바라보는 시각을
고스란히 볼 수 있었다.

"예전에는 예술적으로 보이는 포스터나 이미지를 만드는
것에 관심이 많았는데, 요즘은 일상생활에서 쉽게 접할 수 있는

tat*—
오리기, 풀칠하기, 붙이기

권준호

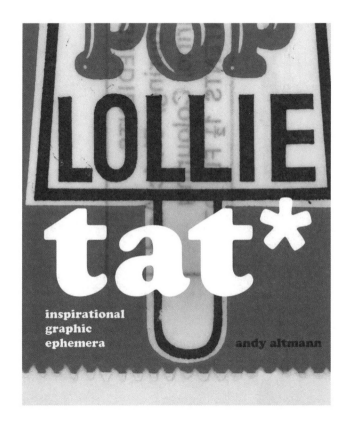

앤디 알트만(Andy Altmann)
『tat*–Inspirational Graphic Ephemera』
런던: CIRCA
2021

궤를 같이한다. 유리 창문마다 붙은 순환 버스 노선이 만들어 내는
자유로워 보이지만 잘 짜인 닫힌 도형 또한 이러한 정서를 이어간다.
한 바퀴를 돌아온 버스는 한숨을 돌린 후 제자리를 확인하고, 다시
다음 한 바퀴를 시작한다.

도록 『밤도둑』(시청각, 2014)의 페이지들을 한 번에 조망했을 때 책의
군데군데 섬처럼 자리했던 해와 달의 궤적이 연결되어 흥미로운
운동성을 만들어 내 거나, 미지의 곤충에 대한 책 『Insecta Erectus』
(G&프레스, 2010)의 삽화를 한꺼번에 접할 때 시각적 생경함이
배가되는 등 의외의 새로움이 발견되는 것이다.

　　이 전시는 홍은주 김형재의 그간 작업물을 감상하는
회고전이라기보다는 그래픽 디자이너로서 협업자의 지향점과
프로젝트의 개념 및 주제를 명료한 시각 언어로 전환하고 연결해 오던
두 사람이 중간 후일담처럼 펼쳐놓는 일종의 번역 방법론이자, 그간의
작업에서 개념적으로 참조했던 사물을 실제 눈앞으로 불러오는
경로를 지난 10년의 행보와 대응시켜보는 실험이라고 볼 수 있다.
〈제자리에〉에서 두 디자이너의 사물 읽기의 방식을 엿보았다면,
과거를 미리 보기 방식으로 배열한 액자 속의 조밀한 화면은 그들이
시간을 인식하는 방법을 유추할 수 있는 장치처럼 보이기도 했다.

　　전시가 열린 공간을 살펴보자. 신생 공간이 막 등장하기
시작하던 2013년, 종로의 디근자 한옥 전시 공간으로 개관한
'시청각'은 8년이 지난 현재 용산의 빌라로 자리를 옮겨 오피스이자
전시장인 '시청각랩'으로 운영되고 있다. 많은 미술 공간들이
흰 입방체의 지성소를 지어 작품을 현실에서 떼어놓고자 할 때
시청각은 생활공간이었던 한옥의 형태에 최소한의 장치만을 더해
관객과 작품 모두를 땅에 발 딛게끔 했었다. 반듯한 흰 벽을 갖춘
장방형의 시청각랩 또한 장식적인 창문과 조명, 유리문을 그대로 둔
채 이를 전시의 환경이자 조건으로 삼은 프로젝트를 선보이고 있다.
홍은주 김형재는 시청각의 개관 시점부터 시청각의 아이덴티티와
홈페이지를 포함하여 이곳에서 열린 많은 전시의 그래픽 디자인을
만들어 왔다. 활동 10년이 되는 해에 홍은주 김형재가 처음으로 함께
갖는 전시 《제자리에》는 장기 협업자인 홍은주 김형재와 시청각이
평소와는 다른 구도에서 가져보는 확장된 협업으로서의 의미도 커
보였다. 현시원이 말하고 싶었던 사물과 사유의 연결과 확장 방식을
홍은주 김형재가 책이라는 그릇에 담도록 협업했다면(현시원,
『사물유람』, 현실문화, 2014), 이번에는 홍은주 김형재가 사물에서
읽어내는 시각적 특질이 현시원과의 협업을 통해 전시라는 몸을 입은
것처럼 보이기도 한다.

　　홍은주 김형재는 그들의 홈페이지에 그동안 작업했던
프로젝트를 열람하는 메뉴 제목을 '(오늘부터 우리는...)'이라고
적었다. 아카이브에 '오늘부터'라는 수식어를 붙이는 두 디자이너의
시간에 대한 태도는 10년을 돌자마자 다시 '제자리에' 구령에
맞추어 달릴 준비를 하는 그들의 순환적이고 일상적인 작업 태도와

뒷면에 놓여있을 뿐이다. 주요한 단행본 작업물 역시 20%의 크기로
축소해 각 한 장의 종이 위에 모아 벽에 걸었다. 회고적인 분위기를
피하려는 간결한 태도와 시간을 인식하는 방식은 지난 10년을 전시를
준비(하느라 사물들을 주문)했던 3주가량에 유비했던 것처럼 이
액자들에서도 드러난다.

　　　책의 페이지들을 한눈에 모아 볼 수 있는 것은 책이 아직 데이터
상태로만 존재할 때이다. 그런 의미에서 이 액자들은 물리적인 책이
만들어지기 전, 디자이너만 볼 수 있었던 장면을 관객과 공유하는
것 같기도 하다. 또한 이 기념비적이지 않은 기념비들은 그들의
작업물에 또 다른 의미와 생명력을 발생시킨다. 구동희 작가의 전시

홍은주 김형재의 '영업 비밀'과도 같다. 그 비밀은 '도둑맞은 편지'처럼
버젓이 놓여있지만 아무도 찾아낼 수 없는 것이다. 그러나 번역은
불가능하지만, 이 비밀문서에서부터 나만의 연결 짓기를 새로 시작해
볼 수 있을 것이다. 물론 오롯한 감상도 가능하다. 군데군데 친절히
놓인 의자는 그러한 목적들을 위해 마련된 것으로 보였다.

　　전시의 다른 한 축은 벽에 붙은 액자이다. 여느 10주년 전시를
상상할 때 전시에서 가장 큰 비중을 차지할 법한 것은 그간의
작업물들과 그 목록이다. 그러나 추린 것만 576점인 그들의 10년
기록은 전시장에서는 상석은커녕 줄어든 미리 보기 항목처럼 작게
인쇄되어 전시 동선 마지막 자리와 증정용으로 마련된 포스터의

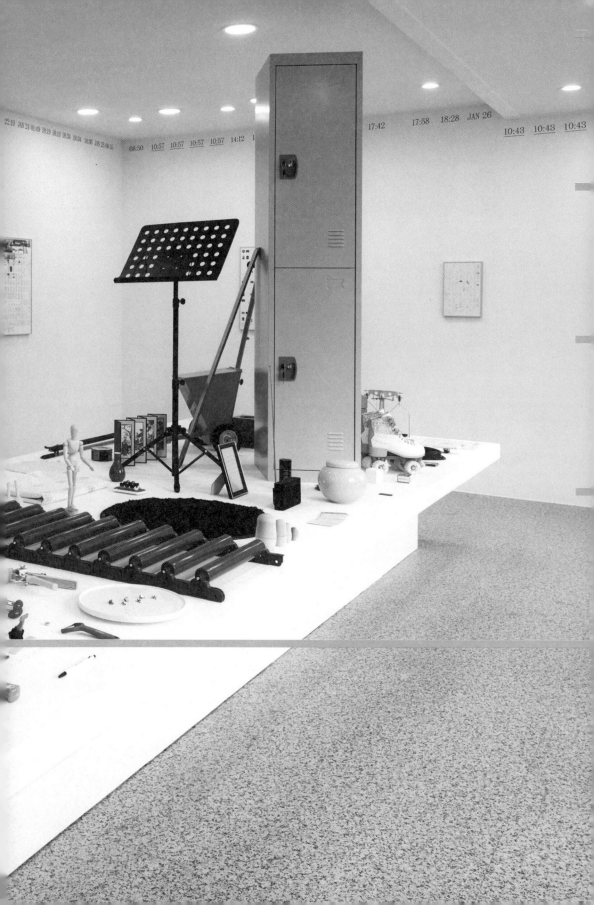

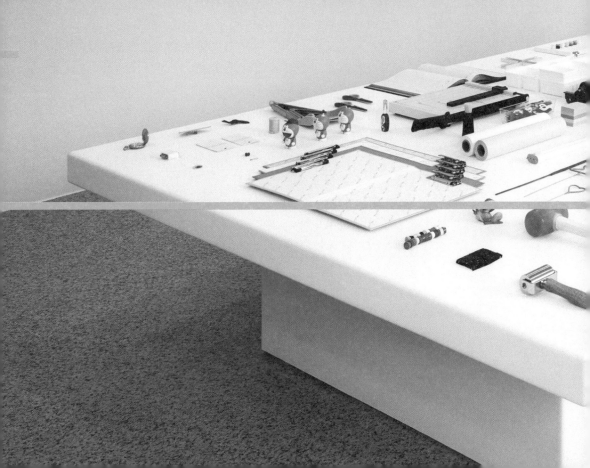

공간의 입구이자 전시의 시작인 유리문에는 남산 순환 버스 02번의 루트가 부착되어 있고, 그 너머로 흰 전시장이 보인다. 이 순환 버스의 동선을 프레임 삼아 전시장 안을 들여다보니, 홍은주 김형재가 만든 시청각의 아이덴티티처럼 산맥 모양을 형성하고 있는 각기 다른 높낮이의 사물들이 가장 먼저 눈길을 끈다. 전시장 한가운데 강한 존재감을 갖고 자리한 것은 커다란 좌대 위에 올라간 영문을 모를 사물들과, 이를 둘러싸고 있는 벽에 붙은 숫자들이었다.

두 디자이너의 작업물을 망라해 보리라 기대하고 방문했다면 다소 당황스러웠을 관객은 이내 각 사물이 가진 외형적인 매력과 몇몇 사물이 각각 다른 이유로 불러일으켰을 개인적인 기억, 용도를 알아내고 싶은 호기심 등에 빠져 이 사물들을 한참 바라보게 될 것이다. 예를 들어 마트료시카를 직접 그려 사용하거나 선물할 수 있도록 하는 DIY 목형이나 채색 키트는 모르던 물건을 발견하는 즐거움을 주고, 오랜만에 본 양팔 저울과 여러 무게의 추는 과학 시간에 하나씩 조심스레 올려보던 아슬아슬한 감각을 불러일으킨다. 장례식장에서 사용하는 구두 집게와 흰 도자기, 앞뒷면의 온도 차가 너무 큰 미니어처 병풍은 알록달록한 사물 사이에서 유독 어떤 날의 기억을 떠올리게 할지도 모르는 일이다.

전시장에 들어가자마자 핸드아웃과 카탈로그의 텍스트 정보부터 꼼꼼히 살피는 관객이라면 시간 순서대로 배치된 벽의 숫자와 테이블의 사물들, 그리고 지금 읽고 있는 텍스트가 모종의 연관을 가졌다는 사실을 알아챌 것이다. 벽면의 숫자들은 테이블 위의 사물들을 구입하고 수령한 시간이고 카탈로그의 빼곡한 텍스트는 그것의 기록이라는 점, 아마도 흰 바탕에 쓰인 것은 판매사나 결제기관에서 온 메시지이고 회색 바탕에 쓰인 것은 배송사에서 온 것이라는 점, 그리고 이 사물과 벽의 숫자와 손에 든 텍스트가 한 작업이라는 점 등을 말이다.

전시와 동명의 작업 〈제자리에〉(2021)를 위해 놓인 사물들은 홍은주 김형재가 작업물의 시각적 특성이나 운동성에 대한 힌트를 얻었던 사물들이라고 한다. 드러내 설명하고 있지는 않지만, 이 사물들은 각각 그들의 특정한 작업물과 연결되어 있을 테다. 그러나 아무리 영민한 관객도 가령 가죽을 고르게 펴는 롤러가 어떤 작업물을 지시하는지, 운동장에 분필 가루를 분사해 선을 내는 일명 '라인기'의 어떤 특성이 어떤 작업에 힌트를 주었는지 포착하기란 거의 불가능한 일이다. 반대로 아무리 상세하고 설득력 있는 설명을 붙인다 해도 사물과 작업 사이의 연관성을 관객에게 납득시키는 것 또한 불가능하다. 종이나 스크린의 평면으로 수렴했던 작업물이 다시 현실에 뱉어놓은 듯한 이 일련의 풍경은 해독 불가능한 언어로 쓰인

오늘부터 우리는:
그래픽 디자이너의
시간 쓰기와 사물 읽기

남선우

홍은주 김형재 《제자리에》

홍은주 김형재
《제자리에》
2021. 2. 17–3. 10
시청각랩

발표하기도 했습니다. 추천툴 같은 경우는 기계 학습 방식을 통해
제작할 수 있습니다. 예를 들면 제목과 본문에 주로 사용하는 폰트를
기계에게 계속 보여주고 훈련하면 나중에 사용하려는 상황을
입력하면 기계가 추천해줄 수 있게 되는 거예요.

디자인은 상대적으로 미시적인 작업이지만 시장을 생각하면 때로는 거시적인 관점이 필요한데요, 경제학자로서 이런 상황을 어떻게 보고 있는지요.

디자이너가 처한 상황에 따라 답이 달라질 것 같습니다. 디자이너 개인의 입장에서는 경제적인 관점으로 이 시장을 생각하는 게 꼭 좋은 방향이라고 생각하지 않습니다. 그 이유는 시장을 중요하게 고려하게 되면 독창적인 작업을 하기 어려울 수 있기 때문입니다. 또한 디자이너는 시장을 따라가기보다 시장을 만들어가야 한다고 생각합니다. 시장을 이끌어가기 위해서는 경제적 관점에서 벗어나 독립적으로 생각해야 하는 것 같아요. 그런데 한편으로 안타까운 일은 디자인 업계 사람들이 시장과 경제에 대한 이해와 경험이 부족해서 정당한 보수와 저작권료 등 당연히 챙겨야 하는 것을 챙기지 못하는 모습도 많이 보았습니다. 부당한 일을 방지하기 위해서는 어느 정도 경제적 관점을 가지는 것은 중요하다고 생각합니다. 디자인 회사의 입장에서는 당연히 경제적 관점이 있어야 합니다. 해당 기업의 구성원인 디자이너의 권리를 회사로서 보장해야 합니다. 디자이너는 자신의 능력을 바탕으로 자유롭게 작업하고 회사는 경제적 지식을 바탕으로 사업적 도움을 주는 구조가 이상적이라고 생각합니다.

벡터로 제작한 폰트의 수치 데이터를 바로 활용하지 않고 비트맵에서 데이터를 추출한 이유는 무엇인가요.

제 입장에서 비트맵은 웹사이트에서 바로 데이터화할 수 있지만, 벡터는 폰트 소프트웨어를 사서 역공학(reverse engineering)을 통해 데이터화해야 합니다. 따라서 데이터화 작업이 더 번거롭습니다. 이외에도 폰트는 작업자의 소유물이기 때문에 벡터의 수치를 가져오게 되면 법적인 문제도 발생할 수 있습니다. 이런 이유로 비트맵 자료를 활용했는데요, 만약 폰트 회사가 자신이 소유한 폰트로 같은 작업을 할 때는 말씀하신 방식으로도 접근 가능할 것 같습니다.

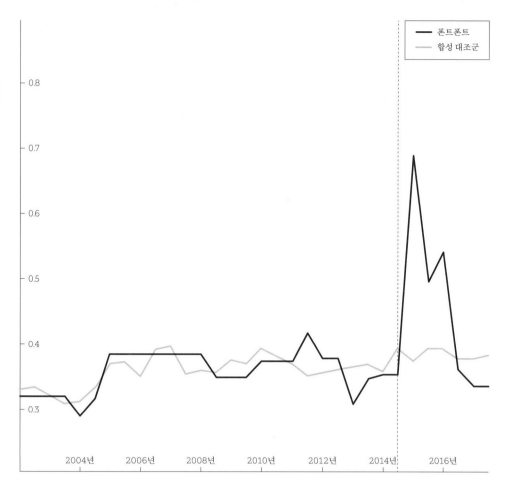

[4] 폰트폰트와 합성 대조군 지표값 비교.

폰트폰트가 마이폰츠에 합병돼서 큰 기업의 일부가
되면서 디자이너가 활용할 수 있는 자원이 많아졌습니다. 전체적인
자원이 많아지면서 다양한 실험을 시도해 볼 수 있는 여건이
갖춰졌어요. 그렇기 때문에 차별화 정도가 심해졌다는 것이 첫 번째
해석이었습니다. 그리고 폰트폰트가 마이폰츠와 합병되기 전에 둘은
경쟁자였어요. 2014년 이전에는 경쟁자로서 비슷한 종류의 폰트를
만들어 경쟁하다가 2014년 합병 이후에는 같은 회사끼리 경쟁하는
것은 비효율적이기 때문에 서로 다른 폰트를 만들게 된 것이죠.
이것이 두 번째 해석입니다.

이미지 임베딩과
워드 임베딩의 관련성은
무엇인가요.

제 연구에 따르면, 디자이너가 비슷하다고
생각하는 폰트는 그들의 좌표값도
비슷해야 합니다. 확인하기 위한 방법은
좌표값이 비슷한 이미지를 그룹으로 나눠
디자이너에게 실제로 비슷한지 물어보는 방법인데, 현실적으로
불가능하죠. 저는 대신 해시태그를 이용했습니다. 마이폰츠에는
각 폰트에 유저들이 추가한 약 30-100개 정도의 형용사 태그가
달려있습니다. 그 태그는 경제 주체가 해당 폰트를 보고 떠오른
느낌을 반영한 단어입니다. 따라서 단어가 담고 있는 정보와 이미지로
찍은 좌표값을 비교해 보려고 했습니다. 그래서 텍스트 데이터에
신경망 알고리즘을 적용해보았어요. 그 결과 이미지 임베딩으로 만든
좌표값과 워드 임베딩으로 만든 좌표값 분포가 비슷했고, 그렇기
때문에 유사한 정보를 공유한다고 할 수 있습니다. 결론적으로
제 연구에서 소개했던 이미지 임베딩이 디자이너가 폰트를 보고
떠올리는 인상과 관련이 있다고 말할 수 있죠.

임베딩을 활용해 어떤
검색툴 또는 추천툴을
제공할 수 있을까요.

검색툴 또는 추천툴을 어떤 방식으로 만들
수 있는지는 어떤 데이터를 사용할 수
있는가에 달려있어요. 마이폰츠는 실제로
이미 오랜 시간 동안 폰트마다 해시태그를
달아왔기 때문에 해당 자료를 사용할 수 있습니다. 이미지 임베딩과
워드 임베딩의 분포 양상이 비슷했기 때문에 그 둘을 실제로 엮어줄
수 있습니다. 그럼 형용사만 검색해도 해당 그룹에 있는 폰트를
모두 검색할 수 있는 거죠. 만약 기존에 달아둔 해시태그가 없다면
하나하나 태그를 달아야 합니다. 실제로 어도비에서 그
방법을 적용했습니다. 디자이너를 모아 크라우드소싱
(crowdsourcing)◆으로 폰트마다 속성(attribute)을
달게끔 한 거예요. 어도비에는 관련 연구로 논문을

◆ 생산 주체가 생산 과정에서
소비 주체를 참여시켜
아이디어를 얻고, 서비스에
활용하는 방식이다.




- 네스크톱 30일
- 웹폰트 30일
- 네스크톱 하루
- 웹폰트 하루

Y축: 0.0, 0.1, 0.2, 0.3, 0.4, 0.5, 0.6, 0.7, 0.8

X축: 2014년 5월, 2014년 11월, 2015년 5월, 2015년 11월, 2016년 5월, 2016년 11월, 2017년 5월, 2017년 11월

[3] 소비자 측면 트렌드 연구.

노력했다는 것을 알 수 있었습니다. [도판 2]

소비자 측면 트렌드 연구에서는 폰트 구입 라이선스의 종류별로 나눠봤어요. 마이폰츠에서는 폰트 구입 라이선스가 데스크톱, 웹폰트로 세분되어 있습니다. 시대와 상관없이 데스크톱 라이선스로 구입한 폰트의 차별화 정도가 높았어요. 웹폰트 라이선스는 평균값에 훨씬 가까웠습니다. 아무래도 데스크톱 라이선스로 구입한 폰트는 포스터, 초청장과 같이 디자인 자유도가 높은 작업에 주로 사용되고 웹폰트 라이선스로 구입한 폰트는 웹사이트, UX 등 가독성이 중요한 작업에 주로 사용되니까 후자의 경우에서 덜 모험적인 폰트를 많이 구입한다는 결론에 도달했습니다. [도판 3]

두 번째 연구는 생산자 측면의 심화 연구입니다. 2014년에 폰트 시장에서 흥미로운 사건이 일어났습니다. 바로 1990년에 에릭 슈피커만(Erik Spiekermann)과 네빌 브로디(Neville Brody)가 설립한 대형 파운드리인 폰트폰트(FontFont)가 모노타입에 합병된 일입니다. 다시 말해 폰트폰트가 마이폰츠에 수수료를 내고 폰트를 판매하는 파운드리였는데 마이폰츠 자체가 된 것이죠. 이와 같은 시장의 큰 변화 이후 폰트폰트의 디자인에 어떤 변화가 있을지 궁금해졌습니다.

단순하게 생각해보면 합병 전후의 차별화 지표값이 얼마나 달라졌나를 보면 되죠. 그래서 폰트폰트에서 2014년 이전에 출시된 폰트의 지표값과 2014년 이후 출시된 폰트의 지표값을 찍어봤어요. 그 결과를 비교했더니 2014년 직후부터 갑자기 차별화 지표값이 크게 증가했어요. 그런 현상이 약 2년 정도 지속되었습니다. 그런데 이것만으로는 이 결과가 합병 때문이라고 확답할 수 없었어요. 합병 이외의 다른 사건이 영향을 미쳤을 수 있기 때문입니다. 그래서 비교할 수 있는 대조군이 필요했어요. 대조군이 될 수 있는 다른 파운드리가 충족해야 할 조건은 우선 다른 회사에 합병되지 않아야 했고, 폰트폰트의 디자인 양상과 비슷해야 해요. 그러나 그 조건을 충족하는 다른 파운드리를 찾기가 거의 불가능에 가까워요. 그래서 최근에 경제학에서 개발된 통계 기법인 '합성 대조군 기법(synthetic control method)'을 사용했습니다. 기존에 있는 파운드리의 특성을 적절하게 조합해서 그들의 차별화 지표값이 2014년 이전 폰트폰트의 지표값과 비슷하게 움직이도록 설정했어요. 그다음에는 2014년 이후 지표값이 어떻게 변하는지 지켜봤습니다. 즉 이렇게 합성된 대조군은 폰트폰트가 합병이 되지 않았다면 어떻게 되었을지 보여주는 역할을 하죠. 결론적으로는 2014년을 기점으로 폰트폰트와 합성된 대조군의 지표값이 큰 폭으로 달라집니다. 둘의 차이를 보면 합병 때문에 발생한 차이를 알 수 있는 거죠. [도판 4]

[2] 생산자 측면 트렌드 연구.

범례:
- 분기별
- 2000년
- 평균 거리

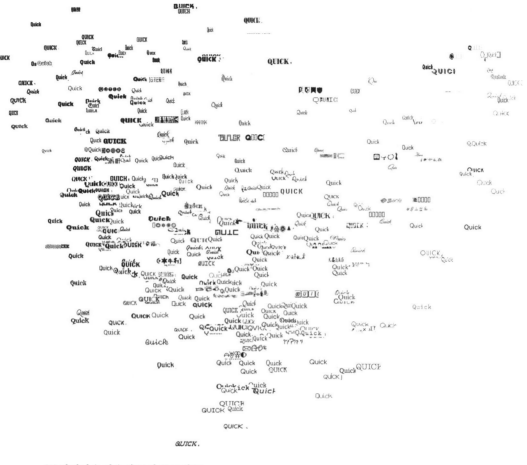

[1] 임베딩을 이용해 그린 폰트지도.

부여하는 것과 같습니다. 좌표값이 있으므로 폰트와 폰트 사이의
거리를 계산할 수 있고요. 이 거리 개념은 이어서 말씀드릴 연구에
중요하게 쓰였습니다.[도판 1]

이후에 진행한 연구는 두 가지입니다. 첫 번째 연구는 트렌드
분석입니다. 생산자 측면 트렌드 연구에서는 지난 10년간 마이폰츠에
업로드된 새로운 폰트가 어떤 좌표값을 갖는지를 확인하고 싶었어요.
좌표 공간 자체로는 추상적인 공간이기 때문에 경향을 파악하기
어려워 '디자인 차별화 지표(index)'를 만들었습니다. 지표가 작은
값을 가지면 비교적 일반적인 형태의 폰트이고, 큰 값을 가지면
더 실험적인 형태의 폰트입니다. 새로 만들어진 폰트의 차별화
지표를 시간에 따라 찍어봤어요. 2000년 이전 모든 폰트의 차별화
평균값과 새로운 폰트의 차별화 평균값을 비교했더니 흥미롭게도
새로운 폰트의 차별화 평균값이 더 높았습니다. 기존 시장의 경쟁이
이미 치열했기 때문에 새로운 폰트는 기존에 없는 형태를 만들려고

제 연구의 제목은 '선택으로서의 형태'인데요, 여기서 '선택'은 디자이너의 선택이고, '형태'는 선택으로 나오는 서체의 형태입니다. 연구 제안서를 쓸 때 아무래도 제가 이 분야를 잘 모르기 때문에 홍익대학교 시각디자인과에 교수로 재직 중이신 석재원 선생님의 도움을 받았어요. 그때 추천해주신 폰트회사가 마이폰츠(MyFonts)◆였고 바로 연구 제안서를 보냈습니다. 한 달 쯤 후에 마이폰츠에서 함께 연구해보고 싶다는 답변이 왔습니다. 마이폰츠는 전 세계에서 가장 큰 폰트 플랫폼이고 모노타입(Monotype)이 소유하고 있습니다. 마이폰츠의 판매 구조는 모노타입이 소유하고 있는 파운드리(foundry)◆◆가 폰트를 팔거나 외부 파운드리가 수수료를 내고 폰트를 판매하는 구조입니다.

제가 마이폰츠로부터 제공받은 데이터는 폰트 이미지, 파운드리 정보, 소비자의 구매 정보입니다. 그 정보 중에서 가격, 파운드리 정보, 제작 시기, 구매 시기, 글리프 개수, 지원 언어 등은 기존 경제학 연구에서 많이 다루는 '구조화된 데이터(structured data)'입니다. 반면 폰트 상품에서 제일 중요한 폰트 소개 이미지는 '구조화되지 않은 데이터(unstructured data)'입니다. 이 연구의 첫 단계는 구조화되지 않은 데이터를 어떻게 구조화할지 결정하는 것이었습니다. 개별 알파벳 이미지보다 팬그램(pangram)◆◆◆ 이미지가 시장주체가 관심을 가지는 대상이라고 생각해서 그것을 수치화했습니다. 그리고 기계 학습(machine learning)◆◆◆◆ 알고리즘 중 구글 연구원이 개발한 안면 인식 알고리즘을 가져와 사용했습니다. 폰트 이미지를 수치화한다는 것은 기계가 폰트 이미지를 인식하도록 학습하는 것입니다. 기계 학습에서 손글씨로 쓴 2와 3을 구분하는 것은 '분류(classification)' 문제라고 하는데, 제 연구의 경우는 각 글자의 양식을 구분해야 해서 그보다 훨씬 더 정교한 알고리즘이 필요했어요. 그래서 안면인식 알고리즘을 가져왔습니다. 이 과정에는 논문의 공동 저자이자 기계 학습의 대가인 크리스틴 그라우만(Kristen Grauman)의 도움이 컸습니다.

안면인식 알고리즘은 신경망(neural network) 알고리즘입니다. 이 알고리즘은 뇌 신경망 구조와 비슷한 수학 모델을 만들고, 마치 눈을 통해 시각 데이터를 받아들이고 뇌로 정보를 처리하는 과정처럼 팬그램 이미지의 픽셀 정보 값을 입력하고 숫자열로 처리하는 것이죠. 그 숫자열을 임베딩(embedding)이라고 부릅니다. 오늘 말씀드리는 연구에서 자주 나올 단어인데요, 쉽게 말해 각 폰트에 공간의 좌표값을

◆1999년에 설립된 디지털 폰트 유통사로, 2012년에 모노타입에 인수되었다. https://www.myfonts.com
◆◆폰트 제작사. 납활자를 주조하던 시기부터 사용한 용어이다.
◆◆◆'a'부터 'z'까지 모든 알파벳을 사용하여 만든 문장으로 폰트의 인상을 확인할 때 사용한다.
◆◆◆◆경험을 통해 훈련하는 컴퓨터 알고리즘을 개발하고 연구하는 분야이다.

사람이 인지하는 차원을 1차원이나 2차원으로 낮춘 다음 3차원을 경험하게 하는 것이었습니다. 예를 들면, 좁고 낮은 터널이 갑자기 높고 열린 공간으로 연결되게 하는 거예요. 그런 종류의 법칙을 생각해보고 건축가의 도움을 받아 다양한 건축 구조에 적용해 영상을 만들었습니다. 그리고 작곡가의 도움을 받아 그 경험을 극대화할 수 있는 음악도 넣었어요. 나중에 알게 되었는데 제 아이디어는 실제로 건축가들이 성당 건축에 많이 사용했던 방식이라고 하더라고요.

진행하신 연구 주제를 말씀해주세요. 앞서 말씀드린 것처럼 디자인, 건축, 예술에도 관심이 많은데요, 제 전공과 이들 분야의 접점에서 연구 주제를 찾다가 폰트 시장에 관심을 가지게 되었습니다. 사실 처음에는 시각 데이터를 이용한 경제 분석을 해보고 싶다는 생각에서 시작했습니다. 경제 분석을 하기 위해서는 시장을 연구해야 하고, 시장을 연구하기 위해서는 산업 혹은 산업에서 만들어지는 상품을 연구해야 하므로 시각 정보가 중요한 상품이 무엇이 있을지 생각해보게 되었어요. 그러다가 우연히 웹사이트에서 폰트를 보았습니다. 평소에는 익숙하게 사용했기 때문에 생각해본 적 없었는데 자세히 살펴보니 폰트가 시각적으로 가장 단순한 상품 중에 하나라는 생각이 들었고, 연구 대상으로 정하게 되었습니다.

폰트 시장을 살펴보니 여러 질문이 떠올랐습니다. 첫 번째로 결정 주체에게 영향을 주는 요소가 무엇인지 궁금했습니다. 폰트를 디자인할 때 디자이너가 하는 여러 결정에 어떤 요소가 영향을 미치는지, 그리고 폰트를 구입하는 소비자의 선택에 어떤 요소가 영향을 미치는지를 파악하고자 했습니다. 두 번째로 폰트의 법적 보호도 중요한 질문이었습니다. 폰트는 긴 시간과 많은 노동을 들여 만드는 대상인 만큼 법적 보호 절차가 중요합니다. 폰트 시장의 경제학적 또는 수학적 모델을 만들 수 있다면 폰트 생산자와 소비자를 이롭게 하는 법정 장치도 제안을 할 수 있지 않을까 생각했습니다.

연구 과정을 듣고 싶습니다. 이 연구는 디자이너를 경제 주체로 보는 것에서 시작합니다. 사회에서 볼 수 있는 다양한 사람들이 경제 주체가 될 수 있는데요, 보통 경제학의 중요한 전제가 자원이 제한된 상황에서 경제 주체가 선택을 한다는 것입니다. 그렇다면 디자이너는 어떤 제약 안에서 선택을 하게 될까요? 폰트를 제작하는 기간, 유사 상품의 존재 여부, 소비자의 구매 패턴 등이 제약이 됩니다. 그렇게 디자이너를 경제 주체로 바라보고 연구를 진행했습니다.

경제학 관점에서 폰트 시장 분석

한석진

이 인터뷰는 2021년 2월 19일 진행된 티스쿨(T/SCHOOL)에서
한석진이 강연한 〈경제학 관점에서 폰트마켓분석〉을
『글짜씨』 독자를 위해 더욱 알기 쉽게 풀어낸 것이다.

**자기소개를
부탁드립니다.**

안녕하세요. 저는 한석진입니다.
영국 브리스톨대학교(University of
Bristol) 경제학과에 교수로 재직하며
연구하고 학생을 가르치고 있습니다. 제 연구 분야는 '계량경제학
(econometrics)'인데요, 데이터를 이용해서 경제 분석을 하는데
필요한 통계 기법을 개발하는 경제학의 한 분야입니다.

전공 이외에도 평소에 제 생각을 물성이 있는 대상이나
시각적인 형태로 풀어내는 것에 관심이 있습니다. 그래서 지난
몇 년간 설치 미술가, 디자이너, 작곡가와 협업하면서 작업 활동도
하고 있습니다. 대표적인 사례를 말씀드리자면 통계 기법을 개발할 때
수학을 많이 다루게 되는데요, 수학에는 차원이라는 개념이 있습니다.
문득 이런 차원이 넘나드는 경험을 일상에서 어떻게 구현할 수
있을까 생각해봤습니다. 그리고 동시에 그런 경험을 체험할 수 있는
공간을 만들고 싶었습니다. 저희는 3차원의 공간에 살고 있기 때문에
4차원 또는 그 이상의 공간을 경험할 때 어떤 경외감 같은 감정을
느낄 수 있을 것 같다고 생각했어요. 그러나 3차원에서는 4차원
공간을 만드는 것이 불가능하잖아요? 그래서 제가 생각한 방법은

대화

〈식물 극장〉.

그런데 문자에는 아쉽게도 생명체를 구성하는 단백질, 지질,
탄수화물, 핵산이 없네요. (웃음)

〈입자〉.

없던 길도 만들지' 같은 이벤트는 정말 그 센스에 감탄했어요.
『크메르 문자 기행』도 문자가 다리가 되어 크메르인을 타자로
보지 않도록 해주었습니다. 크메르인이 발신을 해도 크메르
문자를 해석해 줄 책이라는 통용할 매체가 없다면 수신자인
우리에게 닿지 않았을 거예요. 이런 경계를 확장하는 작업이
좋은 선례라고 생각합니다.

선생님에게 문자는 무엇인가요? 문자는 생명으로 볼 수 있을까요?
그 이유도 함께 듣고 싶습니다.

'원자-분자-세포-조직-기관' 구조처럼 '자모-음절-단어-어절-
문장-문단' 이렇게 문자에게도 생명과 유사한 조직적 질서가
있고 조화·균형·리듬을 지닙니다. 문자는 수신자에게 뜻과
감정과 에너지를 전달합니다. 이는 생명의 에너지 교환 과정과
비슷합니다. 생명처럼 문자도 형태의 항상성을 유지함과
동시에 시대나 환경에 따라 변화합니다. 또 서체는 생명처럼
성장과 발전을 거듭하며 풍성해집니다. 생명의 번식처럼
글자가족도 있고, 기존 문자 체계에서 더 확장되기도 하며, 닮은
꼴 그룹으로 분류될 수도 있습니다. 시대와 환경에 따라 문자도
생장하고 소멸합니다. 생명이 엔트로피를 거스르는 존재인
것은 무엇보다 중요한 특성이며, 문자도 엔트로피에 저항하는
생명으로서 문자력(力)을 지닙니다. 세포막으로 일컬을 수 있는
다른 문자들과 변별되는 경계, 글자체의 고유성도 있습니다.
이런 여러 특성을 생명과 문자에서 공통으로 볼 수 있습니다.

〈컨템포러리 애니미즘: 수초와 물고기〉.

문자의 생명

'환경보호'라는 용어 그 자체가 타자화한 느낌이라고 하셨습니다.
이처럼 용어 자체가 대상을 타자화하고 편견을 만들기도 하는데요,
문자와 타이포그래피 차원에서 방지할 수 있을까요?

용어는 단순히 대상을 가리키는 것을 넘어 정신적인 관념을
전달하기 때문에 차별이나 배제의 요소가 있는지 세심하게
살피는 게 우선이겠지요. 용어를 잘 살펴 쓰고 자신을 큰 자아로
넓혀 가는 것이 타자화를 줄이는 방법일 겁니다. '타인'과
'타자'는 그 뉘앙스가 다릅니다. 세포막이 생명의 필수 활동인
물질이동을 하지 않거나 적절한 신호를 주고받지 않는다면
그 세포는 얼마 가지 않아 고사하고 말 거예요. '타인'이라
할 때는 이를테면 세포막이라는 경계 안에 위치한 '내'가
세포막이라는 경계선을 긋고 있지만, 밖에 위치한 '타인'과
신호를 주고받는 상태예요. '타자'라고 지칭할 때는 내가
세포막을 닫고 적절한 정보 유입을 차단한 상태입니다. 아마
'타자'보다 자기가 먼저 에너지가 고갈되지 않을까 합니다. 다른
생명의 '생명 권리'를 생각하고 여러 곳에서 벌어지는 사회·
문화 현상을 열린 시각으로 보는 게 무엇보다 타자화를 막는
길이겠지요. 요즘 타이포그래피의 형태가 점점 다채로워지고
있는데 이것 자체가 타자화를 방지하는 실마리가 될 것입니다.
지역 문화에 남아있는 글자를 채집하고 문자화하는 버내큘러
서체나,「길버트(Gilbert)」와「길벗체」에서도 공존을 발견할 수
있습니다. 문자의 예는 아니지만, 온라인 퀴어퍼레이드 '우리는

〈컨템포러리 애니미즘〉 포스터.

(Contemporary Animism)〉은 생명체 이미지가 제일 많은 작업입니다. 지구는 여러 차례 대멸종을 겪었습니다. '생명의 과거'와 '생명의 현재'는 서로 다른 것도, 또 같은 것도 있습니다. 이 작업을 통해 생명의 시원으로 소급해 올라가 '생명이 일어나는 자리'를 탐구했습니다. 아메바, 폴립, 불가사리, 지네 등을 소재 삼아 생명을 배태한 공간과 움직이지 않으나 움직이는 그 숨겨진 힘을 찾으려 했습니다. 〈입자(Particle)〉, 〈자연의 무늬(Nature's Pattern)〉는 생물과 무생물의 공통점과 차이점을 살피는 데서 나온 작업입니다. 생물과 무생물은 모양과 패턴을 형성하는데 비슷한 규칙을 사용하기도 하기 때문이지요. 〈가이아〉에서 〈식물 극장(Theater of the Flora)〉까지 그동안 시각 이미지를 공부하고 발신해 왔습니다. 아직 공부가 산적해 갈 길이 멀지만, 걷는 길에 여러분과 함께 지금까지의 결과물을 즐기게 되어 고맙게 생각합니다.

| Contemporary Animism | Zebra Menhir |

〈컨템포러리 애니미즘: 토템〉.

〈디바: 애플 디바〉. 〈디바: 지구 어머니〉.

토크에서 보여준 작업을 보면 생명의 원리를 이해하고 관찰해 작업을
풀어내는 것 같습니다. 이 과정에서 특히 중요하게 생각하는 것은
무엇인가요? 애착을 갖고 있는 작업 이야기도 듣고 싶습니다.

시리즈마다 배태된 생명의 원리가 조금씩 다릅니다. 1995년
작업 〈가이아(Gaia)〉는 시리즈의 바탕이 되는 작업입니다.
〈가이아〉에서 지구 권역을 빛, 해, 땅, 바람, 물, 생물권 등으로
나누어 표현했어요. 이는 각 권역이 지구의 유기체적 관계
안에 놓인다는 점, 이 큰 공동체적 권역에서는 무생물과
생물 구분 없이 상호 조절한다는 점, 생명 대 물질로 서로
대칭되지만 이것 역시 서로 이어져 있다는 점 등 여러 생각을
합쳐 작업한 것입니다. 가이아는 대지의 여신으로 포용성과
고양됨, 생명성을 가진 지구 전체이기도 합니다. 〈호모 루덴스
(Homo Ludens)〉는 생명을 꼭짓점으로 폭넓게 사유한
결과물입니다. 이 작업에서는 사이보그에서 시작해서 문화,
놀이에까지 생각이 뻗어 나갔습니다. 〈디바(Diva)〉는 모든
생명의 고유성과 신성함, 생명이 만들어내는 놀이에 대한
사유입니다. 사과나무, 잣나무, 밤나무, 비와 같이 주변에서
흔히 볼 수 있으나 항상 배경의 역할인 소재를 주인공으로
바라보았습니다. '추상적 속성'과 '만화적 속성'의 간격을
부수고 그 근간에 생명과 놀이에 대한 생각을 두었습니다.
모든 생명은 놀이를 만들어 내기 때문입니다. 사람뿐만 아니라
돌고래, 악어, 도마뱀, 짚신벌레 등에서도 놀이를 즐기는
모습을 발견할 수 있다고 합니다. 〈컨템포러리 애니미즘

〈가이아〉.

생명의 문자

다양한 생명체의 의사소통체계를 예로 들며 문자로서의 가능성에
관해 이야기했는데요, 선생님에게 문자는 무엇인가요?

《사이사이》토크에서 생명체의 의사소통체계로 보호색,
경고색, 혼인색을 들어 발신 문자로서의 가능성을 말했는데요,
실제로 생명체는 문자 언어보다 다른 언어가 더 발달한 것
같아요. 곤충에게 피해를 입은 식물이 화학 물질을 배출하면
이웃한 식물이 이를 감지해 방어 물질을 만들어 피해를 줄이는
현상은 식물의 의사소통 방식을 보여주는 대표적인 예입니다.
생명체는 생존과 번식을 위해 주위의 상황을 감지하고
그 데이터를 축적해서 생명을 향한 의지를 표출합니다.
태극나방이 태극무늬 패턴을 만들 수 있는 건 패턴 형성에
대한 '자발성'이 있다는 뜻입니다. 그래서 수신보다 발신에
방점을 두고, 생명을 문자의 주체자로 두었습니다. '생명은
발신한다'라는 제목은 앞서 말한 단계를 거쳐 나왔습니다.
아마도 생명의 형태와 패턴 모두에 어떤 의미를 덧씌울 필요는
없을 터이고, 또 잘못 덧씌워진 예는 오류를 범할 수도 있을
겁니다. 그러나 발신자와 수신자 둘 사이에 정보가 흐른다는
것은 이 둘이 발신하는 바를 서로 이해한다는 것을 의미합니다.
발신자에게서 오는 정보를 수신자가 받아서 공유하거나 해석할
수 있다는 것은 둘 사이에 프로토콜(통신규약)이 존재한다는
것입니다. 그래서 문자는 상생이건 상극이건 간에 발신자와
수신자 그 둘을 잇는 '공유와 공명의 프로토콜'이 아닐까 싶어요.

구애용 발신문자

"나의 짝이 되어줘."

혼인색 ·········

같은 생명 종 사이: 암수 사이의 발신, 주로 새와 물고기 종

생명의 의사소통체계.

배움을 '즐거움'으로 받아들이면 그 기억은 일생에서 오랫동안
유지됩니다. 저는 아이들에게 가장 양질의 콘텐츠를 다양하게
제공해야 한다고 생각해요. 제가 아이들에게 줄 수 있는 관점은
일상의 경험보다 더 큰 '조망'입니다.

『아가씨와 여우』는 세 번째 그림책입니다. 칠교놀이의
칠교로만 그림책을 만들었어요. 일곱 개밖에 안 되는 칠교의
삼각형, 정사각형, 평행사변형이 서로 만나 다양한 모양을
만들어내는 체계가 마치 세상 만물의 이치를 알려주는
듯했습니다. 주기율표에서 보듯이 만물은 한정된 원소로
이루어지는데, 이와 비슷하게 칠교도 기본 도형이 어떻게
맞물리느냐에 따라 복잡한 형태가 파생되는 재미있는 구조를
보여줍니다. 연결, 관계, 부분과 전체라는 좋은 시사점을 준다는
점에서 수학적·디자인적 가치가 있다고 봤습니다. 출간 계획이
아직 정확하게 잡히진 않았지만, 여러 권을 흩뿌려놓고 조금씩
살을 붙여 나가는 중이에요. 칠교놀이 시리즈 『아가씨와 여우』
보다 쉬운 버전과 어려운 버전을 구상하고 있고, 기하학적
도형으로만 이루어진 그림책도 있습니다. 이외에도 자연과
생명에 관한 그림책, 한국의 미감과 생명력을 체현해 볼 수 있는
자수를 놓아 만드는 민화 그림책도 있습니다. 시간을 내어 '생명'
시리즈도 계속해나가야 하지요.

『샘이깊은물』 1988년 5월호 표지.

1990년 DTP(Desktop Publishing)의 대표적인 플랫폼
매킨토시에 신문사 서체를 도입한 것을 계기로, 곧이어
쿼크익스프레스(QuarkXpress) 2.04를 사용하다가 1991년
잡지 전체를 모두 컴퓨터로 작업했습니다. 글자와 그래픽을
흑백 인화지 한 장으로 출력하고 사진이나 그림을 따로
스캔해 그 인화지에 붙인 뒤 색을 지시하는 방식이었습니다.
초기 DTP의 조판 상태는 대부분 시각적으로 안정적이지
않았는데, 『샘이깊은물』은 DTP를 상대적으로 일찍 도입한
편임에도 서체를 비교적 부드럽게 운용했습니다. 퇴사
이후에도 폰토그래퍼(Fontographer, FOG)를 사용해 공병우
세벌식 자판을 활용한 한글 서체를 만들기도 했는데요, 이처럼
포토샵(Photoshop)에 레이어가 없던 시절부터 여러 그래픽
소프트웨어를 사용했습니다. 아직까지 현장에서 일할 수
있는 토대가 된 것은 이른 시기에 접한 『샘이깊은물』의 DTP
덕분이라 생각하여 늘 고마운 마음입니다.

2019년에 그림 책『아가씨와 여우』를 출간했습니다. 그림 책을 만드는
이유와 과정, 그리고 앞으로의 출간 계획을 알고 싶습니다.

『글짜씨』도 씨앗이 하나의 실마리가 된 것 같이, 씨앗의
중요성과 가능성은 모두 공감하실 거로 생각합니다.
아이들이야말로 씨앗이지요. 샤를 단치(Charles Dantizg)는
"책을 읽는다는 것은 뇌리에 새기는 문신이다"라고 했어요.
특히 어릴 적 경험하는 책은 고준위입니다. 아이들이 책과

생명은 발신한다

박영신

디자이너 박영신

『글짜씨』독자들에게 인사와 소개를 부탁드립니다.

안녕하세요. 이안디자인 아트 디렉터 박영신입니다.
저는 『샘이깊은물』창간 멤버로 일했습니다. 그 뒤에는
이안디자인에서 도감과 국어사전, 어린이 책을 디자인하고
있습니다. 이외에도 그림책 작가이자 북 아티스트이기도
합니다. 제가 만든 그림책 두 권으로 브라티슬라바
일러스트레이션 비엔날레(Biennial of Illustrations
Bratislava, BIB)에 참가했습니다. 그리고 작년 《책의 날》에
대한출판문화협회로부터 디자인 공로상을 받았습니다.

편집 디자이너, 그림책 작가, 북 아티스트로서 여러 활동을 하고
있는데요, 그 시작점에 『샘이깊은물』이 있습니다. 한국 시각 디자인
역사에서도 의미 있는 책이지만 선생님께는 더욱 특별한 책일 것
같습니다. 『샘이깊은물』의 디자이너로서의 경험과 2021년 현재
그 경험이 끼친 영향을 듣고 싶습니다.

'사람의 잡지'를 표방한 『샘이깊은물』은 그 시대의 가치와
방향을 잡아준 책이고, 저에게도 역시 생각의 잣대를 마련해
준 책입니다. 토박이의 아름다움을 일으켜 세우면서도
디자인적으로 선구적인 곳이었지요. 특히 네모꼴을 탈피한
사례로 꼽히는 「샘이깊은물체」의 모듈로 자소를 조합해
글자를 만든 일과 잡지 서체 매뉴얼 작업이 기억에 남습니다.
『샘이깊은물』은 새로운 도구의 도입에도 앞서 있었어요.

《타이포잔치 사이사이 2020-2021: 국제 타이포그래피 비엔날레》. 사진: 박재용.

고슴이 굿즈.

고슴이 굿즈를 디자인할 때 특별히 신경 쓰시는 기준이 있나요?
최근에는 다양한 곳에서 환경 문제를 의식하고 제작한 굿즈도 꽤 많이
볼 수 있는데요 이에 관한 생각도 듣고 싶습니다.

저 역시 굿즈를 만들지만, 집에 한가득 쌓여가는 굿즈를 보며
피로감을 느낄 때가 있습니다. 그러다가 정작 제 작업을 할
때는 욕심이 생기지만 정말 쓸모 있는 굿즈만 만들려고 마음을
다잡습니다. 굿즈를 만들 때 디자이너가 아닌 팀원들도 지구에
해를 끼치지 않는 방법을 함께 연구하고 있어요. 테이프를
사용하지 않는 박스를 구하거나, 재활용이 가능한 포장지를
찾고 있어요.

디자인과 환경 문제에서 결정해야 할 때면 고민이 많아집니다.
지구를 지키자니 디자인 콘셉트가 잘 살지 않을 것 같고, 디자인
콘셉트를 살리자니 지구가 신경 쓰이고. 솔직히 말하자면,
그때그때 결정을 달리하고 있습니다. 저는 지구를 지키는
슈퍼맨이 아니고, 욕심 많은 디자이너이기 때문이죠. 하지만
지구에 최대한 덜 미안한 방법을 찾으려고 노력하고 있습니다.

고슴이 돌잔치.

지속해서 고슴이 관련 행사를 기획해 뉴니커와 소통하고 친밀감을 쌓는 모습을 볼 수 있었습니다. 행사를 기획할 때 디자인적으로 중요하게 생각하는 점은 무엇인가요?

원체 일 벌이는 걸 좋아합니다. 집들이를 100번도 넘게 했을 정도로 사람 모으는 것도 좋아하고요. 뉴닉에서 행사를 기획할 때도 2가지를 중요하게 고려했어요. 첫째, 소속감을 느낄 수 있을 것. 둘째, 깊은 인상을 남겨 오래 기억하도록 할 것.

회사 창립 1주년을 기념해 고슴이 돌잔치를 기획한 적이 있습니다. 뉴니커와 함께 커왔으니 축하 자리를 만들면 좋겠다 싶어 고슴이 얼굴 모양으로 돌떡을 맞춰 돌상을 준비하고, 돌잔치의 하이라이트인 돌잡이도 준비했습니다. 그 뒤로 매해 여름 창립 기념일 즈음에 뉴니커와 함께 고슴이 생일을 기념하고 있어요. 2020년에는 코로나19 때문에 비대면으로 행사를 진행했습니다. 생일에 맞춰 고슴이 팬클럽을 창단했고, 유튜브 라이브로 창단식도 생중계했죠. 뉴니커의 후원으로 아이돌만 할 수 있다는 지하철 광고도 했습니다. 팬 사인회는 온라인으로 했고요. 이처럼 메일만 주고받던 뉴니커를 실제로 마주하고 얘기를 나누다 보면 우리가 어떤 사람들에게 메일을 보내는지 더 잘 알 수 있습니다. 크든 작든, 구독자를 만날 수 있는 기회를 자주 만들려고 합니다.

고슴이 초기 스케치.

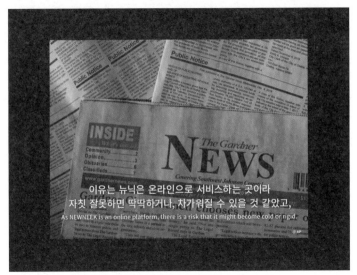

이유는 뉴닉은 온라인으로 서비스하는 곳이라
자칫 잘못하면 딱딱하거나, 차가워질 수 있을 것 같았고,
As NEWNEEK is an online platform, there is a risk that it might become cold or rigid.

고슴이의 모티브가 된 신문의 지그재그 재단선.

고슴이를 살아 숨 쉬게

뉴닉의 화자를 고슴도치로 설정한 점이 독특합니다. 종이 신문의
윤전기 재단선에서 생각났다고 했는데요 기존 매체의 특징을 가져와
캐릭터에 적용한 이유와 그 효과는 어떤가요?

뉴닉은 비록 레거시 미디어의 새로운 대안을 제시했지만,
온라인에만 존재하기 때문에 차갑거나 딱딱하게 느껴지지
않았으면 했어요. 새벽에 배달되어 하루를 여는 느낌, 잉크
냄새가 나는 얇은 종이, 정해진 틀 안에서 기사의 위계에
따라 바뀌는 레이아웃 등 레거시 미디어의 매력적인 부분을
뉴닉에서 살리고 싶었습니다. 윤전기에서만 볼 수 있는
지그재그 재단 모양에서 고슴도치의 가시가 떠올랐고요.
속은 부드럽지만 해야 할 말을 할 때는 가시를 세울 줄 아는
귀엽지만 당돌한 고슴이를 만들었습니다.

고슴이가 더욱 생명력 있게 느껴지도록 팀에서 자체적으로
MBTI를 진행해보기도 했어요. 각자가 생각하는 고슴이의
성향을 가정하여 두 시간에 걸쳐 테스트한 결과, 고슴이는
ENFP라고 합니다. 공감 능력이 높고, 자유롭고 재기발랄한
활동가 유형이 맞는 것 같더군요. 뉴니커 역시 고슴이가
자신이 하고 싶은 말을 속 시원하게 대신해주거나, 자주 말을
걸고 생각을 물을 때 친근감을 느낀다고 답하고요. 종종 "안녕
고슴아"라고 시작한 답장이 오는 걸 보면, 월수금 아침마다
메일함에서 만나는 소중한 친구가 된 것 같습니다.

- **좋았어요** 😊: "쿠팡 물류창고 화재에 대해 깊이 다
 뤄줘서 좋았다", "전세(X)와 전기료(O) 중에 뭐가
 맞는 표현인지 알게 됐다"는 의견 있었어요.
- **아쉬워요** 😕: "박성민 청년비서관 임명에 대한 논
 란을 더 자세히 알고 싶다", "전기료 안 올라서 좋아
 하는 사람도 많을 텐데 비판적인 내용이 많아서 아
 쉬웠다"는 의견 있었어요.

오늘 레터는 어땠나요? 어디가 좋고 어디가 아쉬웠는지,
다음에 알고 싶은 이슈가 무엇인지 아래 버튼을 눌러 알려
주세요!

좋았어요 😊

아쉬워요 😕

뉴닉은 항상 지난 뉴스레터의 피드백을 요약해서 보여준다.

뉴닉은 레터 마지막에 항상 그날 레터가 어땠는지 물어봐요.
많게는 천여 개의 피드백이 들어오기도 합니다. 모든 피드백을
팀원들이 꼼꼼히 확인하는데, 그 속에는 저희의 실수는
없었는지, 레터가 술술 읽혔는지, 뉴니커가 요즘 어떤 이슈를
궁금해하는지 힌트가 엿보일 때도 있어요. 그 힌트를 바탕으로
다음 콘텐츠를 기획하기도 합니다.

뉴니커의 피드백으로 생긴 변화는 꽤 다양해요. 뉴스레터 속
광고 정책과 기준도 뉴니커의 피드백으로 만들어졌습니다.
저희는 사회 구성원 모두를 존중하고, 성별·외모·인종 등에
대한 잘못된 고정관념을 강화하지 않는 기업 철학을 가진
브랜드, 뉴니커에게 새로운 정보나 분야를 소개할 수 있는
브랜드 등과 주로 협업하고 있어요. 물론 변화를 요구하는
피드백만 있는 건 아닙니다. 뉴닉팀을 격려하는 메시지도
남겨줘요. 제가 출산 휴가 들어간다는 소식에 많은 분이 따뜻한
축하와 격려 메시지를 보내주셨는데요. 이럴 때마다 레터 뒤에
사람이 존재한다고 느껴요.

뉴닉의 여성용어 가이드

뉴스레터를 만들 때 뉴닉은 이런 단어를 사용합니다 ✍️

그

- 🚫 뉴닉은 안 쓰는 단어: 그/그녀
- 🚫 뉴닉은 안 쓰는 단어: '여'를 접두어로 쓰는 단어들
 ex. 여비서, 여장부, 여의사, 여검사, 여걸, 여대생, 여기자 등

'뉴닉 여성 용어 가이드' 캡처 화면.

뉴닉의 가장 큰 특징 중 하나는 빠른 독자 피드백 반영이죠. 어쩌면 뉴닉이라는 플랫폼이 정말 살아있게 느껴지는 원동력 같습니다. '뉴닉 여성 용어 가이드'도 그렇게 탄생했는데요, 독자의 피드백이 용어 가이드까지 이어지게 되는 과정을 자세히 듣고 싶습니다. 피드백으로 뉴닉에 변화가 있었던 또 다른 사례도 알고 싶습니다.

2019년 1월 28일 일본군 '위안부' 피해자인 김복동 인권운동가께서 별세하셨어요. 그 소식을 전하며 '할머니'라는 표현을 사용했는데 따끔한 피드백이 많이 들어왔습니다. 왜 남성 인권운동가에게는 '운동가' '선생님'이라는 표현을 사용하면서, 여성인권운동가는 '할머니'라는 표현을 사용하냐는 지적이었죠. 할머니라는 단어가 존중의 의미를 담고는 있지만, 지휘 혹은 활동 경력을 고려해 직위로 반영할 필요가 있다고 판단했습니다. 즉각 실수를 인정하고 다음 레터 때 이를 정정하겠다고 알렸어요. 이를 계기로 뉴닉팀에서 사용하지 않는 단어와 이를 대체할 단어를 아카이브 하기 시작했습니다. 그렇게 만들어진 게 '뉴닉 여성 용어 가이드'이고요. 뉴닉 여성 용어 가이드는 팀 내에서 레터를 작성할 때 참고하기 위해 만들었지만, 뉴니커에게도 공유할 필요가 있다고 느껴 저희 웹사이트에 공개하고 수시로 업데이트하고 있어요. 단어는 그 시대상을 반영하기 때문에 무의식적으로 잘못된 용어를 사용하고 있다면 점점 옳은 방향으로 바꿔야 한다고 생각해요. 이처럼 뉴닉팀과 뉴니커는 끊임없이 새로운 상식에 관해 공부하고 자기검열하고 있습니다.

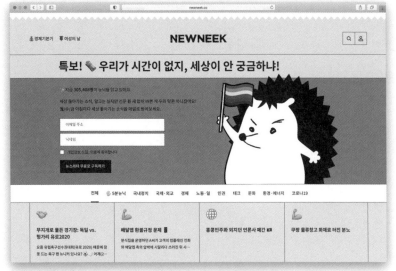

뉴닉의 웹사이트.

뉴스를 살아 숨 쉬게

MZ세대가 기존 뉴스를 잘 읽지 않는 이유를 파악하고 해결하기 위해
신경쓴 뉴스레터의 타이포그래피 전략이 있나요?

우선, 모바일 가독성과 공유를 고려하여 글의 분량을 조절하고
있습니다. 뉴니커는 저희 뉴스레터를 웹보다 모바일에서 더
많이 봐요. 초반에는 별다른 광고 없이 입소문으로 구독자가
늘었는데, FGI(Focus Group Interview)를 통해 그들이 캡처한
화면을 카카오톡 등의 메신저로 공유한다는 사실을 알게
됐어요. 그래서 스마트폰 화면에 한 장으로 캡처될 수 있으면서
집중력이 분산되지 않는 분량을 에디터와 함께 연구했습니다.

글꼴과 색깔도 중요하죠. 뉴스를 이야기하는 곳이기
때문에 특정 정당, 미디어에서 사용하고 있는 글꼴과 색깔은
제외했습니다. 본문은 「노토 산스」를, 주요 색상은 주황색을
사용하고 있어요. (참고로 2020년 국민의당이 생기면서
주황색을 사용하는 정당이 생기긴 했네요.)

이모지 사용에도 몇 가지 주의점이 있습니다. 종류에 따라
여백이 달라져 레이아웃이 깨지기 때문에 글 시작점에서
불릿(bullet)으로 사용하지 않는다면, 문장이 끝나는 위치에
사용하고 있어요. 또한 사람을 나타낼 때는 남녀를 함께
표시하고 순서는 번갈아 가면서 사용해요. 피부색 역시 인종
구분 없이 기본값인 노란색을 사용하고 있어요.

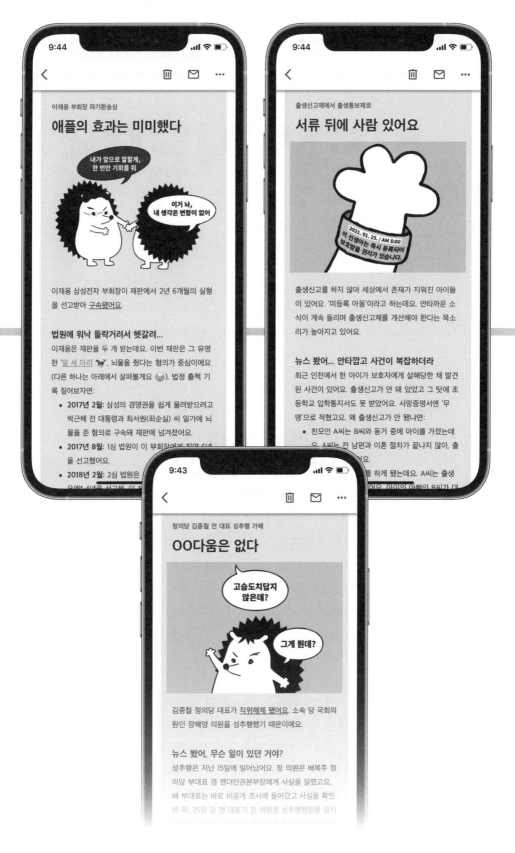

9:44

이재용 부회장 파기환송심

애플의 효과는 미미했다

내가 앞으로 잘할게,
한 번만 기회를 줘

이거 놔,
내 생각은 변함이 없어

이재용 삼성전자 부회장이 재판에서 2년 6개월의 실형
을 선고받아 **구속됐어요**.

법원에 워낙 들락거려서 헷갈려...
이재용은 재판을 두 개 받는데요. 이번 재판은 그 유명
한 '**말 세 마리** 🐴', 뇌물을 줬다는 혐의가 중심이에요
(다른 하나는 아래에서 살펴볼게요 😊). 법정 출석 기
록 짚어보자면:

- **2017년 2월:** 삼성의 경영권을 쉽게 물려받으려고
 박근혜 전 대통령과 최서원(최순실) 씨 일가에 뇌
 물을 준 혐의로 구속돼 재판에 넘겨졌어요.
- **2017년 8월:** 1심 법원이 이 부회장에게 징역 5년
 을 선고했어요.
- **2018년 2월:** 2심 법원은 ~~집행
 유예~~ 실형을 선고했어요. 이 부 ~~~

9:44

출생신고제에서 출생통보제로

서류 뒤에 사람 있어요

2021. 01. 25. / AM 5:00
이 신생아는 즉시 등록되어
보호받을 권리가 있습니다.

출생신고를 하지 않아 세상에서 존재가 지워진 아이들
이 있어요. '미등록 아동'이라고 하는데요. 안타까운 소
식이 계속 들리며 출생신고제를 개선해야 한다는 목소
리가 높아지고 있어요.

뉴스 봤어... 안타깝고 사건이 복잡하더라
최근 인천에서 한 아이가 보호자에게 살해당한 채 발견
된 사건이 있어요. 출생신고가 안 돼 있었고 그 탓에 초
등학교 입학통지서도 못 받았어요. 사망증명서엔 '무
명'으로 적혔고요. 왜 출생신고가 안 됐냐면:

- **친모인 A씨는 B씨와 동거 중에 아이를 가졌는데**
 요. A씨는 전 남편과 이혼 절차가 끝나지 않아, 출 ~~~
  ~~~ 하게 됐는데요. A씨는 출생
  ~~~ 아이의 아빠인 B씨가 대

9:43

정의당 김종철 전 대표 성추행 가해

OO다움은 없다

고슴도치답지
않은데?

그게 뭔데?

김종철 정의당 대표가 **직위해제 됐어요**. 소속 당 국회의
원인 장혜영 의원을 성추행했기 때문이에요.

뉴스 봤어, 무슨 일이 있던 거야?
성추행은 지난 15일에 일어났어요. 장 의원은 배복주 정
의당 부대표 겸 젠더인권본부장에게 사실을 알렸고요.
배 부대표는 바로 비공개 조사에 들어갔고 사실을 확인
한 뒤, 25일 김 전 대표가 장 의원을 성추행했음을 공식

스마트폰 화면 한 장으로 캡처할 수 있는 분량과 레이아웃.

NEWNEEK

뉴닉의 로고.

들어보니 레거시 미디어에서 다루는 이슈가 공감되지 않고
딱딱하고 어려운 말이 우리를 향하는 것 같지 않다는 대답이
돌아왔어요. 하지만 세상이 궁금하다는 말과 함께요. 그래서
뉴닉은 처음부터 그들의 니즈를 기반으로 탄생했습니다.

본격적으로 디자인을 하면서 "나 뉴닉 읽어"라는 말의 의미가
달라야 한다고 상상했어요. 고리타분하지 않고 재미있게
똑똑해질 수 있고, 다양한 의견들이 존중받을 수 있는, 지금
우리가 정말 궁금하고 알아야 하는 이슈에 대해 소통할 수
있는 곳을 만들려고 노력했어요. 그 노력 중 하나가 그날의
주요 이슈를 쉽게 설명해주는 '고슴이'라는 화자입니다.
뉴스레터 특성상 편한 친구와 메일을 주고받는 경험을 만들고
싶었거든요. 고슴이를 디자인하면서 그가 비주얼뿐 아니라
뉴닉 이름으로 구독자를 만나는 모든 접점에 관여하도록
했습니다. 또한, 디자이너로서 고슴이의 성격과 말투가
누군가에게 상처를 주지 않을지 고민하고, SNS 운영, 굿즈
제작, 마케팅 기획, 이슈 선정 등 고슴이가 뉴니커(뉴닉
구독자를 부르는 애칭)와 어떻게 관계 맺을지도 챙깁니다.
하나 더 재미있는 예를 들자면, 대표가 인터뷰나 강연 때 어떤
옷을 입고 나갈지도 확인하는 편이에요. 대표가 고리타분해
보이지 않길 바라거든요. 가끔은 모범생처럼 입지 말고, 탈색을
해도 부족하다고 잔소리도 해요.

뉴닉은 어떻게
뉴스를 살아 숨 쉬게 했나

양수현

디자이너 양수현

『글짜씨』 독자들에게 인사와 소개를 부탁드립니다.

밀레니얼 세대를 위한 시사 뉴스레터 뉴닉에서 그래픽
디자이너로 브랜딩을 담당하고 있습니다. '고슴이'라는
캐릭터를 만들어 고슴맘이라고도 불리는데, 얼마 전 출산을 해
진짜 엄마가 되었습니다.

뉴닉 초창기부터 그래픽 디자이너로 합류한 것으로 알고 있습니다.
디자이너로서 하나의 브랜드를 만들기 위해 어떤 일을 하고 있고
브랜드에 어떻게 개입하는지 듣고 싶습니다.

2018년 여름, 뉴닉 김소연 대표와 빈다은 공동대표를 처음
만났을 때 그들이 제게 이렇게 말했습니다. "힙하고 재밌고
진정성 있는 브랜드를 만들고 싶어요. 뉴스를 다루지만
미디어가 아닌 브랜드로 인식되면 좋겠고요. 힙한 브랜드,
재미있는 브랜드, 혹은 진정성을 강조하는 브랜드는 많지만,
셋을 모두 갖춘 브랜드는 없는 것 같아요. 우리가 함께 만들어
봐요." 애매하고 어려운 요구였지만, 무슨 말인지 이해할 수
있었어요. 저 역시도 그들처럼 레거시 미디어에서 풀리지 않는
갈증을 느끼고 있었어요.

'뉴닉'이라는 브랜드를 만들기 전에 간단히 리서치를
진행했습니다. "젊은 애들은 뉴스 안 봐"라고 쉽게 얘기하지만
정말 그런 건지 궁금했거든요. 잠재 구독자들을 만나 이야기를

워크숍 2〈재생再生하는 글자 — 나의 얼굴, 나의 쓸모〉. 사진: 박재용.

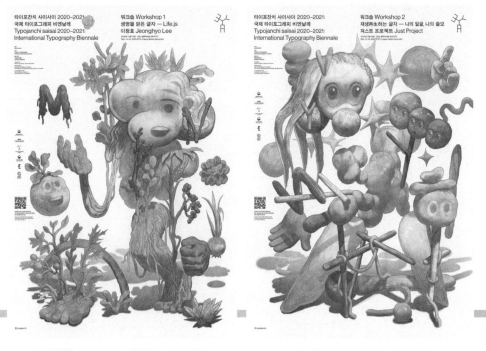

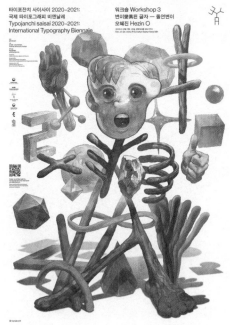

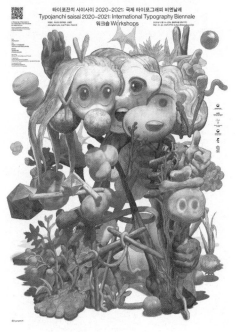

《타이포잔치 사이사이 2020–2021: 국제 타이포그래피 비엔날레》워크숍 포스터.
그림: 이홍민. 디자인: 타이포잔치 기획팀.

워크숍 3 〈변이變異된 글자 — 돌연변이〉. 사진: 박재용.

전통적인 방법론 안에서 글자를 다루는 것보다는 MZ 세대, 환경문제,
인터넷, 미디어아트, 생물 등을 키워드로 삼는 이야기들에 더 비중을
두었던 이번 《사이사이》 행사의 구성을 다소 당황스럽게 느끼실
분들도 있으리라 예상한다. 타이포그래피는 그래픽 디자이너들이
주로 쓰는 도구이자 방법론이다. 《타이포잔치》는 자연스럽게
'타이포그래피 잔치'로 간주되고, 그래픽 디자이너들이 만들고
즐기는 잔치로 인식되는 경향도 있다. 모바일 메신저나 이메일 작성
폼 등에서 문자와 정보를 쉽고 보기 좋게 만드는 타이포그래피
활동은 디자이너가 아니더라도 누구나 하고 있다. 그 과정에서 자주
사용되는 이모지나 애니메이션 등의 새로운 요소도 엄연한 오늘날
타이포그래피의 부분으로 간주할 수 있다. 이 잔치를 찾을 수 있는
손님의 범위를 그래픽 디자이너나 타입 디자이너로 제한하고 싶지는
않았고, 그것은 《타이포잔치》의 지평을 더 넓힐 수 있는 부분과도
관련이 있다고 생각했다. 이번 《사이사이》의 포스터에는 분해되거나
재조합된 육체처럼 보이는 것들이 등장한다. 글자나 그 레이아웃을
직접적으로 다루지 않더라도 '뼈와 살' 같은 소재는 타이포그래피의
개념을 상징적으로 보여준다. 글자가 아닌 상상력을 자극하는 그림을
전면에 내세운 포스터 연작과, 행사 정보 및 신청을 위한 웹페이지,
영상 화면의 여러 디자인을 통해서도 그러한 생각을 공유하고 싶었다.

하기와라 슌야(萩原 俊矢)는 '정보에 대한 능동성'을 기반으로 자신의
주된 활동 영역인 인터넷이라는 매체, 또는 그 외연의 '인터넷스러운
것들' 안에서 익숙한 개념들의 과감한 트위스트를 통해 매체에 대한
한계와 고정관념을 벗어났던 경험을 이야기했다. 저마다 자신의
감각과 지능을 계발해 외부로 정보를 보내고 또 받아들이며 '발신하는
것'을 생명의 가장 대표적인 특성으로 간주해 이를 테마로
1995년부터 시도해 온 다양한 작품과 사유를 되돌아보았던 박영신과,
표현의 재료로서 문자를 활용하며 세계적인 그래픽 디자이너로
거듭나기까지의 과정과 대표작을 소개했던 에리히 브레히뷜
(Erich Brechbühl)의 이야기도 들어보았다.《사이사이》토크에는
총 2,201명이 사전신청을 했고, 무료 행사임에도 불구하고 1,577명이
실제로 행사에 접속하여 평소 오프라인 이벤트와 비교해볼 때 훨씬
많은 대중과 소통할 수 있었다.

온라인 토크 스크린샷. 왼쪽부터 양수현, 박영신, 에리히 브레히뷜.

주제가 내포한 다채로운 가능성을 탐색해 보았던 《사이사이》
토크에서는, 각자 다른 방식으로 디자인·생명·환경·문자에 관해
연구해온 국내외 여섯 명의 디자이너와 활동가를 초대해 각자의
케이스 스터디와 통찰을 공유해 달라고 부탁했다. 팬데믹 상황에
적합한 온라인 비대면 형식으로 기획하여 워크숍 때보다 더 많은
사람에게 참여 기회를 제공하고자 했다. 양수현은 새로운 세대를
위한 뉴스레터 플랫폼 뉴닉의 브랜딩 경험을 통해 캐릭터를
개발하고 팬덤을 형성하는 등의 새로운 서비스 운영 및 디자인
방식을 고안해 낸 이야기를 들려주었고, 정다운은 '일회용 컵이
없는 카페가 가능할까.'라는 질문을 시작으로 지속 가능한 일상을
제안하는 플랫폼을 만들고 운영한 경험을 통해 환경과 생명에 대한
적극적인 관심과 변화를 촉구했다. 비그스튜디오(Byggstudio)의
소피아 어스터러스(Sofia Østerhus)는 공공 프로젝트에 전통적이고
지역적인 특색의 공예적 기법을 적용하거나, 특정 지역의 고유한
식물을 바탕으로 사이니지를 만드는 등, 평범하고 무기력했던 공공
공간을 활기차게 변모시켰던 과정을 공유했다.

워크숍 1 〈생명을 얻은 글자—Life.js〉. 사진: 박재용.

《사이사이》워크숍은 전통적인 타이포그래피나 시각 디자인을
다루는 것이 아니라 텍스트 기반의 프로그래밍을 통해 '디지털상의
생명'을 만들어보는 정효의 〈생명을 얻은 글자—Life.js〉로 다소
과감하게 시작했다. 이후, 쓸모나 기능을 다한 글자를 전혀 다른
용도로 부활시켜보는 져스트프로젝트(Just Project)의 〈재생再生
하는 글자—나의 얼굴, 나의 쓸모〉, 자의적인 미감을 통해 그리기
도구를 직접 만들어보며 조건을 바탕으로 드로잉 해보는 오혜진의
〈변이變異된 글자—돌연변이〉가 뒤를 이었고, 워크숍의 성격과 방역
문제를 고려해 매우 소규모인 7-15인으로 두 번씩 총 여섯 번에 걸쳐
진행했다. 참여자들이 결과보다는 과정을 즐기며 문자와 생명에 대해
함께 상상하고 탐색해보기를 바랐다. 한편, 본디 온라인으로 개최된
한국타이포그라피학회의 전시《만질 수 없는》이《사이사이》워크숍
장소인 문화역서울284의 RTO에서 오프라인 전시로 이어지는
기회를 만들어 학회와《타이포잔치》의 연계를 더 공고히 했고,
워크숍 참여자들에게도 관람의 기회를 제공했다.

타이포그래피와
여러 가지 것들 사이에서

이재민

《타이포잔치 사이사이 2020–2021: 국제 타이포그래피 비엔날레》
(이하《사이사이》)는 본 전시에 앞서 그 주제를 미리 탐색하며
기대감과 가능성을 보여주기 위한 사전행사로, 해당 예술감독의
재량에 따라 심포지엄, 워크숍, 전시 등의 다양한 방식으로 구성된다.
이번《사이사이》는 2020년 12월 14일부터 22일까지 진행한
워크숍과 2021년 5월 1일의 토크로 구성했다. 조직위원회에서
결정한 '문자와 생명'이라는 주제는 어느 정도 팬데믹의 시의성을
담고 있다 여겨진다. 하지만 거리 두기에 지친 관람객들에게
너무 심각한 메시지를 던지거나 계도하는 방향으로 그 주제를
풀어내고 싶지는 않았다. 그렇다고 주제를 구체적으로 어떻게
풀어갈지 세부적인 아이디어가 정해진 것도 아니었다. 그런
상황에서《사이사이》를 진행해야 했기에 본 전시의 예고편이나
미리 보기라기보다는, 주제를 어느 방향으로 어디까지 확장할 수
있을까 스케치해보는 기회로 삼는 것이 더 마땅했다. 두 가지 행사인
워크숍과 토크는 문자와 생명이라는 두 단어의 조합으로 표현할 수
있는 여러 가지 가능성을 시도해보고자 했던 결과다.

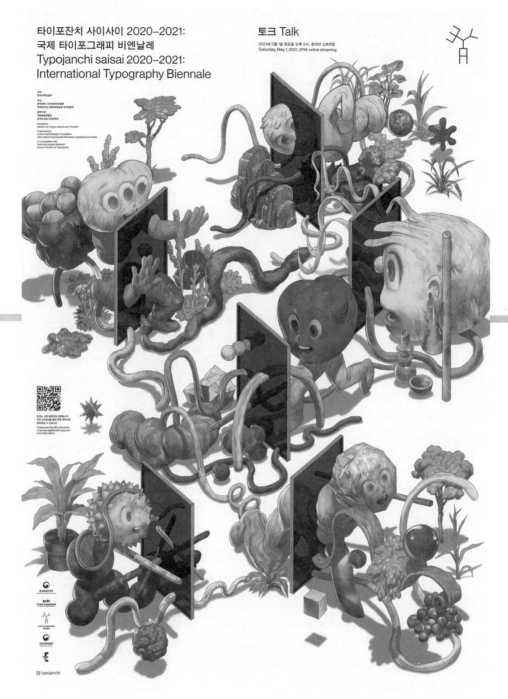

타이포잔치 사이사이 2020–2021:
국제 타이포그래피 비엔날레
Typojanchi saisai 2020–2021:
International Typography Biennale

토크 Talk

2021년 5월 1일 토요일 오후 2시, 온라인 스트리밍
Saturday, May 1, 2021, 2PM; online streaming

주최:
문화체육관광부

주관:
재단법인 디자인문화재단
국제타이포그래피비엔날레 조직위원회

함께한 곳:
국립한글박물관
한국타이포그라피학회

Hosted by
Ministry of Culture, Sports and Tourism

Organized by
Korea Craft & Design Foundation
International Typography Biennale Organizing Committee

In cooperation with
National Hangeul Museum
Korean Society of Typography

위 또는 사진 등록이 가능합니다.
위의 QR코드를 통해 레지스터
페이지를 볼 수 있습니다.
Please scan the QR code above
to access registration page and
more information.

ⓘ typojanchi

《타이포잔치 사이사이 2020–2021: 국제 타이포그래피 비엔날레》토크 포스터.
그림: 이홍민. 디자인: 타이포잔치 기획팀.

타이포잔치 사이사이 2020-2021: 국제 타이포그래피 비엔날레

워크숍: 2020년 12월 14–22일
토크: 2021년 5월 1일

총감독: 이재민
큐레이터: 박이랑, 조효준

주최: 문화체육관광부
주관: 한국공예·디자인문화진흥원,
국제타이포그래피비엔날레 조직위원회
협력기관: 국립한글박물관, 한국타이포그라피학회
공인: 국제디자인협의회

[9] 「호코 헤비」 제작 과정.

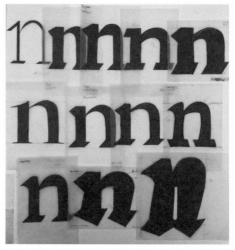

[10] 'n'의 굵기 테스트. 아주 가는 굵기부터 아주 굵은 굵기까지 그려보았다.

[11] 「호코」 사용 예시.

과정이자 타이포그래피 탐험의 시작점이라는 의미가 있다. 앞으로
탐구의 폭을 넓히고 협력을 이어나갈 수 있기를 희망한다. 향후를
위한 흥미로운 소재도 계속 발굴하고자 한다.

HOKO Regular

abcdefghijklmn
opqrstuvwxyz fifl
ABCDEFGHIJKLMN
OPQRSTUVWXYZ
0123456789
€$@[(*)]?!-–—/.,:;·."""' «»&
æœ àåçëíñôü ÆŒ
ÀÅÇÉÎÑÔÜ

Hoko Regular Features:
Dynamic form, sharp stroke, asymmetrical structure

HOKO Heavy

abcdefghijklmn
opqrstuvwxyz
ABCDEFGHIJKLMN
OPQRSTUVWXYZ

Hoko Heavy Features:
Super bold stroke, narrow counter spaces, asymmetrical structure

「호코」: 이중 언어 도시의 타이포그래피

작업

[8]「호코 레귤러」와「호코 헤비」.

[4] 「호코」의 초기 스케치.

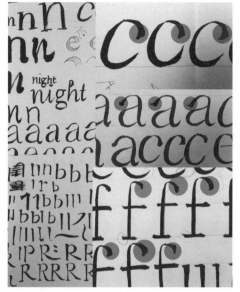

[5] 서예용 붓으로 쓴 라틴 문자.

[6] 서예의 감성이 담긴 「호코」의 두 번째 스케치.

[7] 「호코」의 최종 스케치. 한자 획의 특징을
파악하고 재해석해 라틴 문자의 구조에 맞게
적용했다.

역시 느껴졌다.[도판 6]

하지만 두 문자 간의 균형을 맞추는 것이 프로젝트의 주요 과제 중 하나였다. 한자 서체의 획을 그대로 라틴 문자에 적용한 것은 잘못된 접근 방식이었다. 두 문자는 극도로 비대칭을 이룬다. 본문을 위한 서체를 디자인할 때면 더 나은 읽기 환경을 조성할 수 있도록 글자의 형태를 보다 시각적으로 안정되게 처리해야 한다. 따라서 한자 서체의 획을 그대로 가져오는 것이 아니라, 그 특징을 파악하고 재해석해 라틴 문자에 적용해야 했다. 이 과정을 거쳐 만든 「호코」의 최종 스케치를 보면 획의 곡선이 완화되어 글자가 더 안정적으로 보이는 효과를 확인할 수 있다.[도판 7] 글자 'e'의 줄기와 막대는 거의 직선을 이루고 있다. 세리프의 모양은 평행사변형에 가깝지만 어느 정도 곡선이 적용되어 있어 독특한 세리프 시스템을 구현하고 있다.

「호코」는 두 가지 굵기가 있는데, 본문에는 중간 굵기를, 제목에는 다소 굵은 굵기를 주었다.[도판 8] 글자 형태는 역동적이다. 붓글씨의 영향을 받아 글자의 획은 날카로우면서 살짝 비대칭적인 구조를 지니고 있다. 「호코 헤비」는 더 큰 스케일에 적용 가능한 굵고 강렬한 활자로 먼 거리에서도 쉽게 눈에 띈다. 좁은 속공간과 두꺼운 획, 그리고 살짝 비대칭을 이루는 구조가 특징이다. 굵은 굵기의 글자는 매우 흥미로운 작업이었다. 「호코 헤비」는 상당히 강렬하고 시선을 잡아 끄는 특징이 있기 때문에 북위체 간판과 더 어울린다.[도판 9-10]

「호코」는 완성된 작업이기보다는 하나의 실험이다. 이 프로젝트는 학습의

HONG KONG
BEIWEI
KAISHU

Hong Kong Beiwei Calligraphy Type
designed by TRILINGUA

北 d 風 j 港 K

HOKO

香

港

TYPEFACE INSPIRED BY
Hong Kong Beiwei Kaishu Calligraphy.
Beiwei Kaishu in fact performs very well at
largescales and viewed from fair distances.
The beginning, endings and turns of strokes are very sharp
and exaggerated, making the shapes of the characters very distinctive
and easy to recognise.

「호코」: 이중 언어 도시의 타이의 타이포그래피

작업

[3] 「호코」 견본.

Tam)은 다음과 같이 설명한다. "청대에
이르러 서화 연구가 다시 부흥했고,
서예가들은 '종이에 먹물'을 고수하던
북쪽 유파와 남쪽의 비문 유파로
나뉘어졌다. 하지만 북위체라고 불리던
해서체라는 독특한 서체가 있었는데,
홍콩이 그 발상지라고 볼 수 있다."
북위 해서체는 북위 왕조 시대(386-
534년)로 거슬러 올라가며, 비문은 물론
역사적 기록에도 쓰였다. 글씨를 새길
때 끌이 남긴 자국에서 영향을 받은 북위

[2] 북위 해서체가 사용된 홍콩의 한 찻집 간판.

해서체는 날카로운 획, 역동적 형태, 그리고
경미하게 비대칭인 구조를 특징으로 한다.

필자는 북위체의 매우 친숙하면서 특별한 느낌을 좋아한다.
지금 살고 있는 도시의 약국, 찻집, 식당, 오래된 인쇄소, 의원, 산업
시설 등 어느 곳에서든 이 서체를 찾아볼 수 있다. 북위체는 단독으로
쓰기도 하지만 영어와 병기되기도 한다.

타입파리에서 서체 디자인 프로젝트 주제를 고를 때
이방인으로서 고향과 관련된 뭔가를 만들어보겠다고 결심했다.
동시에 프로젝트가 실험적이고 재미있는 요소를 지니고 있기를
원했다. 그렇기에 북위체를 떠올렸고, 이어서 질문이 떠올랐다.
'라틴 문자를 북위체로 쓰면 어떤 느낌일까.' 당시 홍콩에는 북위체를
디지털화하려는 디자이너들이 있었다. 그들과 마찬가지로 북위체
스타일이 적용된 라틴 서체를 디자인하고 디지털화해보고 싶었다.

활자의 형태와 세부 요소를 결정하기 전에 몇 가지 연구가
필요했다. 「호코」의 초기 디자인은 서예가들이 돌에 끌로 새긴 글자의
형태를 참고해서 매우 뾰족하고 날카로운 획을 특징으로 한다. 'n' 'p'
그리고 'f'의 세리프는 평행사변형에 가깝다. 'p'의 끝은 삼각형처럼
뾰족하다. 문자 세트는 다소 대칭적인 인상을 준다. [도판 4] 초안은
너무 진지하고 감성이 부족해서 그다지 만족스럽지 않았다. 다시 말해
북위체와는 거리가 멀었던 것이다.

첫 번째 시도 후 탐색 방향을 전환했다. 원하는 결과물을
위해 다른 매체를 선택해야 했다. 서예용 붓과 먹물로 글씨를 쓰기
시작했고, 이 작업에서 어떤 통찰을 얻고자 했다. [도판 5] 부드러운
붓을 사용했기에 더 역동적인 형태가 만들어졌다. 획의 시작은 두꺼운
반면 끝은 날카로운 형태가 도출되었다. 이렇게 만들어진 획은 서예의
감성에 보다 근접해 있었다. 글씨 쓰기 작업의 결과물을 두 번째 안에
적용했고, 글자들이 생기를 띠게 되었다. 서예적인 리듬과 에너지

조화를 고려해 바꿔야 할지도 모른다. 이 과정에는 아마도 많은 시간이 걸리겠지만, 때로는 마지막 단계에서 예기치 못한 결과물이 나오기도 한다.

　　디자인 작업 시에는 항상 다양한 문자의 우선 순위를 정하는 과정이 선행된다. 다시 말해 독자가 어떤 문자를 먼저 접하게 될지 결정하는 것과 같다. 대부분의 경우 서로 다른 문자에 동일한 지위를 부여하지 않는다. 왜냐하면 대상 언어 그룹을 기준으로 어떤 문자를 더 중요하게 다뤄야 하는지 결정해야 하기 때문이다. 그러나 독자는 단일 언어 또는 이중 언어 사용 여부에 관계 없이 다른 언어 콘텐츠의 그래픽적 표현에 영향을 받을 수밖에 없다. 따라서 두 문자가 같은 레이아웃상에 위치할 때는 서로 조화를 이루도록 디자인하여 독서를 방해하지 않도록 조정해야 한다.

　　최근에 작업한 한 작가의 전시《柔和之光 Softened》의 포스터가 좋은 예다. 이 전시의 대상 관객은 홍콩 현지인이다. 제목이 네 개의 한자와 하나의 영어 단어로 표현되기 때문에 한자를 크게 표기하면서도 두 문자 간의 조화를 이룰 수 있는 방법을 고민해야 했다. 그리고 자칫 한자 '柔和之光'가 'Softened (유화된)'라는 단어의 꾸밈을 받는 듯한 인상을 줄 수도 있다. 실제 작업에서는 두 문자의 균형을 맞추기 위해서 그래픽적 장치가 사용되었다. 또한 이 작업을 위해 한자 폰트를 사용자 정의를 통해 조정해야 했다. 가로획의 두께를 대폭 줄였고, '之'와 '光'는 일부 획을 연결시키는 대신 떨어뜨려서 글자 간의 공간을 좀 더 확보했다. 각 한자의 단부는 둥글게 처리해 라틴 문자와 조화를 이루게끔 했다. 또한 문자 사이에 넓은 커닝을 적용했다. [도판 1]

「호코」

◆보통화는 표준 중국어로 간체자를 사용한다. 만다린어라고도 불리며 중국에서 광범위하게 사용된다. 광둥어는 방언으로 번체자를 사용한다. 광둥성, 홍콩, 마카오 등에서 사용되며 보통화와 달리 아홉 가지 성조를 가지고 있다.

◆◆2015년 티포폰더리 (Typofonderie) 팀에 의해 시작된 타입파리는 타입 디자인 교육 프로그램으로, 매주 진행하는 공개 토크를 포함한다.

나는 여름 프로그램인 '타입파리(TypeParis)'◆◆ 기간에 「호코」를 디자인했다. 「호코」는 홍콩의 북위 해서체에서 영감을 받은 인문적 느낌의 서체이다. 1950년대에서 1960년대부터 홍콩에서는 대형 간판에 북위체가 일반적으로 사용되었다. 홍콩에 오게 되면 누구나 쉽게 북위체 스타일의 간판을 가진 전통적 상점을 찾아볼 수 있다. [도판 2] 북위체는 멀리서도 식별 가능할 만큼 획이 굵고 강렬하다. 그러니 매우 활기찬 느낌을 주고 눈에 쉽게 띈다. 하지만 요즘 들어 간판에 북위 해서체를 쓰려는 가게들이 거의 없기 때문에 이 서체는 사라질 위험에 처해 있다.

　　홍콩의 타이포그래퍼 키스 탐(譚智恒, Keith

「호코(Hoko)」: 이중 언어 도시의 타이포그래피

이중 언어 도시 속 타이포그래피의 조화

영어는 홍콩이 영국 식민지로 할양된 1842년부터 이 도시의
공용어였다. 중국어는 1974년에 이르러 반식민지 폭동을 계기로
영어와 함께 공동 공용어의 지위에 올랐다. 오늘날 홍콩의 공용어는
여전히 영어와 중국어이다. 홍콩 인구의 대다수는 광둥어를 사용하며,
보통화*와 매우 유사한 방식의 글쓰기를 교육받는다. 하지만 홍콩에서
사용되는 공식 문자는 번체인 반면 중국 본토에서는 간체를 공식
문자로 사용한다는 점에서 다르다.

　　　홍콩의 디자이너로서 필자의 작업 대부분은 중국어와 영어의
이중 언어를 기반으로 한다. 하지만 주지하다시피 한자와 라틴
문자는 언어적으로는 물론 시각적으로도 크게 다르다. 한자는 매우
복잡한 형태를 가지고 있고, 특히 번체의 경우에 이런 특징이 훨씬
두드러진다. 반면 라틴 문자는 모듈화된 획과 형태를 지니고 있으므로
매우 간단한 구조를 보인다. 그런 까닭에 작업을 진행하면서 두
문자의 균형을 맞추는 일은 항상 까다롭게 느껴진다. 동일한 레이아웃
안에서도 한자는 라틴 문자에 비해 항상 더 '강해' 보이기 때문이다.
이는 한자가 복잡한 구조 탓에 주어진 공간을 더 많이 차지하는 데서
기인한다. 예를 들어, '열쇠'를 나타내는 한자는 '鑰匙'이다. 포스터에
이 단어를 넣는다면 색상, 무게, 크기, 서체, 또는 그래픽 장치까지

[1] 《柔和之光 Softened》 포스터. 한자와 라틴 문자의 균형을 고민했다.

[4]「구명조」의 디테일.

[5]「기계 명조(Mechanical Mincho)」의 디테일.

큰 그림에만 초점을 맞춘다면 디자인의 사소한 세부 요소를 간과하기
쉽다. 하지만 필자는 보통 이런 복잡한 세부 요소에 공을 들인다.
[도판 4-5] 작업 과정을 살펴보면, 프로젝트에 적합하다고 생각하는
한자·히라가나·가타카나·라틴 문자의 글자체를 조합하고, 이후에
미세한 조정 작업을 진행한다. 디자인의 완성도를 위해 한 단락에
무려 일곱 개의 다른 글꼴을 사용한 적도 있지만, 다른 디자이너나
독자는 이를 거의 알아차리지 못했다. 때로는 원하는 독서의 흐름과
리듬, 회색도를 완벽하게 만들고자 2주 이상 미세한 조정이나
테스트를 진행하기도 한다. 숱한 시행착오는 홍콩 디자이너로서
한자 조판 기술을 연마할 수 있는 유일한 방법인 것 같다. 과거를 통해
배우고, 주위 사람들과 아이디어를 교환하는 것은 언제나 빠르게
성장할 수 있는 방법이다.

[3] 『LOLOSOSO』.

2019년에는 홍콩의 저명한 디자이너 어나더마운틴맨(another-mountainman)의 자서전 『LOLOSOSO』의 디자인을 담당했다. 책의 제목인 'LOLOSOSO'는 광둥어로 잔소리 또는 수다를 의미하는데, 제목처럼 책 전체에 많은 단어가 등장한다. 그리고 이 디자인은 '구룽(九龍, Kowloon)의 왕'으로 알려진 창초우초이(曾灶財, Tsang Tsou Choi)의 작업에서 많은 영감을 받았다.[도판 2] 창초우초이의 작업은 어렸을 때부터 홍콩 시내 전역에서 쉽게 발견할 수 있었고, 어나더마운틴맨 역시 창초우초이의 작업을 기반으로 많은 예술 작품을 만들어 왔다. 이런 이유로 이 개념이 책의 정체성과 완벽하게 어우러진다고 생각했고, 그 결과 타이포그래피로 조밀하게 구성된 하나의 '건축물' 같은 책을 구축하기에 이르렀다. 책의 표지는 일반적으로 입구로 기능하며, 입구를 통해 미리 정해진 선형적인 읽기의 흐름을 따라가는 독서의 여정으로 이어진다. 하지만 이 작업에서 나는 다른 접근 방식을 채택했다. 바로 독자들이 독서의 여정을 어디에서부터 시작해야 할지 스스로 선택할 수 있도록 다양한 크기와 굵기의 글꼴을 사용해 책을 디자인한 것이다. 이를 통해 독자들이 각자가 정한 순서에 따라 책을 탐험할 수 있고, 독서의 여정에서 자신만의 리듬을 따라갈 수 있게 했다.[도판 3]

[2] 창초우초이의 작업.

靑

約 歸 停 實 強
終 步 像 對 動
膠 游 嘴 少 力
草 漫 如 康 化

結 慧 台 藍 炙 婉 微 北
能 擁 光 藥 灰 存 愛 去
美 文 亮 製 產
英 武 傳 謊 發
螞 此 元 變 瑜
謊 深 只 公 粒

藍

[1]「구명조」

「구명조」

지금으로부터 5년여 전에, 절친한 친구이자 모노타입의 전 선임 글자체 디자이너인 줄리어스 후이(許瀚文, Julius Hui)의 새로운 글자체 디자인 프로젝트「구명조」에 참여해 서체 디자인 기술을 배우고 익혔다. [도판 1] 기존의 다양한 중국어 서체 중에서 명조체(明朝體, mincho)◆는 그 구조와 획이 한자의 고전적 운율과 인본주의적인 분위기를 가장 잘 보여주기 때문에 언제나 가장 선호하는 서체이다. 또한 명조체는 중국 전통 서예법에서 유래한 만큼 부드럽고 감성적인 획을 구현하므로 문자로 표현되는 메시지 이상을 느낌을 전달할 수 있다. 하지만 현재 서체 시장에서는 중국어 번체가 거의 배제되고 있기에, 일부 디자이너들은 한자를 일본어 글자체에서 찾아 사용하기도 한다. 그 이유는 일본에서는 우수한 한자 글자체가 시장에 지속적으로 공급되고 있기 때문이다.

◆ 명나라 때 만들어진 글자체라는 뜻이지만 실제로는 송나라 때의 글자체인 송체의 형태에 더 가까워서 중국 본토에서는 송체(宋體, song ti)라고 한다.

「구명조(KuMincho)」와 『LOLOSOSO』: 디테일로 쌓아가기

다양한 문자가 만드는 문화 질감

고등학생 시절부터 타이포그래피와 디자인 세계에 빠져들었던 필자에게 홍콩의 독특한 문화적 질감은 언제나 마음을 사로잡기에 충분했다. 한 세기 반 이상 영국의 식민지로 존재했던 홍콩에서는 중국어와 영어가 일상 생활에서 동등한 지위를 차지하면서 이중 언어 문화를 형성했다. 다른 도시와 비교했을 때 홍콩 디자이너로서 누릴 수 있는 가장 큰 특권은 다양한 문자를 다룰 수 있는 능력을 갖추고 있고, 따라서 더 광범위한 전 세계 고객층에게 다가갈 수 있다는 점일 것이다.

필자가 진행하는 대부분의 디자인 작업은 이중 언어 또는 삼중 언어를 다루는 절차를 수반한다. 디자인 과정에서 가장 노력을 기울여야 하는 부분은 서로 다른 두 서체의 절묘한 균형을 찾고 시각적 인상의 조화를 이루는 일이다. 이제껏 작업해 온 모든 문자 중에서도 가장 선호하는 문자는 단언컨대 한자이다. 틀에 갇힌 다른 문자와는 달리 상형문자에서 파생된 한자는 상상력과 카리스마적 기운을 지니고 있어 보다 과감한 시도를 가능케 하기 때문이다.

예술대학에서 영화를 전공할 때 디자인과 문화를 처음 접하고 새롭게 눈뜬 순간은 당시 영화학 강사였던 영화 평론가 롱 틴(Long Tin)이 학생들에게 일주일에 한두 번씩 꾸준히 1950–1970년대의 흑백 영화를 보여주던 시간이었다. 그가 선택한 영화들은 지금 수준의 기술 발전이 일어나기 훨씬 이전에 촬영되었기에, 우리가 중점적으로 본 부분은 내용과 기법보다는 단순한 색상 구성 안에서 의인화나 물질화를 통해 추상적인 관념을 관객에게 전달하는 방식이었다. 바로 그런 방식이 이 영화들을 시대를 초월한 고전으로 만들었던 것이다. 당시 탐구한 영화들이 필자의 작업에 큰 영향을 주었다고 생각하는데, 그것은 아주 사소한 디자인 요소에서 더 큰 내러티브를 찾아내려는 경향과 관련이 있다.

형태를 가지고 있어서 디자인 과정에서 가장 어려운 과제를 안겨
주었다. 'W'의 경우, 마치 다른 서체처럼 보이기 쉽기 때문에 다른
문자와 전체적으로 일관성을 유지하도록 균형을 부여해야 했다.
[도판 18]

미래 계획

오랜 역사와 전통을 가진 도시가 무관심 속에 조금씩 허물어져
가는 모습을 지켜보는 것은 분명 슬픈 일이다. 한때 홍콩 사람들의
일상의 일부였던 T자형 표지판은 이제 바쁘게 흘러가는 삶의 그늘에
가려져 있다. 언젠가 이 표지판이 그들이 안내하고 있는 건물과 함께
파괴되고 해체되어 사라질지도 모른다고 생각하면 두려워진다.
기존의 전통 유산 보존 방법에 완전히 동의하지는 않지만, 단순히
사진으로 기록하고 박물관에 보존하는 것 이상을 할 수 있다는 것만은
자명해 보인다. 디자이너로서 취할 수 있는 첫걸음은 웹사이트나
전시와 같은 물리적 경로를 통해 글자체를 기록하고 공유해 도시의
역사가 미래 세대에 전승될 수 있도록 하는 것이다. 하지만 더 중요한
사실은 이 글자체가 시간을 초월하는 홍콩의 고전적인 우아함을
지니고 있다는 것이다. 이 글자체는 T자형 표지판 위에서 원래의
목적을 달성한 후에도 미래의 여러 디자이너에 의해 다른 장소나 다른
분야에서 계속해서 쓰일 수 있으리라 생각한다. [도판 19] 이 글자체를
다듬고 완성하는 작업은 계속될 것이고 가까운 미래에 원본에 대한
헌사로서 이 글자체를 대중에게 공개할 수 있기 바란다.

[19] 「ST-RD」 견본.

[14] 윈덤 거리의 T자형 표지판. 사진: 베니 라이 (Benny Lai). http://www.facebook.com/ hkhistory.org

[15] 코놋 중앙로의 T자형 표지판. 사진: Hong Kong Road Signs. http://www.facebook.com/ hkhistory.org

KENNEDY RD.
JAFFE RD.
WHITFIELD RD.
STEWART RD.
DES VOEUX RD.
O'BRIEN RD.
NATHAN RD.
WILSON RD.
CHATER RD.

JUBILEE ST.
PEDDER ST.
GOUGH ST.
RUMSEY ST.
ELGIN ST.
APLJU ST.
CLEVERLY ST.
COCHRANE ST.
D'AGUILAR ST.

[16] 「ST-RD」글자체로 이루어진 다양한 홍콩 도로와 거리 이름.

R R

[17] 대각선 획의 각도가 다양하게 표현된 'R'.

W

[18] 'W'의 작업 과정.

ABCDEFGHI
JKLMNOPQ
RSTUVWXYZ
1234567890
&₽T.,""!?/-()

[13] 「ST-RD」 글자체의 전체 문자 세트.

(Old Road Sign)」「AES 미니스트리(AES Ministry)」와 같은 영국
도로 표지판에 사용된 글자체 조사를 신중하게 진행했지만, 자세한
분석 결과 이들 모두 T자형 표지판에 사용된 것과는 달랐다.[도판 10-
12] 결론적으로 원본 글자체 찾기는 실패했다. 대신 글자체 창작자에
대한 일종의 헌사로서 원본 글자체의 복제본을 직접 만들어 보았다.
T자형 표지판은 60년 넘게 풍화와 침식에 노출되었기 때문에 수십
번의 현장 조사와 방대한 데이터 수집에도 불구하고 정확하게 동일한
글자체를 만들어내기란 불가능했다. 대신 「ST-RD」를 만들었고,
T자형 표지판 글자체에 최대한 가깝게 디자인했다.

　　　이 프로젝트에서 가장 힘들었지만 보람 있었던 부분은 거의
모든 사례를 참고해도 해당 글자체로 전체 알파벳을 조합하는 것은
불가능했기 때문에 명확하지 않고 존재하지 않는 글자체를 창조해야
했다는 점이다. 처음부터 모두 디자인해야 했던 일부 글자의 경우,
퍼즐의 사라진 조각을 맞추는 식으로 작업했고, 마무리에 가까워짐에
따라 서서히 완성되어 만족스러운 결과에 도달할 수 있었다.

　　　'Rd.'와 'St.'에 쓰인 독특한 글자체 외에도 문자 'R'과 'W' 역시
주목할 가치가 있다. 표지판에서 'R'은 여러 글자체로 표현되었는데,
이 가운데 일부는 더 넓은 대각선 획(꼬리)을 특징으로 하지만, 다른
글자체에서는 해당 특징을 찾아볼 수 없었다. 오픈타입에서 대안을
만들 수도 있었겠지만, 원본의 고유한 특징을 유지하고자 넓은 꼬리
버전을 사용하는 쪽을 택했다.[도판 17] 한편, 'W'는 무겁고 좁은

[10] 조크 키네르(Jock Kinneir)와 마거릿 캘버트(Margaret Calvert)가 디자인한 「트랜스포트」의 전체 라틴 문자와 숫자 세트. 폰트 파일은 나다니엘 포터(Nathaniel Porter) 제작. 사진: http://www. roads.org.uk/fonts

[11] 「올드 로드 사인」의 전체 라틴 문자와 숫자 세트. 폰트 파일은 톰 서치(Tom Sutch) 제작. 사진: http://www. roads.org.uk/fonts

[12] 「AES 미니스트리」 의 전체 라틴 문자와 숫자 세트. 폰트 파일은 해리 블래킷(Harry Blackett) 제작. 사진: http://www. roads.org.uk/fonts

「ST-RD」

T자형 표지판에서 보통 'road'
와 'street'은 'Rd.' 와 'St.'과 같이
축약된 형태로 나타난다. [도판
8] 간판 화가 존 도우너(John
Downer)의 표현을 빌리자면,
이 축약된 단어는 간판에
글자를 쓸 때 공간 절약을 위해
사용되는 일종의 '단어 로고'이다.

ST ROAD
ST STREET
RD ROAD

[8] T자형 표지판에서 단어 'road'와
'street'는 'Rd.'와 'St.'으로 축약해서
표기한다.

일반적으로 숫자를 가리키는 'No.' 또는 회사를 가리키는 'Co.'와 같은
단어 로고는 흔히 볼 수 있다. 하지만 홍콩의 T자형 거리 표지판의
단어 로고가 특히 매혹적으로 다가왔고, 해당 활자 디자인에 관한
연구의 출발점이 되었다.

　　이런 독특한 T자형 표지판은 현재까지 200여 개가 남아
홍콩의 도시 풍경 속에 숨어 있다. [도판 9] 「ST-RD」 프로젝트의
목표는 점차 도시에서 사라져가는 1930–1960년대에 제작된
T자형 표지판의 서체를 연구, 보존 및 재해석하는 것이다. 가까운
미래에 수행할 연구와 교육을 위해서 표지판의 물리적 형태를
디지털로 전환하는 작업을 통해 그 기원과 독창성을 보존하는 것이
디자이너의 중요한 책무라고 생각한다.

　　「ST-RD」 프로젝트는 표지판에 사용된 글자체를 조사하는
작업부터 시작했다. 「트랜스포트(Transport)」 「올드 로드 사인

[9] 콘크리트 정글에서 잃어버린 미지의 서체. 홍콩에 남은 유일한 검은색 바탕에
흰색 글씨의 T자형 표지판 '사이 온 레인(Sai On Lane)'. 사진: 버튼 램(Burton Lam).
http://www.facebook.com/hkhistory.org

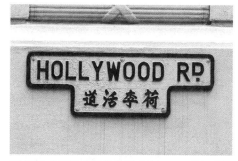

[6] 홍콩 타이쿤에 위치한 할리우드 로드의 T자형 표지판. 사진: Hidden Hong Kong.

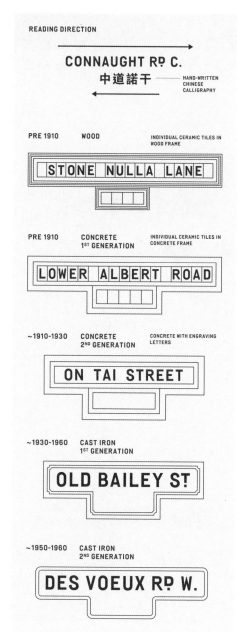

[7] 다양한 유형의 T자형 표지판.

2019년에 이렇게 얻게 된 새로운 시각과 함께 홍콩으로 돌아가기로 결정했다. 디자이너의 눈으로 표지판을 관찰하는 습관은 이후에도 계속됐다. 그리고 어느 날, 한 거리 안내판이 관심을 끌었다. 2018년에 문화유산 보존 사업이 진행된 전 중앙경찰서 구역 타이쿤에 있는 T자형의 '할리우드 로드 (Hollywood Road)' 표지판이었다. [도판 6] 가운데 정렬된 굵은 산세리프 서체의 영문과 손으로 쓴 한문의 조합은 다문자 디자인으로서 흥미로운 대조를 보여주었다. 이를 계기로 T자형 표지판의 세계와 그 탐구에 빠져들기 시작했다.

T자형 표지판은 초기에 만들어진 거리 안내판 중 하나로, 상단에는 영어 대문자, 하단에는 오른쪽에서 왼쪽으로 쓰인 중국어 번체 문자로 구성된다. 위에 자리 잡고 있는 영문은 당시 영어 문자의 우위를 암시한다고 볼 수 있겠다. 이런 안내판들이 왜 T자형 모양을 가지게 되었는지 자주 자문하곤 했다. 자재를 절약하기 위해서였을까? 명확한 이유는 찾지 못했지만, 이것은 아마도 세계 어디에서도 볼 수 없는 표지판일 것이다.

도시에 남아있는 T자형 표지판은 크게 세 가지 유형으로 나누어진다. 첫 번째 유형은 1910년대 표지판으로 목재 또는 콘크리트 프레임에 개개의 세라믹 타일을 맞추는 방식으로 제작되었다. 두 번째 유형은 1910– 1930년대 표지판으로 콘크리트에 글자를 새기는 방식으로 만들어졌다. 세 번째 유형은 1930–1960년대 표지판으로 수공 주철 판으로 제작되었고 무게가 최대 30kg에 이른다. [도판 7]

[1] 삼각형 형태로 조판된 라틴 문자와 한자.

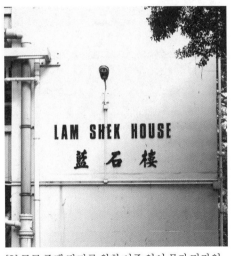

[2] 공공 주택 단지를 위한 이중 언어 문자 디자인.

[3] 홍콩 홀랜드호스텔의 이중 언어 문자 디자인.

[4] 스톡홀름 로드만스가탄 (Rådmansgatan)
지하철역의 표지판.

[5] 모스크바 키엡스카야 (Киевская) 지하철역의
표지판.

「ST-RD」:
콘크리트 정글에서
잃어버린 미지의 서체

피비쿵

홍콩의 타이포그래피 풍경

홍콩의 거리를 거닐다 보면 여러 표지판을 볼 수 있다. 두 언어의
문자와 글자체가 적용된 표지판을 보노라면 영국 식민지 시대의
분위기가 느껴진다. 1997년 홍콩 반환 후, 하나의 디자인에 영어·
중국어 번체·간체 이렇게 3개 언어 시스템이 적용되고 있다.
그중에서도 가장 이질적인 문자 조합은 영어와 번체일 것이다.
그들의 기원, 구조, 필기구, 그리고 전반적인 복잡성의 차이 때문이다.
디자인 측면에서 완전히 다르고 난해한 이 두 문자를 함께 작업할 수
있다는 것은 홍콩 디자이너로서 누리는 선물과도 같다. 한자 글자체의
종류가 제한되어 있기 때문에 라틴 글자체와 어울릴 만한 글자체를
찾기란 언제나 어려운 일이다. 하지만 동시에 한자의 회화적 특성은
디자이너에게 독특하고 새로우면서도 문자의 의미를 잘 나타낼 수
있는 맞춤형 한자 글자체를 만들어낼 기회를 열어 주기도 한다.

 두 개 이상의 문자를 하나의 디자인에서 조화를 이루도록 각
문자에 동일한 중요도를 부여하기란 쉽지 않은 작업이다. 이중 언어
작업을 진행할 때면 항상 더 지배적인 문자가 있어서 어떤 문자에
우위를 부여해야 할 것인지 자문하게 된다. 적절한 균형을 찾기란
절대 쉽지 않지만, 이 도시에서는 다문자 디자인이 도시 전체에 개성
있는 시각 효과를 부여하는 예를 쉽게 찾아볼 수 있다. [도판 1-3].

T자형 표지판

대부분의 사람은 표지판을 볼 때 내용을 본다. 이는 당시 홍콩에
거주하고 있던 필자에게도 마찬가지였다. 해외에서 살기 전까지는
표지판의 '디자인'에 관해 깊이 생각해 본 적이 없었다. 2014년
홍콩 이공대학에서 비주얼 커뮤니케이션 학사 과정을 졸업했고,
지난 5년간 서울, 로테르담, 코펜하겐, 스톡홀름 소재 에이전시와
스튜디오에서 일했다. 외국어를 사용하는 이들 도시에서 표지판의
내용을 더는 이해할 수 없었지만 대신 글자체, 형태, 색상이 환경과
어우러져 도시의 자연스러운 시각 언어를 반영하는 방식을 관찰하기
시작했다. [도판 4-5]

스와시 대문자(swash capital)◆도 포함하는데, 이탤릭으로만 조판할 때 첫 대문자로 사용하면 보다 풍성한 조판을 경험할 수 있다. [도판 10]

마치며

한글 서체와 함께 사용하는 라틴 문자를 만드는 사람은 아마도 다들 한 번쯤 고심하고 애썼던 부분일 것이다. 그러나 이 글에서 미처 다루지 못한 것도 많다. 아직 제작되지 않은 「정체」의 스타일, 무게와 너비 변화 등 새로운 작업이 진행될 때 그에 따른 새로운 문제점을 만나게 될 것이다. 지속해서 그 문제를 해결해 나가며 이를 많은 이들과 공유하다 보면, 언젠가는 한글 서체에 포함된 라틴 서체야말로 한글과 사용하기에 가장 좋다는 말을 듣는 날이 오지 않을까? 누군가는 백일몽이라 말하겠지만, 이 꿈을 꾸면서 오늘도 글자를 관찰하고, 디자인하고, 이야기한다.

산돌 「정체」를 만든 사람들
디렉션: 심우진
한글 디자인: 송미언(「530」 「730」),
박수현(「630」 「830」 「930」 「030」)
라틴 문자 디자인: 김초롱

◆ 장식적인 세리프를 가진 글자로 이탈리아 르네상스 시대 이탤릭체에서 유래되었다. 루도비코 비센티노 델리 아리기(Ludovico Vicentino degli Arrighi)의 『라 오페리나 (La Operina)』에서 최초로 사용되었다.

The "Set of punctuations" for (Latin)
is offered, as an opentype-feature?

The "Set of punctuations" for (Latin)
is offered, as an opentype-feature?

[9]「정체 630」문장부호 세트. 라틴용과 조판(위), 한글용과 조판(아래).

Title Swash

Title Swash

[10]「정체 830i」 스와시 대문자 적용 전(위)과 후(아래).

판단기준이라고 단정 짓기는 어렵다.(「푸투라」의 대문자는 대부분
휴머니스트 계열 서체의 너비를 따르고 있다.) 그럼에도 불구하고,
너비가 주는 인상을 무시할 수 없기 때문에, 디자인할 때 이를
고려해야 한다. 사실 「930」과 「030」의 초기 라틴 문자는 「530」
「630」이나 「730」 「830」의 라틴 문자에 비해 현대적인 인상을 주고자
개별 글자의 너비를 비슷해 보이도록 설계해 기존 「정체」의 라틴 문자
비율과 글자 너비 자체를 다르게 제작했다. 하지만 작업을 진행하며
다양한 실험을 통해 가족으로서 「정체」의 특성을 더 강화하는 편이
낫다고 판단해 수정했다. [도판 7] 결론적으로 고정된 너비에 라틴
문자를 맞춘 것은 최적의 라틴 문자를 만들 수 있는 방법을 내려놓고
한글 조판 환경을 위한 일종의 실험을 한 셈이다. 그렇게 만들어진
「정체」의 라틴 문자는 만족과 아쉬움이 동시에 존재한다.

사용성

한글 서체에 포함된 라틴 서체를 사용하기 어려웠던 이유 중 하나는
사용성이 떨어진다는 것이었다. 유럽 언어권에서 주로 사용되는
발음구별부호(Diacritical Sign)가 붙은 라틴 글자를 사용할 수 없는
경우가 많았고, 설사 사용할 수 있다 하더라도 기본 라틴 문자와
통일성이 없는 형태로 디자인된 경우도 있었다. 하지만 점점 더
다양한 언어권의 문자를 소화할 수 있는 본문용 서체에 대한 수요가
높아지고 있기에 「정체」는 라틴 확장 문자와 기본 그리스 문자, 기본
키릴 문자 등 다양한 언어의 문자를 한글과 함께 표기할 수 있도록
제작했다. 단순히 발음구별부호를 붙인다기보다는, 부호 자체도
글자의 일부로 생각하고 디자인했다. 발음구별부호의 조형을
살펴보면 각 「정체」의 글자가 가지고 있는 특징을 공유하고 있다.
[도판 8]
 또한 라틴 문자용 부호류 세트를 추가했다. 기본 부호류의
위치나 너비는 한글에 더 잘 어울리게 설계되었으며, 라틴 문자용
부호류는 라틴 문자만 조판했을 경우 더 조화롭도록 새로 디자인하고
위치와 너비를 조정해 구성했다. [도판 9]
 마지막으로 빼놓을 수 없는 것이 이탤릭이다. 편집 작업을
하면서 로만과 함께 이탤릭이 필요할 때 한글 서체와 함께 구성된
라틴 서체를 사용한다 하더라도 이와 조형적으로나 맥락적으로
어울리는 이탤릭을 따로 찾는 것이 수고스러운 일이 된다. 결국엔
로만과 이탤릭이 함께 제공되는 별도의 라틴 자족으로 섞어짜는
상황이 발생하곤 한다. 이런 문제를 해결하기 위해 「정체」는
각 라틴 서체와 함께 사용 가능한 이탤릭 서체도 제공하고 있다.
이탤릭 또한 각 로만 서체와 조화를 이루도록 제작했다. 각 서체는

정체는 하나의 정체성을 유지하며 다양한 분위기를 내도록 뼈대skeleton, 너비width, 무게weight를 축으로 자족이 확장됩니다. 정체로 조판된 글은 530부터 030까지 어떤 구성원으로 변경해도 조판이 그대로 유지됩니다.

정체는 하나의 정체성을 유지하며 다양한 분위기를 내도록 뼈대skeleton, 너비width, 무게weight를 축으로 자족이 확장됩니다. 정체로 조판된 글은 530부터 030까지 어떤 구성원으로 변경해도 조판이 그대로 유지됩니다.

[5] 서체가 변경되어도 유지되는 조판. 「정체 630」(위), 「정체 930」(아래).

latin type

[6] 세로획과 공간이 반복되는 라틴 문자의 공간 패턴.

AENhisw
AENhisw

[7] 세리프 유무에 관계없이 동일한 너비를 갖는 정체 라틴 문자. 「정체 630」(위), 「정체 930」(아래).

åçñḳōỳ
åçñḳōỳ

[8] 발음구별부호가 있는 라틴문자. 「정체 630」(위), 「정체 930」(아래).

문장 속 대문자Upper Case 크기는 독서를 방해하지 않도록 한다.

문장 속 대문자Upper Case 크기는 독서를 방해하지 않도록 한다.

[4] 한글 문장 안에서 라틴 문자 크기 비교.「정체 630」(위), 산돌「명조네오」(아래).

서체로 조판 된 글을 같은 자족의 산세리프 계열 서체로 바꿀 경우 글줄 길이가 줄어드는 현상을 쉽게 볼 수 있다. 한글만 사용해 조판하면 같은 자족 내에서 스타일이나 굵기를 바꿔도 조판이 유지될 수 있다. 하지만 실제로는 대부분 한글과 함께 사용하는 문장부호와 띄어쓰기의 너비 차이로 결국 흐트러지고 만다.「정체」는 라틴 문자를 비롯해 숫자와 띄어쓰기, 그리고 모든 문장부호가 서체를 변경해도 기존 조판을 유지할 수 있도록 디자인되었다. 따라서「정체」만으로 조판된 글은「정체」가족의 다른 어떤 서체로 변경을 해도 글줄이 줄어들거나 늘어남 없이 기존 조판이 그대로 유지된다. [도판 5]

 이를 위해「정체」의 모든 라틴 문자는 획 중심이 아닌 공간 중심으로 제작했는데 이는 꽤 어려운 방식이었다. 그 이유는 크게 두 가지이다. 첫째는, 풀어쓰는 라틴 문자의 특성 때문에 글자의 속공간과 글자의 사이 공간이 매우 중요하다는 점이다. 라틴 문자로 조판 된 글줄의 중간 부분을 확대하면 한글보다 규칙적으로 세로획과 공간이 교차해 나타난다. [도판 6] 이처럼 글자 개별 형태와 속공간만큼이나 사이 공간의 역할이 크고 가독성에 미치는 영향도 지대하다. 그러므로 글자의 좌우 공간을 세밀하게 조정할 수 없다는 것은 큰 걸림돌이었다.

 둘째는, 라틴 서체에서는 개별 글자 너비와 그 너비의 관계가 전체 인상을 결정하는 또 하나의 중요한 요소이기 때문이다. 같은 산세리프 계열 서체라도「헬베티카(Helvetica)」처럼 개별글자의 너비가 전반적으로 비슷하고 고르면 더욱 현대적으로 느껴지고,「길 산스(Gill Sans)」나「신택스(Syntax)」와 같이 개별 글자의 너비 차이가 두드러질 경우 보다 인간적이고 예스러운 인상을 받는다. 물론「푸투라(Futura)」와 같은 경우도 있기 때문에 절대적인

획 대비와 속공간
획 대비와 속공간

ein ein

표현했다. 반면 「930」이나 「030」은 낱자의 속공간이 보다 넉넉해진 한글에 맞추어 엑스하이트를 더 키우고 글자의 윤곽은 가능한 대칭을 이루도록 했다.[도판 3] 더불어 글자의 너비를 보다 고르게 만들어 전체적으로 더 평평한 질감을 주려고 했다. 글자의 폭을 자유롭게 수정할 수 없는 제약이 있었는데, 이것은 '너비'에서 더 자세히 다루도록 하겠다.

크기와 정렬

한글과 라틴 문자를 섞어서 조판할 때 개별 글자의 형태만큼이나 큰 영향을 미치는 것이 바로 크기와 위치다. 한글과 다르게 라틴 문자는 소문자와 대문자로 구성된다. 한글로 조판 된 문장이나 문단에 라틴 대문자가 사용되면 주변 글자보다 크게 보여 글줄의 흐름을 방해하는 경향이 있다. 이 부분을 고려해 「정체」의 라틴 문자는 대문자의 크기를 의도적으로 약간 작게 디자인했다. 라틴 문자의 물리적 세로 길이가 한글의 세로 길이보다 작아 보일 수 있지만, 한글의 속공간을 고려한 선택이다.[도판 4] 또한 소문자는 어센더와 디센더가 있기 때문에 한글과의 조합에 따라 어떤 경우는 글줄이 올라가 보이기도 하고, 다른 경우에는 반대로 내려가 보이기도 한다. 상황을 특정할 수 없다 보니 어떤 경우라도 비교적 안전한 범위, 즉 글줄의 무게 중심선이 조화를 이루도록 한글과의 높이를 맞췄다.

너비

「정체」라틴 문자의 가장 큰 특징은 모든 자족의 동일 글자 너비가 같다는 것이다. 예를 들면, 세리프 서체인 「630」 'n'의 너비와 산세리프 서체인 「930」 'n'의 너비가 같다. 한글과 다르게 라틴은 일반적으로 글자를 중심으로 좌우 공간이 정해진다. 글자에 세리프가 있으면 그만큼 좌우 공간이 더 필요하고 없는 경우에는 덜 필요하다. 세리프

정체 가문

전자책 특화

분류:

- **1 / 2 〈고전 활자체〉** — 고졸 · 고문헌 · 단편 인용
- **3 / 4 〈고전 늦씨체〉** — 단아 · 고문헌·서간문 · 중편 인용
- **5 / 6 〈근대 늦씨체〉** — 친근 · 근대 문학/초등교과서 · 중·장편 서사
- **7 / 8 〈근대 활자체〉** — 강직 · 근·현대 문학/인문 · 장편 서사
- **9 / 0 〈현대 활자체〉** — 전고 · 범용(문학·인문·실용)/중고등교과서 · 범용

급	1 (0)	1 (8)	1 (6)	2 (0)	2 (8)	2 (6)	3 (0)	3 (8)	3 (6)	4 (0)	4 (8)	4 (6)	5 (0)	5 (8)	5 (6)	6 (0)	6 (8)	6 (6)	7 (0)	7 (8)	7 (6)	8 (0)	8 (8)	8 (6)	9 (0)	9 (8)	9 (6)	0 (0)	0 (8)	0 (6)
1g	110	118	116	210	218	216	310	318	316	410	418	416	510	518	516	610	618	616	710	718	716	810	818	816	910	918	916	010	018	016
v	130v			230v			330v			430v			530v			630v			730v			830v			930v			030v		
3g	130	138	136	230	238	236	330	338	336	430	438	436	530	538	536	630	638	636	730	738	736	830	838	836	930	938	936	030	038	036
i							330i			430i			530i			630i			730i			830i			930i			030i		
4g	140	148	146	240	248	246	340	348	346	440	448	446	540	548	546	640	648	646	740	748	746	840	848	846	940	948	946	040	048	046
v	140v			240v			340v			440v			540v			640v			740v			840v			940v			040v		
i							340i			440i			540i			640i			740i			840i			940i			040i		
9g	190	198	196	290	298	296	390	398	396	490	498	496	590	598	596	690	698	696	790	798	796	890	898	896	990	998	996	090	098	096
v	190v			290v			390v			490v			590v			690v			790v			890v			990v			090v		

[1] 「정체」가문표.

「정체」의 라틴 문자: 더 쓰기좋게, 더 조화롭게

김초롱

「정체」는 기존 본문 서체의 아쉬운 점을 개선하여 더욱 쓰기 좋고 새로운 인상을 주는 본문용 서체로 기획된 대형 서체 가문이다. 2019년 4월에 「530」과 「530i」를 처음 선보인 후 현재 「030」과 「030i」까지 총 열두 종이 출시된 상태이며 장기적으로 모든 구성원이 다 제작될 계획이다. 「정체」는 한글, 라틴 문자, 라틴 확장 문자, 기본 그리스 문자, 기본 키릴 문자를 지원하고 각 서체와 함께 사용 가능한 이탤릭 서체도 제공한다. [도판 1]

　　「정체」의 라틴 문자는 '본질을 버리지 않으면서도 한글 조판 환경에 최적화된 라틴 서체를 만들 수 없을까'라는 질문에서 시작되었다. 한글 서체에 포함된 라틴 문자는 쓰기 어렵다는 오래된 인식, 무엇보다 국내 디자이너가 만든 라틴 서체 품질에 대한 불신을 해소하기 위해 고심했다. 작업 기간 중에 있던 세세한 모든 내용을 다 언급할 수는 없겠지만, 가장 크게 고민했던 몇 가지 부분을 나누고자 한다.

뼈대와 살 붙임

「정체」의 한글이 기존 한글 명조들과 다른 여러 측면이 있는데, 그중 하나는 획 굵기 대비가 꽤 약하고 전반적으로 글자가 또렷해 보인다는 점이다. 일반적인 명조에 비해 가는 획과 굵은 획의 대비가 약하다. 그리고 속공간은 다른 명조에 비해 작은 편이다. [도판 2] 획 대비에 있어 고민했던 지점은 라틴 문자에서 획 대비가 약해지는 자체만으로도 현대적인 인상으로 보일 가능성이 크다는 것이었다. 최근에 출시된 「930」이나 「030」의 한글은 비교적 현대적 인상을 주지만, 「정체」 가족의 첫 시작점이었던 「530」 「630」의 경우는 다소 고전적인 인상을 가지고 있다. 따라서 이를 보완할 방법으로 라틴 문자의 뼈대를 「정체」 한글이 가지는 인상에 최대한 맞추려 했다. 「530」 「630」은 고전적 인상의 라틴 휴머니스트 계열 서체의 뼈대 구조와 비율을 반영했다. 글자의 윤곽을 그릴 때는 「630」의 세리프 브라켓, 'e'의 가로획, 'i'의 점 등에서 볼 수 있듯이 비대칭성과 곡선의 유기적인 인상을 강조해 필기에서 나오는 자연스러운 손맛을 더해

이번 '작업'에서는 서울과 홍콩의 디자이너 네 명의 작업을 소개한다.
이들은 모두 타이포그래피적 관점에서 매우 국제적인 도시 출신이고,
자신의 모국자(母國字, native script)◆에 더해 다른 지역의 문자를
자신의 디자인 작업에서 중요한 매개체로 삼고 있다는 공통점이 있다.
하지만 여러 문자들 사이에 필연적으로 발생하는 위계를 설정하는
방식은 각자 다르다. 디자이너 고유의 생각과 원칙으로 저마다의
타이포그래피적 질서를 세워가는 과정에서, 특정 계층에 속한 문자를
기준 삼아 다른 계층에 속한 문자를 '재해석' 한다.

한글 폰트 속 특수 문자로서(김초롱), 혹은 홍콩의 북위
서체◆◆의 짝으로서(포층) 라틴 문자 대소문자의 형태가 재해석되고,
100여 년 전 홍콩 거리표지판의 불균질한 영문과 한자 자형들이
디지털 활자로 통일성 있게 복각되고(피비쿵), 고전 한자 서체인
번체자와 유기적으로 섞일 수 있도록 중화인민공화국의 간체자,
일본의 명조체 한자, 기호와 상징의 모습이 재설정된다(막카이항).

이들은 글자의 '재해석' 과정을 통해 공히 자신에 내재한
'지역성'과 다른 지역의 그것 사이의 관계를 조율하며 일종의 '국제성'을
이끌어내고 있다고 할 수 있다. 한때 국제성을 추구하면서 희생되곤
했던 지역성에 대한 환기의 기회, 혹은 세가 역전되어 지역성에
종속된 채 드러나는 국제성을 관찰하는 기회가 되었으면 한다.

민본

◆ 모국어(native language)에
대응하는 단어로서 이 글에
국한하여 사용한다.
◆◆ 활자체와 구분해 서예에서
비롯된 글꼴을 의미한다.

재해석된 글자들

직업

John Ryder. 『The Case for legibility』. London: The Bodley Head Ltd, 1979.

Mark S. Sanders, Ernest J. McCormick. 『Human Factors in Engineering and Design』. New York: McGraw Hill, 1957.

Miles A. Tinker. 『The legibility of Print』. Ames: The Iowa State University Press, 1964.

Walter Tracy. 『Letters of Credit: A View of Type Design』. Boston: David R. Godin, 1986.

Gerard Unger. 『While You're Reading』. New York: Mark Batty Publisher, 2006.

하는 것은 아니라는 사실을 염두에 둘 필요가 있다.

본 연구에서 다룬 가독성·판독성·legibility·readability의
혼용을 예로 삼아, 유사한 혼란을 겪고 있는 타이포그래피 용어들에 대한
연구자들이 논의가 앞으로 활발히 이어지기를 기대한다.

참고문헌

오병근, 강성중.『정보 디자인 교과서』. 파주: 안그라픽스, 2008.

데이비드 콜리어. 변태식 옮김.『데스크 탑 디자인』. 서울: 디자인하우스, 1995.

로버트 브링허스트. 박재홍, 김민경 옮김.『타이포그래피의 원리』.
　　　서울: 미진사, 2016.

세종대왕기념사업회 한국글꼴개발연구원.『한글글꼴용어사전』.
　　　서울: 세종대왕기념사업회, 2000.

에릭 길. 송성재 옮김.『에릭 길: 타이포그래피에 관한 에세이』.
　　　파주: 안그라픽스, 2015.

원유홍, 서승연, 송명민.『타이포그래피 천일야화』. 파주: 안그라픽스, 2012.

유정미.『잡지는 매거진이다』. 파주: 효형출판, 2002.

이순종, 조영제, 안상수, 권명광.『디자인 사전』. 파주: 안그라픽스, 1994.

제임스 크레이그, 윌리엄 베빙튼, 아이린 코롤 스칼라. 문지숙 옮김.
　　　『타이포그래피 교과서』. 파주: 안그라픽스, 2002.

한국출판연구소.『출판사전』. 파주: 범우사, 2000.

한국타이포그라피학회.『타이포그래피 사전』. 파주: 안그라픽스, 2012.

한국텍학회.『TEX: 조판, 그 이상의 가능성』. 서울: 경문사, 2007.

헤라르트 윙어르. 최문경 옮김.『당신이 읽는 동안: 글꼴, 글꼴 디자인,
　　　타이포그래피』. 서울: 워크룸프레스, 2013.

Gavin Ambrose, Paul Harris.『Typography (Basic Design)』.
　　　West Sussex: AVA Publishing, 2005.

Robert Bringhurst.『The Element of Typographic Style』.
　　　Vancouver: Hartley & Marks, 1992.

James Craig.『Basic Typography, A Design Manual』.
　　　New York: Watson-Guptill, 1990.

James Craig, Irene Korol Scala.『Designing with Type』.
　　　New York: Watson-Guptill, 1971.

David Collier, Bob Cotton.『Basic Desktop Design and Layout』.
　　　Cincinnati: North Light Books, 1989.

Sandra Ernst Moriarty.『The ABC's of Typography』.
　　　Stamford: Art Direction Book Co, 1977.

Eric Gill.『An Essay on Typography』. Boston: David R. Godine, 1988.

Gordon Ernest Legge.『Psychophysics of Reading in Normal
　　　and Low Vision』. London: CRC Press, 2006.

인지(legibility)가 텍스트의 이해(readability)에 선행하는 개념으로 설명된다. C 유형에서 A 유형과 B 유형을 포괄하는 넓은 의미의 용어를 택해야 했다면 상대적으로 좁은 개념의 판독성보다는 상위 개념으로 사용되는 가독성이 적합했을 것으로 보인다. 팅커의 사례와 같이 부득이하게 readability라는 용어를 사용할 수 없는 경우가 아니라면, 모든 의미를 포괄하는 단일 용어로 legibility(판독성)보다 큰 개념인 readability(가독성)를 채택하는 것이 자연스러웠을 것이다.

이러한 혼란은 국내 연구자가 국문을 영문으로 번역할 때도 발생한다. 예를 들어, 제목에 가독성을 포함한 서른세 편의 국내 타이포그래피 논문(1990–2020) 중 영문 제목을 legibility로 번역한 경우는 열다섯 편, readability로 번역한 경우는 스물두 편이다. 그러나 앞선 연구에 기반을 두어 이 논문들에 등장하는 가독성의 의미를 살펴보면, 타이포그래피 분야에서의 말하는 가독성 전반을 포괄하며 판독성과 구분 짓고 있지 않음으로 맥락상 모두 C 유형에 해당한다고 볼 수 있다. 그렇다면 영문 제목도 legibility로 번역하는 것이 적절했을 것으로 판단된다.

4 결론

본 연구는 타이포그래피 분야에서 가독성과 판독성의 정의가 어떻게 혼용되고 있는지를 사용 행태에 따라 검토하고, 통용되고 있는 가독성·판독성·legibility·readability의 정의를 세 가지 유형으로 정리했다. A 유형에서 가독성은 텍스트의 형태 인지 능률을 의미하고 판독성은 낱자의 형태 인지 능률을 의미한다. 가독성=readability, 판독성=legibility로 번역된다. B 유형에서 가독성은 텍스트의 내용 독해 능률을 의미하고 판독성은 낱자 및 텍스트의 형태 인지 능률을 의미한다. 가독성=readability, 판독성=legibility로 번역된다. C 유형에서 가독성은 낱자의 형태 인지 능률, 텍스트 형태 인지 능률, 텍스트의 독해 능률을 모두 포괄하여 의미한다. 가독성=legibility로 번역된다.

이처럼 가독성·판독성·legibility·readability는 유사하지만 조금씩 다른 의미로 정의되어 사용되고 있음을 확인할 수 있었다. 따라서 타이포그래피 연구자는 소통의 혼선을 피하고자 다음과 같은 노력을 기울일 필요가 있다. 첫째, 가독성·판독성·legibility· readability에 대한 정의가 의도한 바와 다르게 해석될 수 있음을 분명히 인지한다. 둘째, 이들 용어를 사용할 때는 의도하는 바를 구체적으로 부연해 전달하려는 의미를 분명히 한다. 셋째, 번역할 때에는 가급적 원문에서 사용한 용어를 병기하여 원저자가 의도한 바를 명확히 드러낸다. 단, 영문 표현과 국문 표현이 일대일 대응해야

	가독성	판독성
A 유형	텍스트 형태 인지	낱자 형태 인지
B 유형	내용 독해	낱자 형태 인지 + 텍스트 형태 인지
C 유형	낱자 형태 인지 + 텍스트 형태 인지 + 내용 독해	–

[4] 가독성과 판독성의 정의 유형.

A 유형	가독성 = readability	판독성 = legibility
B 유형	가독성 = readability	판독성 = legibility
C 유형	가독성 = legibility	

[5] 가독성과 판독성, Legibility와 Readability 번역 유형.

이 두 서적에서는 가독성=legibility, 이독성=readability이다.
이독성이 등장한 경우는 전체 스물세 권 중 이 두 권이 유일하다.)
문제는 C 유형에서 발생한다. C 유형의 경우, A 유형과 B 유형에서
언급된 여러 개념을 가독성이라는 하나의 용어로 포괄하는데
해외서적의 경우 legibility를 사용한다. 즉, A 유형과 B 유형을 통해
가독성=readability, 판독성=legibility를 학습한 경우 C 유형의
가독성=legibility를 접하면 혼란에 빠지게 된다. 본 연구에 사용된
스물세 권의 서적 중 열한 권이 C 유형이며, C 유형 해외서적은
국내에서 모두 legibility=가독성으로 번역되고 있다.

 C 유형 해외서적에서 legibility를 사용하는 이유에 대해서는
F02에 상세히 설명되어 있다. "읽기 자료의 독해능력 측정을 위해
고안된 개념인 readability formulas의 출현으로 인해 우리는 완전히
다른 의미의 동일한 용어를 사용하게 되었다. 당연히 이는 혼란을
가져왔다. 이 혼란을 피하고자 본 서적에서는 legibility of print라는
용어를 사용하는 것으로 국한하도록 한다." 저자 팅커(M. Tinker,
1893–1977)는 미네소타대학에서 32년간 가독성 실험을 진행한
미국 연구자로, 가독성 실험에 있어서 국제적으로 인정받는
권위자이다. 팅커가 legibility를 채택한 것은 당시 미국 인쇄 산업에
큰 영향력을 끼쳐, 지금까지 legibility의 사용이 이어져 오고 있는
것으로 보인다.

 C 유형 국내서적에서 가독성을 사용하는 이유를 구체적으로
기술한 자료는 발견할 수 없었다. 그러나 A 유형, B 유형을 포괄하는
넓은 의미가 있는 용어가 필요했을 것이라고 이유를 추측해 볼
수 있다. 예를 들어, K01에서 낱자의 판독성은 텍스트의 가독성에
선행하는 개념으로 설명된다. 낱자의 형태 인지가 먼저 이루어져야,
글줄의 형태 인지가 이루어지기 때문이다. F12에서는 낱자의 형태

	국내서적	해외서적
A 유형	(텍스트 형태 인지) (낱자 형태 인지) 가독성　　판독성	(텍스트 형태 인지) (낱자 형태 인지) Readability　Legibility
B 유형	(내용 독해) (텍스트 형태 인지) (낱자 형태 인지) 가독성　　　판독성	(내용 독해) (텍스트 형태 인지) (낱자 형태 인지) Readability　Legibility
C 유형	(내용 독해　텍스트 형태 인지　낱자 형태 인지) 가독성	(내용 독해　텍스트 형태 인지　낱자 형태 인지) Readability

[3] 가독성·판독성·readability·legibility 유형 분류.

독해 능률을 모두 포괄한다. 해외서적에서는 legibility를 사용한다.
가독성=legibility이다. C 유형의 가독성은, A 유형과 B 유형의
가독성과 판독성을 모두 포괄한다. C 유형은 K02, K03, K04, K05,
K06, K09, F02, F05, F07, F09, F10, F11이다.

3.4 문제점

앞서 알아본 것처럼 서적마다 가독성, 판독성, legibility, readability의
의미를 다르게 정의하고 있다. 여기서 발생하는 문제점은 크게
두 가지로 정리해 볼 수 있다.

첫째, 동일한 용어가 여러 정의로 사용되는 문제가 있다.
[도판 4] 가독성의 경우, A 유형에서는 텍스트의 형태 인지 능률,
B 유형에서는 텍스트의 내용 독해 능률, C 유형에서는 낱자의 형태
인지 능률, 텍스트 형태 인지 능률, 텍스트의 독해 능률을 포괄하는
의미가 있다. 판독성의 경우, A 유형에서는 낱자의 형태 인지 능률,
B 유형에서는 낱자 및 텍스트의 형태 인지 능률을 의미하며,
C 유형에서는 사용되지 않는다. 유형별로 가독성과 판독성을
정의하는 바가 달라, 새로운 유형을 접할 때마다 혼란에 빠지게 된다.

둘째, 국문과 영문 용어가 일관적으로 호응하지 않는 문제가
있다. [도판 5] A 유형과 B 유형의 경우, 각각 가독성 및 판독성이
정의하는 바는 다르나 두 경우 모두 가독성=readability, 판독성=
legibility이다. (유일한 예외 사례는 K03과 F02 번역서이다.

형태(조판, 즉 폰트, 글자크기, 글자사이, 글줄길이, 글줄사이, 판형, 인쇄
면적, 여백, 그리드 등) 인지 능률로 설명했다. F10에서는 구체적인
legibility의 범위를 설명하지 않았으나, 문맥상 F05, F07, F09와
동일한 입장을 취했다.

readability만 정의
해외서적 열세 권 중 readability만 서술한 경우는 없다.

번역서
해외서적 열세 권 중 번역서가 있는 것은 다섯 권이다. F03, F07, F08,
F10, F13이다. F03은 legibility=가독성, readability=이독성으로
번역했다. F07은 legibility=가독성으로 번역했다. F08, F10, F13은
legibility=판독성, readability=가독성으로 번역했다. F07을 제외한
네 권의 번역서는 정확한 내용 전달을 위해 모두 영문 용어를 병기했다.

3.3 유형 분류
국내외 서적 스물세 권에서 발췌한 가독성, 판독성, legibility,
readability의 정의는 세 가지 유형으로 정리된다. [도판 3]

A 유형
가독성은 텍스트의 형태 인지 능률이다. 해외서적에서는 readability를
사용한다. 텍스트의 조판(글자크기, 글자사이, 글줄사이, 여백,
판형 등)에 영향을 받는다. 판독성은 낱자의 형태 인지 능률이다.
해외서적에서는 legibility를 사용한다. 낱자의 디자인(세리프 유무,
엑스하이트 크기, 속공간 크기와 모양, 획 굵기 등)에 영향을 받는다.
가독성=readability, 판독성=legibility이다. A 유형은 K01, K07, F01,
F03, F06, F08, F11, F12, F13이다.

B 유형
가독성은 텍스트의 내용 독해 능률이다. 해외서적에서는 readability
를 사용한다. 판독성은 낱자 및 텍스트의 형태 인지 능률이다.
해외서적에서는 legibility를 사용한다. 가독성=readability, 판독성=
legibility이나, A 유형과는 용법이 다르다. B 유형의 판독성은
A 유형의 가독성과 판독성을 모두 포괄한다. B 유형은 K03, K05, K08,
K10, F02, F04이다.

C 유형
가독성은 낱자의 형태 인지 능률, 텍스트 형태 인지 능률, 텍스트의

가독성만 정의

국내서적 열 권 중 가독성만 서술한 경우는 다섯 권이다. 이는 K02, K04, K05, K06, K09이다. K02, K04, K05에서는 legibility와 readability를 포괄한 상위개념으로 가독성을 정의했다. K02, K05의 경우 readability의 정의를 F02로부터 빌려왔다. F02는 심리학 분야에서 사용하는 readability와 구분하기 위해, 타이포그래피 관점에서 글을 쉽게 인지하고 독해하는 정도를 포괄적으로 의미하는 용어를 legibility라고 구분하여 명시했다. 이를 참고한 K02는 legibility와 readability 둘 다 가독성이라고 규정하고, 타이포그래피 관점에서의 가독성은 legibility라고 부연하지만, 판독성과 타이포그래피적 관점에서의 readability에 대한 설명은 생략했다. K05는 용어사전이다. 가독성과 판독성 표제어를 둘 다 포함했다. 가독성은 F01, K02와 동일한 입장으로 정의했으나, 판독성(legibility) 은 가독성의 정의와 다른 입장으로 정의하여 혼란을 준다. K06에서는 가독성을 쉽게 읽히는 정도, K09에서는 쉽고 빠르게 읽어서 이해하는 정도로 간략하게 정의했다. 영문 용어는 덧붙이지 않았다.

판독성만 정의

국내서적 열 권 중 판독성만 서술한 경우는 없다.

3.2 해외서적

legibility와 readability를 구분하여 정의

해외서적 열세 권 중 legibility와 readability를 구분하여 서술한 경우는 아홉 권이다. 이는 F01, F02, F03, F04, F06, F08, F11, F12, F13이다. [도판 2] F01, F03, F06, F08, F11, F12, F13에서는 legibility를 낱자(type)의 형태 인지 능률, readability는 텍스트의 형태 인지 능률로 정의했다. F02, F04에서는 legibility를 낱자 및 텍스트의 형태 인지(perception) 능률, readability를 텍스트의 내용 독해(comprehension)로 능률로 정의했다. F03의 번역서에는 생략된 문장이 있다. 원서에는 다음과 같은 문장이 추가되어 있다. "legibility는 글꼴 디자인의 완성도이고, readability는 인쇄된 페이지의 다른 디자인 요소들과 함께 조화를 이루는 완성도이다. (Legibility is the quality of the typeface design and readability with the design of the printed page. Designers aim to achieve excellence in both.)"

legibility만 정의

해외서적 열세 권 중 legibility만 서술한 경우는 네 권이다. 이는 F05, F07, F09, F10이다. F05, F07, F09에서는 legibility를 텍스트

신문을 읽을 수 있다면, 그것은 가독이 쉬운 것이다. 다시 말해 가독성이 전체적인 그림을 일컫는다면 판독성은 글자꼴과 그들의 세부 사항들을 일컫는다. 혹은 이 두 가지 측면 모두를 판독성을 이루는 요소로 간주하고, 가독성은 작가가 읽기 편하고 이해하기 쉽게 언어를 구사하는 방법을 일컫는 수도 있다. 트레이시는 무엇이 글자를 판독하기 쉽거나 읽기 쉽게 만드는지 까지 파고들지는 않지만 자신이 어떤 종류의 활자를 판독이 쉽다고 여기는지 예로 들었다. 얀 판 크림 펀, 프레드릭 가우디, 루돌프 코흐, 윌리엄 A. 드위긴스가 디자인한 활자들과 스탠리 모리슨의 타임스 뉴 로만(Times New Roman, 1932)이 그것이다.

	K01	K02	K03	K04	K05	K06	K07	K08	K09	K10
가독성	○	○	○	○	○	○	○		○	○
판독성	○				○			○		○
legibility		○	○	○	○		○	○		○
readability		○	○	○	○		○	○		○

[1] 국내서적에서 가독성·판독성·readability·legibility 서술 유무.

	F01	F02	F03	F04	F05	F06	F07	F08	F09	F10	F11	F12	F13
legibility	○	○	○	○	○	○	○	○	○	○	○	○	○
readability	○	○	○	○		○		○			○	○	○

[2] 해외서적에서 readability·legibility 서술 유무.

3 분석

3.1 국내서적

가독성과 판독성을 구분하여 정의

국내서적 열 권 중 가독성과 판독성을 구분해 서술한 경우는 다섯 권이다. 이는 K01, K03, K07, K08, K10이다. [도판 1] K01, K07에서는 가독성은 텍스트(이 연구에서 텍스트는 연속된 낱자들이 형성하는 글줄, 문장, 문단을 의미)의 형태 인지 능률, 판독성은 낱자의 형태 인지 능률로 정의했다. K03에서는 가독성=legibility를 글자의 읽기 쉬운 정도, 이독성=readability를 내용의 읽기 쉬운 정도로 정의했다. K08에서는 legibility를 디자인 측면에서 글자 또는 글자들을 배치한 모양이 읽기 쉬운 정도, readability를 언어 또는 내용 측면에서 글이 읽기 쉬운 정도로 정의했다. K10에서는 가독성=readability를 글을 읽고 이해하기 쉬운 정도, 판독성=legibility를 개별 글자나 낱말의 형태를 분별하여 알아보기 쉬운 정도로 정의했다.

F10. Robert Bringhurst. 『The Element of Typographic Style』.
Vancouver: Hartley & Marks, 1992.
로버트 브링허스트. 박재홍, 김민경 옮김. 『타이포그래피의 원리』.
서울: 미진사, 2016.

타이포그래피가 지속성을 가지기 위해 필요한 원칙 중 하나는
판독성(legibility)이다. 그리고 다른 하나는 판독성 이상의
것인데, 그것은 책의 각 페이지에 생생한 에너지를 불어넣는
흥미로움이다.

F11. Gavin Ambrose, Paul Harris. 『Typography (Basic Design)』.
West Sussex: AVA Publishing, 2005. 번역서 없음.

→legibility: 글자디자인에 내제된 특성으로 인해 각각의
글자가 구분되는 정도. →readability: 텍스트 담론의 전반적
시각 표현.

F12. Gordon Ernest Legge. 『Psychophysics of Reading in Normal
and Low Vision』. London: CRC Press, 2006. 번역서 없음.

"legibility"는 readability에 영향을 미치는 텍스트의 지각
속성을 의미한다. 모호한 어휘나 복잡한 구문 또는 의미로
인해 읽기 어려운 텍스트는 독해가 어려울 수는 있으나 동시에
legibility는 매우 높을 수 있다. legibility는 텍스트의 부분적
그리고 전체적 속성으로부터 영향을 받는다. 부분적 속성이라
함은 폰트, 글자크기, 글자사이 등 개별 글자 또는 글자 무리의
특징을 의미한다. 전체적 속성이라 함은 글줄길이, 글줄사이,
지면 크기 등 레이아웃의 특징을 의미한다.

F13. Gerard Unger. 『While You're Reading』.
New York: Mark Batty Publisher, 2006.
헤라르트 윙어르. 최문경 옮김. 『당신이 읽는 동안: 글꼴, 글꼴 디자인,
타이포그래피』. 서울: 워크룸프레스, 2013.

네덜란드어로 판독성을 뜻하는 말은 하나(leesbaarheid) 밖에
없지만 영어에는 두 개의 단어가 있다. 바로 판독성(legibility)과
가독성(readability)이다. 판독성은 하나의 글자를 다른
글자와 구별할 수 있게 해주는 정도를 말한다. 예를 들어,
대문자 I 와 소문자 l 사이에 충분한 차이가 있는지 말이다.
활자 디자이너이자 '신용의 글자(Letters of Credit, 1986)'의
저자 월터 트레이시에 따르면 가독성은 편안함을 일컫는
광범위한 용어이다. 만약 당신이 쉬지 않고 장시간에 걸쳐

역설적으로 전화전호부나 항공사 시간표와 같이 독자가
연속적으로 읽지 않고 단일 정보만을 검색하는 경우에는
그다지 중요하지 않다.

legibility는 인지를 뜻하며, 글자가 인식되는 속도를 말한다.
독자가 글자의 legibility에 주저한다면 그것은 글자 디자인이
잘못된 것이다. readability는 독해를 뜻하며, 독자가 긴
텍스트를 압박 없이 읽는 속도를 말한다.

F07. Eric Gill. 『An Essay on Typography』.
Boston: David R. Godine, 1988.
에릭 길. 송성재 옮김. 『에릭 길: 타이포그래피에 관한 에세이』.
파주: 안그라픽스, 2015.

가독성은 사람들이 글자체와 글자크기, 글자사이 공간,
낱말 사이 공간 등에 얼마나 익숙한지에 비례한다. 가독성이
낮더라도 사람들 눈에 익숙한 글자를 굳이 버릴 필요가 없다는
뜻은 아니다. 이는 15세기 피렌체인과 로마인이 만든 것이다.
창안자의 탁월한 감각과 후세의 호감으로 이를 잘 유지하고
개선할 필요가 있다.

F08. David Collier, Bob Cotton. 『Basic Desktop Design and
Layout』. Cincinnati: North Light Books, 1989.
데이비드 콜리어 밥 코튼. 변태식 옮김. 『데스크 탑 디자인』.
서울: 디자인하우스, 1995.

legibility과 readability라는 두 단어는 종종 혼동된다.
legibility은 낱글자의 명료함이다. 즉, 각 글자가 얼마나 윤곽이
뚜렷하고 식별이 용이한가이다. readability은 연속적인
읽기를 위한 긴 분량의 텍스트에 특정 글자체가 얼마나
적합한가이다.

F09. James Craig. 『Basic Typography, A Design Manual』.
New York: Watson-Guptill, 1990. 번역서 없음.

legibility, 그것은 인지 속도에 영향을 끼치는 글자, 여백,
구성의 완성도이다. 글자의 legibility가 높을수록 빠르고 쉽고
정확하게 인지된다.

F05. John Ryder. 『The Case for legibility』. London: The Bodley Head Ltd, 1979. 번역서 없음.

> (요약) legibility에 영향은 미치는 요소는 다음과 같다. 폰트, 글자크기, 글자사이, 글줄길이, 글줄사이, 판형, 인쇄 면적, 여백, 그리드, 마무리.

F06. Walter Tracy. 『Letters of Credit: A View of Type Design』. Boston: David R. Godin, 1986. 번역서 없음.

> 글자에는 필수적인 두 가지 측면이 있다. 'legible'의 보편적인 의미가 'readable'이다 보니, 일부 타이포그래피 전문가들마저도 글자의 효과에 대해 논의하기 위한 용어로는 'legibility' 하나면 충분하다고 생각한다. 그러나 legibility와 readability는 서로 연결되어 있음에도 불구하고 정확한 의미는 조금 다르다. 제대로 이해하고 사용하면, 이 두 용어는 글자와 글자의 기능을 legibility만 단독으로 사용하는 것보다 상세하게 설명할 수 있다.
>
> 사전적 정의에 의하면 라틴어에 어원을 둔 legibility는 '용이하게 읽는 정도'를 의미한다. 타이포그래피에서 우리는 보다 상세히 정의해야 할 필요가 있다. 우리는 '해독 가능(decipherable)하고 잘 알아볼 수 있는(recognizable) 정도'라고 의미하기 원한다. 예를 들어, 작은 글자크기의 올드 스타일 이탤릭에서 소문자 h는 그다지 legible하지 않다. 왜냐하면 둥근 세로획이 소문자 b처럼 보이게 만들기 때문이다. 항목별 광고용 글꼴에서 숫자 3은 숫자 8과 너무 비슷해 보인다. 그러기 때문에 legibility는 낱자의 선명도(clarity)를 논의할 때 사용하는 용어이다. 전화번호부의 작은 글자크기와 같이, 글자크기와 관련 지어 다뤄져야 하는 문제이다. legibility는 제목용 크기에서는 심각한 문제가 되지 않는다. 8pt에서 불분명했던 글자라도 24pt에서는 충분히 명료히 보일 것이다.
>
> readability는 다른 개념이다. 사전적 의미는 동일하게도 '용이하게 읽는 정도'이다. 타이포그래피에서 우리는 이 용어에 편재된 의미를 부여할 수 있다. 신문 또는 잡지의 칼럼이나, 책의 페이지가 한 번에 압박감이나 어려움 없이 몇 분 동안 읽힌다면 그 글자가 좋은 'readability'를 가지고 있다고 말할 수 있다. 이 용어는 시각적으로 편안한 정도를 나타낸다. 긴 텍스트를 독해하는데 요구되는 중요한 사항이다.

연속된 텍스트 자료를 읽는 것과 연관이 있다. 낱자의 형태는
식별되어야하고, 낱말 형태의 특징은 인지되어야 하며,
연속된 텍스트는 정확하고 빠르고 쉽게 읽히면서도 이해가
되어야 한다. 어떤 타이포그래피 요소들이 쉽고 빠른 읽기에
영향을 미치는지 알아야 한다. 최적의 legibility of print는
타이포그래피 처리 방식을 통해 구현될 수 있다. 이는 편안한
보기와 쉽고 빠른 독해를 위해 글자와 기호의 형태, 특징적인
낱말 형태, 그 외 모든 타이포그래피 요소들(글자크기, 글줄길이,
글자너비, 글줄사이 등)을 조정하는 것이다.

F03. James Craig, Irene Korol Scala. 『Designing with Type』.
New York: Watson-Guptill, 1971.
제임스 크레이그, 윌리엄 베빙튼, 아이린 코롤 스칼라. 문지숙 옮김.
『타이포그래피 교과서』. 파주: 안그라픽스, 2002.

→ 가독성(legibility)과 이독성(readability). 여러분이 선택한
활자체는 가독성이 높아야 한다. 다시 말해서, 그것은 특별히
노력하지 않고도 읽을 수 있어야 한다. 때때로 가독성이 단순히
글자크기의 문제인 경우도 있지만, 그보다는 글자꼴 디자인의
문제인 경우가 더 많다. 일반적으로, 기본 글꼴 그대로인 활자가
폭을 좁히거나 늘리거나 장식하거나 간략화한 것보다 더 읽기
쉽다. 따라서 항상 가독성이 높은 활자체부터 시작해야한다.
그러나 가독성이 높지 않은 활자체라도 디자인을 잘하면
더 읽기 쉬워질 수 있는 것과 마찬가지로, 가독성이 높은
활자체라도 짜임이나 배치가 좋지 못하면 읽기 어려워질 수도
있다는 것을 명심하라. → 가독성(legibility): 인지의 속도에
영향을 주는 활자체 디자인의 속성. 인지가 더 빠르고 쉽고
정확할수록 가독성이 높은 활자다.

F04. Sandra Ernst Moriarty. 『The ABC's of Typography』.
Stamford: Art Direction Book Co, 1977. 번역서 없음.

읽기의 용이성에는 두 가지 요소, 즉 readability와 legibility가
있다. readability는 내용의 이해도를 의미하고, legibility는
개별 글자 형태를 식별하고 인지하는 과정을 의미한다.
일반적으로 readability는 단어 선택이나 문장 길이를 다룰 때
사용하고, legibility는 글자 형태의 크기, 종류, 모양을 다룰 때
사용한다.

K10. 한국타이포그라피학회. 『타이포그래피 사전』.
파주: 안그라픽스, 2012.

→ 가독성: readability. 글을 읽고 이해하기 쉬운 정도. (유사어: 이독성) 글의 내용과 그에 대한 독자의 사전 지식, 독서 거리와 시간, 타이포그래피 등에 따라 크게 달라진다. 가독성과 종종 혼용되는 판독성은 글자의 형태를 알아보기 쉬운 정도를 말한다. 개별 글자의 판독성이 뛰어나더라도 여러 글자를 나열했을 때 가독성이 낮을 수 있으므로 두 용어는 구분해서 사용해야 한다. → 판독성: legibility. 개별 글자나 낱말의 형태를 분별하여 알아보기 쉬운 정도. 판독성과 가독성이 종종 혼용되는데, 가독성의 대상은 글이고 판독성의 대상은 낱말이나 글자이므로 구분해서 사용해야 한다.

2.2.2 해외서적

F01. Mark S. Sanders, Ernest J. McCormick. 『Human Factors in Engineering and Design』. New York: McGraw Hill, 1957. 번역서 없음.

→ visibility: 주변 환경으로부터 글자나 기호가 구분되어 보이는 정도. → legibility: 로마자와 숫자가 서로 식별을 가능하게 하는 글자의 속성. 획 굵기, 글자의 형태, 대비, 색 등에 영향을 받는다. → readability: 로마자와 숫자가 단어, 문장, 연속된 텍스트와 같이 의미 있는 무리를 형성할 때 내용의 인식을 가능하게 하는 정도. 글자사이 간격, 단어사이 간격, 글줄사이 간격, 여백 등에 영향을 받는다.

F02. Miles A. Tinker. 『The Legibility of Print』.
Ames: The Iowa State University Press, 1964. 번역서 없음.

legibility 그리고 readability. 읽기의 용이성과 속도에 영향을 미치는 요소들에 대한 초기 논의에서는 용어 'legibility'가 사용되었다. 그러나 1940년부터 일부 연구자는 동일한 목적을 뜻하기 위해 용어 'readability'를 사용해왔다. 한동안 'readability'는 더 넓은 의미로, 혹은 더 중요한 의미로 느껴졌다. 그러나 읽기 자료의 독해능력 측정을 위해 고안된 개념인 'readability formulas(읽기 난이도 공식)'의 출현으로 인해 우리는 완전히 다른 의미의 동일한 용어를 사용하게 되었다. 당연히 이는 혼란을 가져왔다. 이 혼란을 피하기 위해 본 서적에서는 'legibility of print'라는 용어를 사용하는 것으로 국한하도록 한다. (중략) legibility는 낱자와 낱말을 인지하고

readability와 legibility를 모두 포함하는 뜻으로 통용되지만
두 개념을 특별히 구분하여 표현할 때 판독성(legibility)이라 한다.

K06. 유정미.『잡지는 매거진이다』. 파주: 효형출판, 2002.
　　타이포그래피에서는 가독성이란 말을 서체나 글자 혹은
디자인된 페이지의 바람직한 퀄리티에 한정해서 사용한다.
그러므로 타이포그래피에서 가독성이란 말은 '쉽게 읽히는'
이란 뜻으로 받아들일 수 있다.

K07. 원유홍, 서승연, 송명민.『타이포그래피 천일야화』.
파주: 안그라픽스, 2004.
　　→ 가독성(readability)은 신문 기사, 서적, 애뉴얼 리포트 등과
같이 많은 양의 텍스트를 독자가 과연 얼마나 쉽게 그리고 빨리
읽을 수 있는가 하는 효율을 말한다. 반면 판독성(legibility)은
헤드라인, 목차, 로고 타입, 폴리오 등과 같이 짧은 양의 텍스트를
독자가 과연 얼마나 많이 인식하고 알아차리는가 하는 효율을
말한다. 이 두 가지는 각기 서로 다른 기능을 발휘하지만 독서의
능률을 위한 하나의 목표를 지향한다는 점에서 마찬가지다.
　　→ 가독성: readability. 본문에 대한 독서 효율의 정도. 독서
효율은 폰트의 종류와 조판 방법에 따라 정도가 다르다. 좋은
타이포그래피는 조형성, 독창성과 함께 글자의 가독성을 충분히
검토해야 한다. → 판독성: legibility. 낱자들이 쉽게 식별되어
읽히는 정도.

K08. 한국텍학회.『TEX: 조판, 그 이상의 가능성』. 서울: 경문사, 2007.
　　(타이포그래피에서) 말하는 읽기 쉬움은 'readability'를
뜻하는 것이 아니라 'legibility'를 뜻한다. 'readability'가 언어
또는 내용의 측면에서 글이 얼마나 읽기 쉽게 쓰여 있는가를
의미하는 데 반해 'legibility'는 디자인 측면에서 글자 또는
글자들을 배치한 모양이 얼마나 읽기 쉬운가를 의미한다.

K09. 오병근, 강성중.『정보 디자인 교과서』. 파주: 안그라픽스, 2008.
　　타이포그래피에서 많은 양의 텍스트 정보를 쉽고 빠르게 읽을
수 있는가 하는 시각적 속성을 가독성이라고 한다. 즉, 주어진
시간 내에 얼마나 많은 양의 정보를 이해할 수 있는가와 관련
있는 것으로 정보 전달의 효율성과 직결된다. 가독성의 향상을
위해서는 글자 스타일, 글자크기, 색상의 조화, 글자의 공간,
글줄길이, 정렬 등의 요인을 고려해야 한다.

디자인의 조화, 판짜기(글자사이, 글줄사이 등)의 적정함 등이
있다. 비슷한 말로 이독성(易讀性, readability)이 있는데, 이는
문장 내용의 읽기 쉬움을 나타내는 말이며 눈에 뜨이는 정도를
설명하는 가시성(visibility)이라는 말도 있다.

K04. 한국출판연구소.『출판사전』. 파주: 범우사, 2000.
　　→ 가독성: legibility. readability. 책의 내용이 얼마나 쉽게
읽혀질 수 있는가를 이르는 말. 인쇄물은 읽혀질 서체나 편집,
인쇄방식 여하에 따라 쉽게 읽혀질 수도 있고 더디 읽혀질 수도
있다. 광고물이나 상업디자인에서도 조형성이나 디자인의
독창성과 함께 문자의 가독성은 중요한 검토사항이 된다.

K05. 세종대왕기념사업회 한국글꼴개발연구원.
『한글글꼴용어사전』. 서울: 세종대왕기념사업회, 2000.
　　→ 가독성: 可讀性. legibility. 가독성을 뜻하는 말에는 레지빌리티
(legibility)와 리더빌리티(readability)가 있다. 레지빌리티는
개개의 글자 형태를 '식별하고 인지하는 과정'을 일컫는 것이며,
리더빌리티란 '보고 지각하는 과정(scan-and-perceiving
process)의 성공도'를 나타낸다. 초기에 독서의 용이함과 독서
속도에 영향을 미치는 요소를 논의할 때 '레지빌리티'라는
용어가 사용되었고 '리더빌리티'라는 말은 1940년경부터
일부 학자들이 사용하기 시작하면서 '리더빌리티'라는 말은
'독서 재료의 정신적 장애(mental difficulty)의 수준을
측정하는 것'이라고 말하게 되었고 용어가 두 갈래로 갈라져
혼동을 초래하였다. 결국 레지빌리티는 글자나 낱말을 지각하는
것과 연결된 본문 독서 재료의 읽기와 관련되어 있다. 글자꼴은
꼭 식별되어야 할 뿐 아니라 특성을 지닌 낱말의 형태로
지각되어야 하며, 연속적인 본문은 빠르고, 정확하게, 그리고
쉽게 읽혀 이해되어야 하는 것이다. 다시 말하면 '레지빌리티'란
독서의 용이함과 독서 속도에 영향을 미치는 글자나 다른
심볼, 낱말, 그리고 연속적인 본문 독서 재료에서 본질적인
타이포그래피 요소를 통합하고 조정하는 것을 취급하는
것을 말한다. → 판독성: 判讀性. legibility. 판독성은 글자가
눈에 잘 띄는 것을 말하는 것으로서 개개의 글자 형태를
식별하고 인지하는 과정이며, 산세리프체가 판독성이
높다고 알려져 있다. 유사한 개념인 가독성은 읽기 쉬운 것을
말하는 것으로서 보고 지각하는 과정의 성공도를 나타내며,
세리프체가 가독성이 높다고 알려져 있다. 보통, 가독성의 의미는

굳이 이를 구별하는 이유는 판독과 가독의 시차를 따질 때 판독을 가독의 선행 개념으로 보기 때문이다. 다시 말하면, 여러 개의 글자 중에서 무슨 글자인지 판독이 먼저 되고, 판독된 글자를 계속해서 빨리 읽는 가독의 단계로 넘어간다고 보기 때문이다. 그래서 필자는 서로 다른 여러 개의 글자가 섞여 있을 때 무슨 글자인지 구별하는 것을 판독, 판독된 글자를 계속해서 스피디하게 읽어 나가는 것을 가독이라고 구분해서 생각하고자 한다. 필자가 실용성이 높은 이상적인 글자의 조건 중에서 판독과 가독을 가장 중요한 첫째 조건으로 여기는 까닭은 글자의 제1 기능이 의미 전달이기 때문이다. 글자는 보는 사람이 빨리 판단하고 읽을 수 있어야 하기 때문에 실용성이 높은 이상적인 글자의 첫째 조건은 높은 판독성과 가독성이다.

K02. 이순종, 조영제, 안상수, 권명광. 『디자인 사전』.
파주: 안그라픽스, 1994.
　　→ 가독성: legibility. readability. 가독성이라는 뜻을 나타내는 말에는 레지빌리티(legibility)와 리더빌리티(readability)가 있다. 레지빌리티는 개개의 글자 형태를 '식별하고 인지하는 과정'을 일컫는 것이며, 리더빌리티란 '보고 지각하는 과정 (scan-and-perceiving process)의 성공도'를 나타낸다. 초기에 독서의 용이함과 독서 속도에 영향을 미치는 요소를 논의할 때 '레지빌리티'라는 용어가 사용되었고 '리더빌리티' 라는 말은 1940년경부터 일부 학자들이 사용하기 시작하면서 '리더빌리티'라는 말은 '독서 재료의 정신적 장애(mental difficulty)의 수준을 측정하는 것'이라고 말하게 되었고 용어가 두 갈래로 갈라져 혼동을 초래하였다. 결국 레지빌리티는 글자나 낱말을 지각하는 것과 연결된 본문 독서 재료의 읽기와 관련되어 있다. 글자꼴은 꼭 식별되어야 할 뿐 아니라 특성을 지닌 낱말의 형태로 지각되어야 하며, 연속적인 본문은 빠르고, 정확하게, 그리고 쉽게 읽혀 이해되어야 하는 것이다. 다시 말하면 '레지빌리티'란 독서의 용이함과 독서 속도에 영향을 미치는 글자나 다른 심볼, 낱말, 그리고 연속적인 본문 독서 재료에서 본질적인 타이포그래피 요소를 통합하고 조정하는 것을 취급하는 것을 말한다.

K03. 안상수, 한재준. 『한글 디자인』. 파주: 안그라픽스, 1999.
　　→ 가독성: legibility. 인쇄물의 활자 따위가 쉽게 읽히는 정도. 가독성의 요소에는 글자꼴의 아름다움, 문장 내용과 활자꼴

> Legibility: the quality of being clear enough to read.
> Readability: the quality of being legible or decipherable.

『캠브리지 사전』은 legibility와 readability 모두 '쉽게(easy) 읽히는
(read) 정도'로 정의하고 있으며 legibility에는 시각적인 관점인 'clear,
printed well'이 추가되어 있다.

> Legibility: the degree to which writing or text can be
> read easily because the letters are clear, the text is printed
> well, etc.
> Readability: the quality of being easy and enjoyable
> to read.

『미리엄웹스터』 사전은 legible과 readable을 모두 '읽히는(read)
정도'로 정의하고 있으며 readable에는 '쉽게(easy)'가 추가되어 있다.

> Legible: capable of being read or deciphered.
> Readable: able to be read easily.

위와 같이 사전을 검토한 결과, 가독성과 판독성 또는 legibility와
readability라는 용어의 사전적 정의에는 뚜렷한 변별력이 없음을 알
수 있었다.

2.2 전문 서적

가독성·판독성·legibility·readability의 사전적 정의는 동의어라고
볼 수 있을 만큼 변별력이 적다. 반면, 타이포그래피 분야에서의
실천적 개념에는 차이가 있을 수 있다. 연구자는 타이포그래피
분야에서 이들이 어떤 의미로 사용되고 있는지 정확히 파악하기 위해
명망 있는 국내외 타이포그래피 연구자가 직접 저술하거나 번역한
단행본에서 가독성과 판독성, legibility와 readability를 정의한 사례
스물세 권을 검토했다.

분석에 사용한 서적은 국내서적 열 권과 해외서적 열세 권으로
구성했으며, 가독성·판독성·legibility·readability를 구체적으로
정의한 사례만 포함했다. 서적은 출판년도 순서로 나열했고, 편의를
위해 국내서적은 K(Korean), 해외서적은 F(Foreign)로 고유번호를
붙였다. 이때 번역서가 존재하는 해외서적의 경우에는 번역서의
내용을 옮겼다. 번역서가 없을 때는 연구자가 번역했으며, 왜곡 없이
의미를 전달하기 위해 legibility, readability를 포함한 주요 용어는
영문 용어를 그대로 옮겼다. 국내서적의 경우에도 원문에 병기된 영문
용어는 그대로 옮겼다.

2.2.1 국내서적

K01. 송현. 『한글 기계화 운동』. 서울: 인물연구소, 1984.

> 판독성과 가독성을 서로 비슷한 개념으로 볼 수 있지만, 필자가

1 서론

이 연구는 타이포그래피 분야에서 가독성과 판독성의 정의가 어떻게 혼용되고 있는지를 사용 행태에 따라 검토하고, 통용되고 있는 가독성·판독성·legibility·readability의 정의를 유형화하고자 했다. 이를 통해 소통의 혼란을 일으키는 원인을 파악하고, 혼용되고 있는 용어의 윤곽을 명확히 하여 정확한 소통의 발판을 마련하고자 한다.

가독성과 판독성은 타이포그래피 분야에서 빈번히 언급되는 용어이다. 타이포그래피의 본질적인 기능이자 목표와 관계된 용어로 중요하게 의미를 살펴 사용해야 한다. 그런데도 타이포그래피 전공 서적에서조차 두 용어의 구분 기준은 모호하다. 두 용어는 서로 유사하지만, 동의어로 보기는 어렵다. 그러나 구분 없이 사용하거나 일관되지 않은 의미로 사용하는 경우가 잦아 소통의 혼란이 발생한다.

이런 문제가 발생한 주요한 원인은 원서의 번역 과정에서 비롯했다고도 볼 수 있다. 다수의 타이포그래피 용어와 마찬가지로 가독성과 판독성도 원서를 인용해 용어 개념을 설명하는 경우가 많은데, 원서마다 legibility와 readability의 정의가 일관되지 않아 혼란을 주는 데다, 번역 과정에서 채택된 국문 용어가 역자에 따라 다르다는 문제가 있다. 어떤 경우에는 readability를 가독성으로 legibility를 판독성으로 번역하기도 하고, 어떤 경우에는 legibility를 가독성으로 번역하기도 한다. 그 외에도 이독성, 시인성, 독해성, 읽힘성, 가해성, 가시성 등의 유사 용어로 번역되는 경우도 발생한다.

이러한 혼란은 지난 50여 년간 계속됐으나 아쉽게도 이에 관한 학술 연구는 이루어지지 않았다. 이에 연구자는 명망 있는 국내외 타이포그래피 연구자가 직접 저술하거나 번역한 단행본에서 가독성과 판독성, legibility와 readability가 각각 어떻게 정의되고 있는지 알아보고, 종합적으로 분석해 유형화하고자 했다.

2 용어 사용 현황

2.1 사전

국립국어원 『표준국어대사전』은 가독성을 다음과 같이 정의한다. 판독성(判讀性)은 표제어에 미포함 되어 있으나, 가독성의 可(옳을 가)와 판독성의 判(판단할 판)은 옳고 그름을 구분한다는 동일한 의미가 있다.

> 가독성(可讀性): 인쇄물이 얼마나 쉽게 읽히는가 하는 능률의 정도. 활자체, 글자 간격, 행간(行間), 띄어쓰기 따위에 따라 달라진다.

『옥스퍼드 사전』은 legibility와 readability를 다음과 같이 정의한다. legibility를 설명하기 위해 'read'를, readability를 설명하기 위해 'legible'을 사용한다.

가독성과 판독성은 타이포그래피 분야에서 빈번히 언급되는 용어이다. 그럼에도 그 정의가 명확히 정립되어 있지 않아 혼용되거나 오용되는 경우가 많다. 특히, 번역 과정에서 가독성과 판독성, legibility의 readability의 의미가 불규칙하게 연결되어 소통의 혼란이 일어나기도 한다.

이 연구의 목적은 혼란의 원인을 파악하고, 불분명하게 통용되고 있는 용어의 윤곽을 명확히 하여 정확한 소통의 발판을 마련하는 것이다. 이를 위해 타이포그래피 분야에서 가독성·판독성·legibility·readability가 각각 어떻게 정의되고 있는지 수집하고 분석해 유형화했다. 연구 범위는 명망 있는 국내외 타이포그래피 연구자가 직접 저술하거나 번역한 단행본 스물세 권으로 선정했다. 국내 서적 열 권과 해외 서적 열세 권으로 구성되며 구체적으로 가독성·판독성·legibility·readability를 정의한 사례만 포함했다.

가독성·판독성·legibility·readability의 용례는 다음의 세 가지 유형으로 정리할 수 있다. 첫째, A 유형에서 가독성은 텍스트의 형태 인지 능률을 의미하고 판독성은 낱자의 형태 인지 능률을 의미한다. 가독성=readability, 판독성=legibility로 번역된다. 둘째, B 유형에서 가독성은 텍스트의 내용 독해 능률을 의미하고 판독성은 낱자 및 텍스트의 형태 인지 능률을 의미한다. 가독성=readability, 판독성=legibility로 번역된다. 셋째, C유형에서 가독성은 낱자의 형태 인지 능률, 텍스트 형태 인지 능률, 텍스트의 독해 능률을 모두 포괄하여 의미한다. 가독성=legibility로 번역된다.

따라서 타이포그래피 연구자는 소통의 혼선을 피하고자 다음과 같은 노력을 기울일 필요가 있다. 첫째, 가독성·판독성·legibility·readability의 정의가 의도한 바와 다르게 해석될 수 있음을 분명히 인지한다. 둘째, 이들 용어를 사용할 때는 의도하는 바를 구체적으로 부연한다. 셋째, 번역할 때에는 가급적 원문에서 사용한 용어를 병기한다.

타이포그래피 분야에서 가독성과 판독성의 정의 유형 분석

석재원, 구자은

주제어: 타이포그래피, 판독성, 가독성, Legibility, Readability
투고: 2021년 4월 16일
심사: 2021년 5월 11일
게재 확정: 2021년 5월 16일

드러냄으로써 우리가 취해야 할 태도를 모색한다. 더 나아가 연구자는 기술, 권력 그리고 미학의 상호관계 연구에서 시의성 있는 사회 주제로 범위를 확대해 나가며 앞으로도 보이지 않는 중요한 가치를 지속해서 이야기하고자 한다.

참고문헌

슬라보예 지젝. 김희진, 이현우 옮김.『실재의 사막에 오신 것을 환영합니다』. 서울: 자음과모음, 2011.

유지원.『글자 풍경』. 서울: 을유문화사, 2019.

로빈 킨로스. 최성민 옮김.『현대 타이포그래피』. 스펙터프레스, 2009.

데이비드 킴.「Tobias Frere-Jones, Type Designer」.『서피스 매거진』, 파워 100 이슈, 6/7월호. 뉴욕: 서피스미디어, 2014.

유발 노아 하라리.「Yuval Noah Harari: the world after coronavirus」.『파이낸셜 타임스』, 2020년 3월 20일. 2021년 5월 21일 접속. www.ft.com/content/19d90308-6858-11ea-a3c9-1fe6fedcca75

미국 의회도서관(Library of Congress). 2021년 5월 21일 접속. www.loc.gov/marc/languages/language_code.html

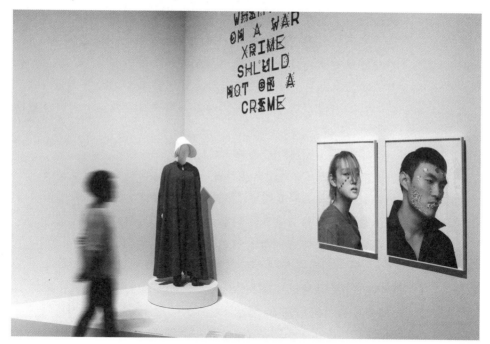

[13] 「ZXX」가 설치된 모습. 필라델피아 미술관, 2019.

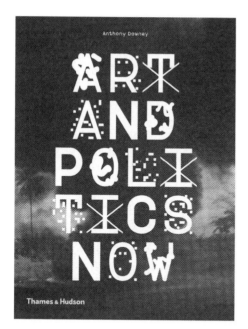

[14] 『예술과 정치의 현재』 표지와 내지에
「ZXX」가 사용되었다.

해독 기술에 맞서 완벽히 해독이 불가한 활자체를 구현하는 것이
본 프로젝트의 본질은 아니다. 실제 앞으로 등장할 광학 문자 판독
기계는 단일 글자보다는 전체 텍스트와 맥락을 인식하도록 정교화될
것이다. 「ZXX」는 기술적으로 글자를 해독할 수 없게 만들기보다
디지털 감시에 관한 인식을 상기시키는 상징적 존재로서 의의가 있다.

「ZXX」 활자체의 활용

2013년 NSA 기밀자료 폭로사건*을 통해서 미국 국가안보국이
민간인을 상대로 신호정보를 취합한다는 사실이 전 세계에 알려졌다.
스노든 사건이 보도되면서, 다양한 매체와 전시**에서 「ZXX」가 지닌
디지털 감시에 대한 저항의 의미가 새롭게 부각되었다.[도판 13]
　　웹사이트를 통해 「ZXX」를 무료로 배포했고, 영국 그래픽
디자이너 조너선 반브룩(Jonathan Barnbrook)이 디자인한 책자
『예술과 정치의 현재(Art and Politics Now)』[도판 14]에서
사용되었다. 이 책을 필두로 「ZXX」는 '디지털 반항'을 표현하는
선언으로서 하나의 운동처럼 퍼져나갔다. 저항 의식을 담은 프로젝트
사례에서 언급했던 아담 하비 또한 「ZXX」를 본인 작업에 사용했으며,
이외에도 「ZXX」를 활용한 사례는 스위스, 독일, 러시아, 미국, 한국
등에서 발견할 수 있다.
　　무료 배포된 활자체의 사용을 통해 사용자가 능동적인
주체로서 디지털 검열 현상에 의견을 개진하고 직접적인 변화를
요구하게 된 것이다. 「ZXX」는 실용적·상징적 가치를 충족하는 새로운
형태의 활자체로서, 미비하나마 사용자들의 능동적인 인식과 행동
변화를 촉발하는 매개로 활용된 것에 의의가 있다.

마치며

현대 사회에서 우리는 항상 검열과 감시에서
자유롭지 않다. 「ZXX」 프로젝트는 이런 제한된
자유를 시각적으로 드러냄으로써 개인정보 보호에
관한 논의를 촉발하고, 편의를 위해 개인의 권리
보호가 경시되는 디지털 사회에 대한 경각심을
불러일으키고자 했다. 디지털 감시와 개인정보
보호라는 복합적인 주제를 단일한 표상으로 담아내고,
이를 통해 사회 문제를 직접적으로 해결하는 것은
불가능할 것이다. 그러나 상징성을 지닌 활자체의
능동적인 활용을 통해 주제 의식을 효과적으로 전달할
수 있다. 따라서 본 프로젝트는 하나의 완성형 활자체를
제안하는 것만이 아닌, 활자 형태의 진화 과정을

* 에드워드 조지프 스노든
(Edward Joseph Snowden)은
미국 중앙정보국(CIA)과 미국
국가안보국(NSA)에서 일했던
컴퓨터 기술자다. 스노든은
2013년 『가디언』을 통해 미국
내 통화 감찰 기록과 프리즘
(PRISM) 감시 프로그램 등
미국 중앙정보국의 다양한
기밀문서를 공개했다.

** CNN, 『와이어드(WIRED)』,
샌프란시스코 현대미술관,
파리 장식미술관, 필라델피아
미술관 등에서 「ZXX」에 관한
전시와 인터뷰를 진행했다.

TEXHNOLOGY IS NEITHER GOOD NOR BAD; NEITHER IS IG NEUTRAL.

[12] 열여섯 가지 활자 가족으로 섞어짜기한 예.

Good Morning, Mister Orwell

[11] 여섯 가지 활자가족 섞어짜기 예.

통해서 인식 능력이 지속해서 향상되고 있다. 버전 5까지 출시된 테서렉트는 「ZXX False」를 뺀 나머지 활자체를 모두 쉽게 판독했다.

새로 만드는 활자가족은 테서렉트 소프트웨어를 기준으로 시험했다. 오프라인 문자 인식 기법의 하나인 테서렉트는 입력된 이미지의 특징을 추출해 문자를 인식한다. 이미지의 곡선, 모서리, 각도, 선과 같은 개별 구성 요소를 분해해 특정 문자와 비교한다. 각 요소를 아웃라인 처리하고 다각형에 근접하게 추출해서 데이터베이스에서 비슷한 형태의 문자와 비교해 오차율이 가장 낮은 문자를 출력하는 방식이다.

연구자는 개별 구성 요소를 분해하는 테서렉트의 문자 인식 원리를 역으로 이용해 새로운 형태의 활자가족 제작을 시도했다. 기본 글자 구조는 유지하면서 의도적으로 연결점을 크고 각진 형태로 과장해 과감한 대비를 만들고, 기존 활자와 섞어서 조판했다.◆◆ [도판 12] 이런 극단적인 형태는 현시점에도 계속 훈련 중인 테서렉트의 판독 기술을 방해하는 유일한 방법이었다. 새로 개발 중인 「ZXX」 의 극단적으로 모호한 형태는 현재 문자 판독 기술이 얼마나 발전했는지를 보여주는 가시적인 척도이다.

「ZXX」 프로젝트는 시대와 기술의 변화에 따라 끊임없이 확장할 수 있다. 단, 급진적으로 고도화되는

◆ 구글의 테서렉트처럼 무료 광학 문자 판독 서비스를 제공하는 어도비 애크러뱃 프로를 활용해 「ZXX」를 판독 시험했다. 해당 소프트웨어는 모든 「ZXX」를 판독하지 못했다.

◆◆ 이전에는 수동 섞어짜기만 가능했지만 글립스(Glyphs)의 '문맥에 따른 대체 글자 (Contextual Alternatives)' 기능으로 자동 섞어짜기가 가능해졌다.

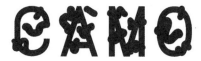

[5] 광학 문자 판독 소프트웨어 판독성 테스트.

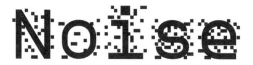

[6] 「ZXX Camo」.

[7] 「ZXX False」.

Noise

[8] 「ZXX Noise」.

m

[9] 「ZXX Noise」의 소문자 m.

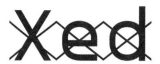

[10] 「ZXX Xed」.

[도판 7]는 이름 그대로 거짓 정보를 전달하기 위해 스물여섯 가지 알파벳과 열 가지 숫자의 시작과 끝을 맞바꾸어서 질서를 흩트렸다. A는 Z안에, 0은 9안에 숨겨져 있다. 글을 읽기 위해서는 교체된 낱글자 안에 숨겨진 작은 알파벳을 읽어야 하는 수고가 필요하다. 「ZXX Noise」[도판 8]는 낱글자의 빈 공간을 각각 개별적인 노이즈로 채우면서 광학 문자 판독의 기능 한계를 시험했다. 대부분의 광학 문자 판독 기계는 어둡고 밝은 배경을 구별하는 사전 처리를 거친다. 상대적으로 개성적 형태를 가진 글자는 노이즈가 더해져도 판독이 용이했다. 소문자 m[도판 9]의 경우 밝은 배경이 사라질 듯 노이즈가 가득 채워져야 판독이 불가능했다. 「ZXX Xed」[도판 10]은 가독성을 최소만 해치도록 모든 낱글자에 규칙적인 X자 패턴을 입혔다. X 패턴은 글자의 각각 모서리 영역을 침범하며 최소한의 왜곡으로 광학 문자 판독 기능을 가장 효과적으로 혼란스럽게 만들었다. 여섯 가지 활자가족은 섞어짜기를 통해 무한에 가까운 순열로 OCR의 판독 기능에 더 큰 영향을 끼칠 수 있다. [도판 11]

「ZXX」 개발 과정 2: 2020년

2020년에 미국 카네기미술관의 『기억이 담긴 거울(Mirror with a Memory)』 간행물에 참가하며 「ZXX」의 이차 개발을 시작했다. 당시 가장 고도화된 광학 문자 판독 시스템을 구축한 구글의 테서렉트(Tesserect) 광학 문자 판독을 이용해 2012년에 개발된 「ZXX」를 다시 판독 시험했다. 테서렉트는 인공지능 트레이닝을

[4] CV 대즐.

아담 하비(Adam Harvey)는 감시와 검열 사회에 저항하기 위해 방대한 저항성 프로젝트를 진행했다. 하비의 대표작품인 CV대즐(CV Dazzle)[도판 4]은 감시와 패션의 미학을 결합했다. CCTV와 드론 같은 디지털 안면인식 기술로부터 얼굴을 감추는 일종의 퍼포먼스에 가까운 변장술이다. 헤어스타일과 얼굴에 과도한 패턴을 입혀 컴퓨터 비전이 사람으로 인식하지 못하게 만드는 아날로그적인 작업이다. 하비는 안면인식 방해 패턴 개발 이후 스텔스 웨어(Stealth Wear) 프로젝트를 통해 각종 디지털 감시 기술로부터 사람을 인식하지 못하도록 막는 의류를 제작했다.

암스테르담에 기반을 둔 디자인 및 연구 스튜디오인 메타헤이븐(Metahaven)은 사회 비평 디자인 운동의 선봉에 있다. 그들은 그래픽 디자인을 이용하여 미디어와 정부를 포함한 권력의 작동 기제에 대한 비판적인 디자인과 저술을 내놓는다. '예술은 무엇을 해야 하는지'에 관해 끝없이 질문하고 답을 탐구하는 활동을 지속한다. 내부고발 및 군사 폭로 사건으로 유명한 저널리즘 비영리 단체인 위키리크스(WikiLeaks)의 자발적 브랜딩 운동은 단연 메타헤이븐의 독보적인 행보를 잘 보여주는 프로젝트이다. 이들의 작업은 음흉하고 수수께끼 같이 불가해한 느낌을 풍기며 검열적 통제에 대한 비판을 표현한다.

「ZXX」 개발 과정 1: 2012년

슬라보예 지젝(Slavoj Žižek)은 "우리가 자유롭다고 느끼는 것은 우리의 부자유를 표현할 언어 그 자체가 결여되어 있기 때문이다"◆ 라고 말했다. 이와 같은 맥락에서 검열, 감시 그리고 표현 억압에 관한 문제를 제기하기 위해, 연구자는 지젝이 말했던 부자유를 활자체로 보여주고자 했다. 부자유를 시각화하기 위해 광학 문자 판독 소프트웨어가 해독할 수 없도록 분열된 글자를 그리기 시작했다. [도판 5] 「ZXX」는 의도적으로 글자를 여러 종류의 노이즈와 시각적 왜곡으로 흩트려 소프트웨어를 혼란스럽게 만든다.

「ZXX Camo」[도판 6]는 마치 동물들이 포식자에게 식별이 안 되도록 위장하듯 활자체 위에 위장 패턴을 입혔다. 위장의 유기적 벡터 형태는 다양한 동물의 위장 요소를 그대로 차용했다. 「ZXX False」

◆ 슬라보예 지젝. 김희진, 이현우 옮김. 『실재의 사막에 오신 것을 환영합니다』. 서울: 자음과모음, 2011. 12쪽.

ABCDEFGHIJKLMNOPQRSTUVWXYZ

ABCDEFGHIJKLMNOPQRSTUVWXYZ

ABCDEFGHIJKLMNOPQRSTUVWXYZ

ZYXWVUTSRQPONMLKJIHGFEDCBA

ABCDEFGHIJKLMNOPQRSTUVWXYZ

ABCDEFGHIJKLMNOPQRSTUVWXYZ

[2] 일차로 개발된 여섯 가지 「ZXX」 활자 가족.

ABCDEFGHIJKLMNOPQRSTUVWXYZ

ABCDEFGHIJKLMNOPQRSTUVWXYZ

ABCDEFGHIJKLMNOPQRSTUVWXYZ

ABCDEFGHIJKLMNOPQRSTUVWXYZ

ABCDEFGHIJKLMNOPQRSTUVWXYZ

ABCDEFGHIJKLMNOPQRSTUVWXYZ

ABCDEFGHIJKLMNOPQRSTUVWXYZ

ABCDEFGHIJKLMNOPQRSTUVWXYZ

ABCDEFGHIJKLMNOPQRSTUVWXYZ

ABCDEFGHIJKLMNOPQRSTUVWXYZ

[3] 이차로 개발된 열 가지 「ZXX」 활자 가족.

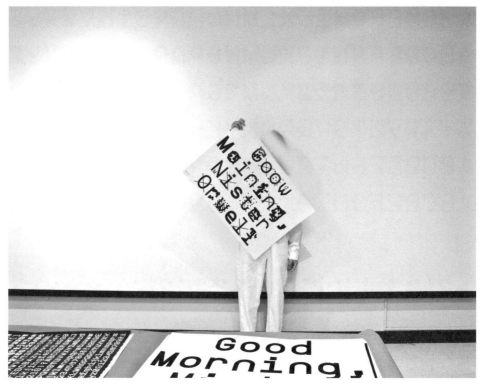

[1] 「ZXX」 견본.

활자체를 고안했다. 여섯 가지 활자 가족[도판 2]을 시작으로, 2021년 현재 기계의 지능에서 벗어나기 위한 열여섯 가지 다른 위장 요소를 지닌 활자체[도판 3]를 단계별로 개발했다. 일반적으로 읽을 수 없는 글자는 무용지물에 불과하다는 것이 상식이지만, 「ZXX」 활자 가족은 읽히지 않음으로써 존재한다는 역설을 제시하고 있다.

디지털 감시에 대한 저항 의식을 담은 프로젝트 사례

다양한 활동가와 예술가, 그리고 디자이너는 여러 형태로 개인정보 보호와 검열 사회에 대한 비판적 시각을 담은 활동을 전개했다. 컴퓨터 보안 연구원이자 해커인 제이콥 애플바움(Jacob Appelbaum)은 개개인의 온라인 활동을 익명으로 유지하고 개인정보 보호를 보장하기 위해 토어 프로젝트(Tor Project)를 공동 개발했다.

토어 프로젝트의 시스템은 분산된 릴레이 네트워크로 구성되어 누적된 메타데이터가 제대로 작동하지 않게끔 설계되어 있다. 토어는 목적지까지 한 번에 통신하지 않고 여러 국가의 네트워크를 경유하기에 이를 역추적하는 일은 불가능에 가깝다.♦♦♦♦♦ 이런 이유로 토어 프로젝트를 다운받거나 사용하는 것만으로도 NSA의 관심 리스트에 오른다는 정보가 유출되기도 했다.

♦♦♦♦♦ 예를 들면 트래픽이 A→Z가 아닌, A→C→ B→D→Z 방식으로 우회하며 목적지에 도달하게 된다. 한국의 컴퓨터에서 시작되어 독일, 미국 등의 네트워크를 경유하여 최종 목적지인 특정 인터넷 사이트에 도달하게 되는 형식이다.

활자체는 필연적으로 시대를 반영한다. 활자체는 문명과 기술 및
사회 맥락과 함께 변모해왔으며, '문명을 관통하는 실'◆로서 상징성과
시간성을 지닌 시대적 산물로 사회적 기능을 수행해왔다. 현재 우리
사회에서 활자체 디자인은 어떤 시대적 이야기를 하고 있는가?
이 연구는 수동적인 서비스 디자인부터 적극적인 메시지 전달
디자인까지 활자체 디자인의 가능성을 모색해보고자 한다.

연구 배경

「ZXX」◆◆ 프로젝트는 연구자의 군 복무◆◆◆ 경험에서 착안한 것으로,
물리적 데이터 수집에 대한 디지털 반항으로부터 시작했다. 「ZXX」는
고도로 정보화된 사회에서 개인정보 보호 문제를 제기하고 경각심을
촉구하자는 실질적이고 상징적인 호출이었다. 「ZXX」 프로젝트를
준비하던 당시 새롭게 등장한 다양한 기술은 개인정보를 포함한
방대한 데이터를 상시 수집 가능한 형태로 저장·연결하는 것을
가능케 했다. 예를 들어, 구글 글라스를 시작으로 기하급수적으로
개발된 웨어러블 기기는 눈으로 보는 것을 모두 기록하는 편의를
제공하지만, 이는 동시에 하루 스물네 시간 동안 개인이 인지하지
못하는 수준의 데이터까지 수집될 수 있는 새로운 감시 사회가
도래했음을 암시하기도 한다. 이러한 변화들은 근접(over the skin)
감시가 밀착(under the skin) 감시로 급속히 바뀔 수
있다는 것을 의미한다.◆◆◆◆ 급속히 발전한 기술은 우리
생활 속에 깊이 침투한 한편, 수집된 개인정보를 어떻게
보호하고 활용할 것인지에 관한 사회적 인식은 아직
미비한 수준이다.

　　본 프로젝트는 '어떻게 사람의 생각을
인공지능과 인공지능을 사용하고 배포하는 사람 혹은
기관으로부터 숨길 수 있을까'라는 질문에서 시작했다.
그리고 뒤이어 '정치적·사회적으로 활용된 디자인은
어떻게 대중의 사고를 체계화 혹은 탈체계화시킬
수 있는가' '드러내는 혹은 표현하는 양식으로서의
디자인이 아닌 감춤이 곧 본질인 디자인이란 어떤
것인가' '디자인이 어떻게 프라이버시를 강화해줄 수
있을 것인가' '프라이버시라는 의제에 대하여 현재와
미래의 주도적 태도를 보일 수 있는 디자인의 방법이란
어떻게 가능한가' 등 심화한 문제 인식으로 이어졌다.

　　이에, 사람은 읽을 수 있지만, 컴퓨터의 광학
문자 판독 인공지능은 해독할 수 없는 상징성을 가진

◆ 데이비드 킴(David Kim).
「Tobias Frere-Jones, Type
Designer」. 『서피스 매거진
(Surface Magazine)』.
파워 100 이슈, 6/7월호.
뉴욕: 서피스 미디어, 2014.
◆◆ ZXX는 미국 의회도서관에서
글자 판독이 불가할 때 사용하는
세 글자 코드다. ZXX가
지정하는 의미는 '언어적 내용
없음'이다.
◆◆◆ 연구자는 군복무 당시
특수정보 한국군으로 미국
국가안보국과 함께 북한의
신호정보를 취합하고 분석하는
일을 수행했다.
◆◆◆◆ 유발 노아 하라리(Yuval
Noah Harari). 「Yuval Noah
Harari: the world after
coronavirus」. 『파이낸셜
타임스』, 2020년 3월 20일.

활자체는 언어적 상징인 동시에 특정 사회에서 통용되는 시각적 기호로써, 시대상을 담고 있는 사회적 산물이라 할 수 있다. 이 연구는 지난 10여 년간 연구자가 디지털 감시로부터 개인정보를 보호하기 위해 개발한 활자체 「ZXX」를 중심으로 활자체 디자인의 사회적 기능과 능동적인 활용 방안을 모색하고자 한다.

이 연구는 물리적 데이터 수집에 대한 문제 인식에서 시작해 실질적이고 상징적인 「ZXX」를 고안한 과정과 결과를 서술한다. 감춤이 곧 본질인 「ZXX」는 컴퓨터의 광학 문자 판독(Optical Character Recognition, OCR) 인공지능이 해독할 수 없는 열여섯 가지 각기 다른 위장 요소를 단계별로 개발했다. 시대와 기술 변화에 따른 판독 시험을 통해 프로젝트는 현시점에도 계속 확장 중이다. 본 연구의 목적은 완벽히 해독이 불가한 활자체를 구현하는 것이 아닌, 디지털 감시 문제에 대한 인식을 상기시키는 상징적 존재로서의 의의를 찾는 것이다.

이 연구의 궁극적인 목적은 활자체를 통해 디지털 감시와 같은 이 시대의 주요 사회 현상들에 관해 토론의 장을 마련하는 데 있다. 이 연구는 시대의 목소리를 담는 매체로서 활자체 디자인의 의미를 고찰하며, 디지털 시대에 개인정보 보호의 인식을 제고하는데 그 의의가 있다.

디지털 시대에 개인정보 보호의 인식 제고를 위한 「ZXX」 활자체 디자인

18

문상현

주제어: 타이포그래피, 활자체 디자인, 디지털, 감시
투고: 2021년 4월 26일
심사: 2021년 5월 11일
게재 확정: 2021년 6월 6일

다음 『글짜씨 21』에 실릴 논문을 모집합니다. 그것이 어떤 형식의 논문이던 어떤 주제를 다루던 논문편집위원회는 항상 열려있습니다. 작은 씨앗이 있다면 싹을 틔워 주십시오. 주위에 씨앗이 보인다면 알려주셔도 좋습니다. 인사말을 부드럽게 꺼내고자 했으나 마음이 급했는지 할 말이 먼저 튀어나옵니다. 그래도 제게 허락된 지면을 통해 먼저 이 말씀은 꼭 드리고 싶었습니다.

20호의 원고를 찬찬히 훑어보니 한량없이 세밀한 이 정성스러운 열매는 너무나 아름답습니다. 그런데 왜 인사말을 쓰려는 제 머릿속은 학술대회에서 발표를 앞두고 긴장하던 때로 돌아간 듯 서서히 새하얘지는 것일까요. 논문 투고를 생각하는 분들도 마찬가지겠지요. 논고를 담당한 18호부터 이 부담을 덜어보고자 형식을 간소화하고 자유주제로 접수하기 시작했지만, 여전히 자발적 투고는 많지 않습니다. 결심하기도 힘든 마당에 심사까지 거쳐야 하니 이 얼마나 고된 일인지요. 다행히 심사의견들은 엄정한 평가라기보다는 애정 어린 칭찬 및 조언에 가깝기에 오히려 글을 완결짓는 데 큰 힘이 된답니다. 다만 그 내용을 독자에게 공개할 수 없음이 매번 아쉬울 따름입니다. 이번 논문편집위원회는 18호·19호의 논고 다섯 편에 더해 개인정보 수집을 비판적 시각에서 다룬 문상현의 「ZXX」 활자체 디자인 프로젝트부터 항상 애매했던 가독성과 판독성의 정의를 낱낱이 추적한 석재원·구자은의 연구까지 총 일곱 편의 논고를 담당했습니다. 그간 저자를 비롯해 좋은 논고가 실릴 수 있도록 독려해주신 분들과 바쁜 와중에도 따뜻하고 섬세한 심사의견을 남겨주신 모든 심사위원께 깊은 감사의 말씀을 드립니다. 이제 다시 21호를 준비하겠습니다.

논고는 20호의 일부일 뿐입니다. '재해석된 글자들'이라는 주제의 작업 소개를 시작으로 '기록' '대화' '비평' '수집'에 해당하는 다양한 볼거리 읽을거리들이 줄을 잇습니다. 어서 쪽을 넘겨 이 값진 결과를 함께 즐겨주시기 바랍니다. 기획 회의에서 '수집'의 〈뒤집어 보기〉를 디자이너분들이 한글로 만들기에 어렵지 않을까 걱정하던 이사님들이 떠오릅니다. 아이쿠야, 괜한 걱정이었네요.

이병학

한국타이포그라피학회
논문편집위원장

저자 존중
심사위원은 전문 지식인으로서의 저자의 인격과 독립성을 존중해야 한다. 평가 의견서에는 논문에 대한 자신의 판단을 밝히되, 보완이 필요한 부분에 대해서는 그 이유도 함께 상세하게 설명해야 한다. 정중하게 표현하고, 저자를 비하하거나 모욕하는 표현은 삼간다.

비밀 유지
편집위원과 심사위원은 심사 대상 논문에 대한 비밀을 지켜야 한다. 논문 평가를 위해 특별히 조언을 구하는 경우가 아니라면 논문을 다른 사람에게 보여주거나 논문 내용을 놓고 다른 사람과 논의하는 것도 바람직하지 않다. 또한 논문이 게재된 학술지가 출판되기 전에 저자의 동의 없이 논문의 내용을 인용해서는 안 된다.

윤리위원회의 구성과 의결
1 윤리위원회는 회원 5인 이상으로 구성되며, 위원은 논문편집위원회의 추천을 받아 회장이 임명한다.
2 윤리위원회에는 위원장 1인을 두며, 위원장은 호선한다.
3 윤리위원회는 재적위원 3분의 2의 찬성으로 의결한다.

윤리위원회의 권한
1 윤리위원회는 윤리 규정 위반으로 보고된 사안에 대해 증거자료 등을 통하여 조사를 실시하고, 그 결과를 회장에게 보고한다.
2 윤리 규정 위반이 사실로 판정되면 윤리위원장은 회장에게 제재 조치를 건의할 수 있다.

윤리위원회의 조사 및 심의
윤리 규정을 위반한 회원은 윤리위원회의 조사에 협조해야 한다. 윤리위원회는 윤리 규정을 위반한 회원에게 충분한 소명 기회를 주어야 하며, 윤리 규정 위반에 대해 윤리위원회가 최종 결정할 때까지 해당 회원의 신원을 외부에 공개하면 안 된다.

윤리 규정 위반에 대한 제재
1 윤리위원회는 위반 행위의 경중에 따라서 아래와 같은 제재를 할 수 있으며, 각 항의 제재가 병과될 수 있다.
　ㄱ. 논문이 학술지에 게재되기 이전인 경우 또는 학술대회 발표 이전인 경우에는 당해 논문의 게재 또는 발표의 불허
　ㄴ. 논문이 학술지에 게재되었거나 학술대회에서 발표된 경우에는 당해 논문의 학술지 게재 또는 학술대회 발표의 소급적 무효화
　ㄷ. 향후 3년간 논문 게재 또는 학술대회 발표 및 토론 금지
2 윤리위원회가 제재를 결정하면 그 사실을 연구 업적 관리 기관에 통보하며, 기타 적절한 방법으로 공표한다.

[규정 제정: 2009년 10월 1일]

3 논문심사의 결과는 아래와 같이 판정한다.
통과 / 수정 후 게재 / 수정 후 재심사 / 불가

심사 내용
1 연구 내용이 학회의 취지에 적합하며
타이포그래피 발전에 기여하는가?
2 주장이 명확하고 학문적 독창성을 가지고
있는가?
3 논문의 구성이 논리적인가?
4 학회의 작성 규정에 따라 기술되었는가?
5 국문 및 영문 요약의 내용이 정확한가?
6 참고문헌 및 주석이 정확하게 작성되었는가?
7 제목과 주제어가 연구 내용과 일치하는가?

[규정 제정: 2009년 10월 1일]
[개정: 2013년 3월 1일]

연구 윤리 규정
목적
본 연구 윤리 규정은 한국타이포그라피학회
회원이 연구 활동과 교육 활동을 하면서 지켜야
할 연구 윤리의 원칙을 규정한다.

윤리 규정 위반 보고
회원은 다른 회원이 윤리 규정을 위반한 것을
인지할 경우 해당자로 하여금 윤리 규정을
환기시킴으로써 문제를 바로잡도록 노력해야
한다. 그러나 문제가 바로잡히지 않거나 명백한
윤리 규정 위반 사례가 드러날 경우에는 학회
윤리위원회에 보고할 수 있다. 윤리위원회는
문제를 학회에 보고한 회원의 신원을 외부에
공개해서는 안 된다.

연구자의 순서
연구자의 순서는 상대적 지위에 관계없이 연구에
기여한 정도에 따라 정한다.

표절
논문 투고자는 자신이 행하지 않은 연구나 주장의
일부분을 자신의 연구 결과이거나 주장인 것처럼
논문에 제시해서는 안 된다. 타인의 연구 결과를
출처를 명시함과 더불어 여러 차례 참조할 수는
있을지라도, 그 일부분을 자신의 연구 결과이거나
주장인 것처럼 제시하는 것은 표절이 된다.

연구물의 중복 게재
논문 투고자는 국내외를 막론하고 이전에 출판된
자신의 연구물(게재 예정인 연구물 포함)을
사용하여 논문 게재를 할 수 없다. 단, 국외에서
발표한 내용의 일부를 한글로 발표하고자
할 경우 그 출처를 밝혀야 하며, 이에 대해
편집위원회는 연구 내용의 중요도에 따라 게재를
허가할 수 있다. 그러나 이 경우, 연구자는 중복
연구실적으로 사용할 수 없다.

인용 및 참고 표시
1 공개된 학술 자료를 인용할 경우에는 정확하게
기술해야 하고, 반드시 그 출처를 명확히 밝혀야
한다. 개인적인 접촉을 통해서 얻은 자료의
경우에는 그 정보를 제공한 사람의 동의를 받은
후에만 인용할 수 있다.
2 다른 사람의 글을 인용할 경우에는 반드시
주석을 통해 출처를 밝혀야 하며, 이러한 표기를
통해 어떤 부분이 선행 연구의 결과이고 어떤
부분이 본인의 독창적인 생각인지를 독자가 알 수
있도록 해야 한다.

공평한 대우
편집위원은 학술지 게재를 위해 투고된 논문을
저자의 성별, 나이, 소속 기관 및 어떤 선입견이나
사적인 친분과 무관하게 오직 논문의 질적 수준과
투고 규정에 근거하여 공평하게 취급하여야 한다.

공정한 심사 의뢰
편집위원은 투고된 논문의 평가를 해당 분야의
전문적 지식과 공정한 판단 능력을 지닌
심사위원에게 의뢰해야 한다. 심사 의뢰 시에는
저자와 지나치게 친분이 있거나 지나치게
적대적인 심사위원을 피함으로써 가능한 한
객관적인 평가가 이루어질 수 있도록 노력한다.
단, 같은 논문에 대한 평가가 심사위원 간에
현저하게 차이가 날 경우에는 해당 분야 제3의
전문가에게 자문을 받을 수 있다.

공정한 심사
심사위원은 논문을 개인적인 학술적 신념이나
저자와의 사적인 친분 관계를 떠나 공정하게
평가해야 한다. 근거를 명시하지 않은 채 논문을
탈락시키거나, 심사자 본인의 생각과 상충된다는
이유로 논문을 탈락시켜서는 안 되며, 심사 대상
논문을 제대로 읽지 않고 평가해도 안 된다.

저작권, 편집출판권, 배타적발행권

저작권은 저자에 속하며, 『글짜씨』의 편집출판권,
배타적발행권은 학회에 영구 귀속된다.

[규정 제정: 2009년 10월 1일]
[개정: 2020년 4월 17일]

논문 작성 규정

작성 방법

1 원고는 편집 작업 및 오류 확인을 위해 TXT/
DOC 파일과 PDF 파일을 함께 제출한다.
특수한 경우 INDD 파일을 제출할 수 있다.
2 이미지는 별도의 폴더에 정리하여 제출해야 한다.
3 공동 저술의 경우 제1연구자는 상단에
표기하고 제2연구자, 제3연구자 순으로 그 아래에
표기한다.
4 초록은 논문 전체를 요약해야 하며,
한글 기준으로 800자 안팎으로 작성해야 한다.
5 주제어는 3개 이상, 5개 이하로 수록한다.
6 논문 형식은 서론, 본론, 결론, 주석, 참고문헌을
명확히 구분하여 작성하는 것을 기본으로 하며,
연구 성격에 따라 자유롭게 작성할 수도 있다.
그러나 반드시 주석과 참고문헌을 수록해야 한다.
7 외국어 및 한자는 원칙적으로 한글로 표기하고
뜻이 분명치 않을 때는 괄호 안에 원어 또는
한자로 표기한다. 단, 처음 등장하는 외국어
고유명사의 표기는 한글 표기(외국어 표기)로
하고 그 다음부터는 한글만 표기한다.
8 각종 기호 및 단위의 표기는 국제적인 관용에
따른다.
9 그림이나 표는 고해상도로 작성하며,
그림 및 표의 제목과 설명은 본문 또는 그림,
표에 함께 기재한다.
10 참고 문헌의 나열은 매체 구분 없이 한국어,
중국어, 영어 순서로 하며 이 구분 안에서는
가나다순, 알파벳순으로 나열한다. 각 문헌은
저자, 논문명(서적명), 학술지명(저서일 경우
해당없음), 학회명(출판사명), 출판연도 순으로
기술한다.

분량

본문 활자 10포인트를 기준으로 표지, 차례 및
참고문헌을 제외하고 6쪽 이상 작성한다.

인쇄 원고 작성

1 디자인된 원고를 투고자가 확인한 다음
인쇄한다. 원고 확인 후 원고에 대한 책임은
투고자에게 있다.
2 학회지의 크기는 170×240mm로 한다.
(2013년 12월 이전에 발행된 학회지의 크기는
148×200mm)
3 원고는 흑백을 기본으로 한다.

[규정 제정: 2009년 10월 1일]
[개정: 2020년 4월 17일]

논문 심사 규정

목적

본 규정은 한국타이포그라피학회 학술지
『글짜씨』에 투고된 논문의 채택 여부를 판정하기
위한 심사 내용을 규정한다.

논문 심사

논문의 채택 여부는 편집위원회가 심사를
실시하여 다음과 같이 결정한다.
1 심사위원 3인 중 2인이 '통과'를 판정할 경우
게재할 수 있다.
2 심사위원 3인 중 2인이 '수정 후 게재' 이상의
판정을 하면 편집위원회가 수정 사항을 심의하고
통과 판정하여 논문을 게재할 수 있다.
3 심사위원 3인 중 2인이 '수정 후 재심사' 이하의
판정을 하면 재심사 후 게재 여부가 결정된다.
4 심사위원 3인 중 2명 이상이 '게재 불가'로
판정하면 논문을 게재할 수 없다.

편집위원회

1 편집위원회의 위원장은 회장이 위촉하며,
편집위원은 편집위원장이 추천하여 이사회의
승인을 받는다. 편집위원장과 위원의 임기는
2년으로 한다.
2 편집위원회는 투고된 논문에 대해 심사위원을
위촉하고 심사를 실시하며, 필자에게 수정을
요구한다. 수정을 요구받은 논문이 제출
지정일까지 제출되지 않으면 투고의 의지가
없는 것으로 간주한다. 또한 제출된 논문은
편집위원회의 승인을 얻지 않고 변경할 수 없다.

심사위원

1 『글짜씨』에 게재되는 논문은 심사위원 3인
이상의 심사를 거쳐야 한다.
2 심사위원은 투고된 논문 관련 전문가 중에서
논문편집위원회의 결정에 따라 위촉한다.

목적

이 규정은 본 학회가 발간하는 학술지『글짜씨』
투고에 대한 사항을 정함을 목적으로 한다.

투고 자격

『글짜씨』에 투고 가능한 자는 본 학회의 정회원과
명예회원이며, 공동 연구자도 동일한 자격을
갖추어야 한다.

논문 인정 기준

『글짜씨』에 게재되는 논문은 미발표 원고를
원칙으로 한다. 다만, 본 학회의 학술대회나
다른 심포지움 등에서 발표했거나 대학의 논총,
연구소나 기업 등에서 발표한 것도 국내에
논문으로 발표되지 않았다면 출처를 밝히고
『글짜씨』에 게재할 수 있다.

투고 유형

『글짜씨』에 게재되는 논문의 유형은 다음과 같다.
1 연구 논문: 타이포그래피 관련 주제에
대해 이론적 또는 실증적으로 논술한 것.
예: 가설의 증명, 역사적 사실의 조사 및 정리,
잘못된 관습의 재정립, 제대로 알려지지 않은
사안의 재조명, 새로운 관점이나 방법론의 제안,
국내외 타이포그래피 경향 분석 등.
2 프로젝트 논문: 프로젝트의 결과가 독창적이고
완성도를 갖추고 있으며, 전개 과정이 논리적인
것. 예: 실용화된 대규모 프로젝트의 과정 및 결과
기록, 의미있는 작품활동의 과정 및 결과 기록 등.

투고 절차

논문은 다음과 같은 절차를 거쳐 투고, 게재할 수
있다.
1 학회 사무국으로 논문 투고 신청
2 학회 규정에 따라 작성된 원고를 사무국에 제출
3 심사료 60,000원을 입금
4 편집위원회에서 심사위원 위촉, 심사 진행
5 투고자에게 결과 통지 (결과에 이의가 있을 시
이의 신청서 제출)
6 완성된 원고를 이메일로 제출, 게재비
140,000원 입금
7 학술지는 회원 1권, 필자 2권 씩 우송
8 학술지 발행은 6월 30일, 12월 31일 연2회

한석진(브리스톨대학교, 브리스톨)
영국 브리스톨대학교 경제학과 정교수이다.
예일대학교와 서울대학교에서 학위를 받고
오스틴 소재 텍사스대학교에서 조교수로
재직했다. 최근 연구 주제는 기존 경제학 연구에서
간과했던 텍스트나 시각 정보를 통계학적 분석에
이용해 대상을 다각도로 분석하는 것이다. 평소
예술과 건축, 글쓰기에 관심이 많고 관련 분야
전문가와 협업하며 소통을 이어가는 중이다.

역자

김노을(번역가, 삼척)
서울대학교에서 국제학 석사를 마치고 예술
및 과학 분야 전문 번역가로 활동 중이다.
한국타이포그라피학회 『글짜씨』, 안그라픽스
『타이포잔치 2017』 번역에 참여했다.

손현정(번역가, 서울)
이화여자대학교 통번역 대학원을 마치고
십여 년 간 번역을 하고 있다. 한국타이포
그라피학회 『글짜씨』 번역에 참여했다.

홍기하 (번역가, 서울)
제니퍼초이, 번역가. 미술(과 그 외 모든 것)을
번역한다. khiahong@gmail.com

모스부호로 표기한 『Bird & Bird Sound』, 생명을
품은 씨앗으로 구성한 책 『God's Garden』처럼
새로운 방법을 담은 북 아트를 시도했다. 2020년
'책의 날'에 디자인 공로상을 받았다.

박진현(글자체 디자이너, 서울)
글자를 다루고 그리며 종종 글자와 관련된 교육을
하기도 한다. 2018년에 세로짜기 전용 글자체
「갈맷빛」을 출시했고, 현재는 세 가지 굵기로
구성된 본문용 민부리 활자 가족 「지백」을 그리고
있다. 《50인, 50꼴》《펠트포메트 코리아》등의
전시에 참여했다.

박철희(햇빛스튜디오, 서울)
햇빛스튜디오 소속 그래픽 디자이너.
글자 그리기와 형태 만들기를 좋아한다.

석재원(홍익대학교, 서울)
그래픽 디자이너○홍익대학교 시각디자인과
조교수×에이에이비비 디렉터○예일대학교
그래픽 디자인 석사×홍익대학교 시각 디자인 학사

신건모(포률러, 서울)
신건모는 계원예술대학교에서 그래픽 디자인을
공부했으며, 졸업 이후 프리랜서 디자이너로
작업해왔다. 글자와 글자를 다루는 것에 보통
이상의 관심이 있으며, 주로 종이를 작업 매체로
사용하고 있다. 2013년부터 온양민속박물관의
아이덴티티와 간행물들을 작업하고 있으며,
국립현대미술관, 서울문화재단, 건축평단 등
여러 문화기관 및 단체와 협업해왔다.

안마노(안그라픽스, 파주)
글자와 포스터를 좋아하는 그래픽 디자이너.
안그라픽스 크리에이티브 디렉터.

양수현(뉴닉, 서울)
건국대학교에서 현대미술을 공부했고 그래픽
디자이너로 활동하고 있다. 2018년 밀레니얼을
위한 뉴스레터 서비스 뉴닉에 합류하며 '고슴이'를
개발했고 브랜드에 필요한 다양한 제품과 경험을
디자인했다. FDSC 회원으로, 동시대에 활동하고
있는 여성 디자이너와 연대하고 있다. 일을 자주
벌이는 편이고 유머와 진심을 놓치지 않길 바라며
이야깃거리가 있는 디자인을 지향한다. 최근 딸을
낳았고, 멋진 엄마가 되기 위해 노력 중이다.

이재민(studio fnt, 서울)
그래픽 디자이너. 서울대학교에서 시각 디자인을
공부했고, 2006년 설립한 그래픽 디자인
스튜디오 fnt를 기반으로 동료들과 함께 여러
분야의 프로젝트를 진행한다. 국립현대미술관,
서울시립미술관, 국립극단, 서울레코드페어
조직위원회 등의 클라이언트와 함께 다양한
문화 행사와 공연을 위한 작업을 해오고 있다.
서울시립대학교에 출강 중이며, 2016년부터
AGI 회원으로 활동하고 있다. 작고 어여쁜
두 고양이의 아빠이기도 하다.

이화영·황상준(보이어, 서울)
보이어는 이화영, 황상준이 2016년에 설립한
디자인 스튜디오로 브랜드 아이덴티티, 인쇄물,
전시 등 폭넓은 분야를 다루고 있다.

장수영(양장점, 서울)
타입 디자인 스튜디오 양장점에서 한글 디자인을
담당하고 있다.

포층(Poe Cheung, 張少寶,
그래픽 디자이너, 홍콩)
홍콩 이공대학에서 시각 디자인을 전공하고
베를린에서 경력을 쌓고 있다. 아이덴티티, 편집,
전시 디자인과 이중 언어 타이포그래피에 관심이
많다. 주로 파격적인 방법으로 개념을 시각화하는
방법을 탐구한다.

피비쿵(Fibi Kung, 孔曉晴,
그래픽 디자이너, 홍콩)
피비쿵은 홍콩 이공대학에서 시각 디자인 학사
학위를 받았다. 2014년 홍콩 영디자인 탤런트
어워드를 받은 뒤 스톡홀름, 코펜하겐, 로테르담,
서울의 디자인 에이전시와 스튜디오에서 수년간
연습과 경험을 쌓아 광범위한 국제 프로젝트를
진행했다. 활자 디자인과 레터링에 관심이 많고,
디자인을 통해 여행하고 새로운 문화를 경험하는
것을 좋아한다.

하형원(바톤, 서울)
현재 바톤(BATON)에서 브랜드 디자이너로
일하고 있다. 이외에도 레터링과 서체 개발을
병행한다. 학생 및 현직 디자이너 대상으로
레터링 수업과 워크숍을 종종 진행한다.

작업'으로 선정되었다. 2012년 영국
디자인 위크가 선정하는 '올해의 떠오르는
스타'로, 런던 사치갤러리의 '사치 뉴
센세이션' 20인의 아티스트로 선정되었다.
런던 기반의 조너선반브룩스튜디오와
와이낫어소시에이츠에서 그래픽 디자이너로
일한 후 2013년부터 디자인 스튜디오
일상의실천을 운영하고 있다. 2017년 AGI
회원이 되었으며, 동료들과 함께 다양한 디자인
프로젝트를 진행하고 있다.

김영선(VCNC, 서울)
인쇄 매체 디자인, 브랜딩, 레터링, 일러스트레이션
작업을 하고 있다. 주로 흥미로운 형태의 글자를
다양한 프로젝트에 접목해 작업한다. 《100 필름
100 포스터》《대강포스터제》《펠트포메트
코리아》《"THEN TO NOW" Gate way》
《TUKATA NEW BLUE CHALLENGE》 등의
전시에 참여했다.

김초롱(산돌, 서울)
폰트를 만들고, 생각하고, 이야기하며 생계를
꾸리는 사람이다. 경희대학교와 프랑스
브장송예술대학에서 시각 디자인을, 아미앙
예술디자인대학에서 타입 디자인을 공부했다.
태국 방콕의 카싼디막에서 폰트 디자이너로
일했고 현재는 산돌에서 근무하고 있으며,
한글타이포그라피학교에서 강의하고 있다.
카싼디막의 「통로(Thonglor)」, 라이노타입의
「노이에 프루티거 타이(Neue Frutiger Thai)」,
카카오 전용서체, 네이버 「나눔스퀘어」,
배달의민족 「을지로체」, 산돌 「정체」,
「IBM 플렉스 산스 KR」 등에 참여했다.

김현진(글자체 디자이너, 서울)
글꼴 디자이너이자 그래픽 디자이너이다.
낯설지만 아름다운 조형의 글자 탐험을 즐기며 늘
새로운 인상의 한글꼴을 찾고자 한다. 이외에도
다양한 분야의 디자인 작업을 병행하고 있다.

남선우(큐레이터, 서울)
큐레이터. 예술학과 미학을 공부했고 『월간미술』,
큐레토리얼랩서울, 일민미술관 등에서 일했다.
《막후극》《무무》《연극의 얼굴》 등의 전시를 공동
기획했고, 『게이트웨이미술사』를 공동 번역했다.

마리아 도렐리(Maria Doreuli,
콘트라스트파운드리,
샌프란시스코·모스크바)
독립 스튜디오 콘트라스트파운드리(Contrast
Foundry)를 설립했다. 새로운 도전을 갈망하던
2018년 샌프란시스코로 건너갔다. 타입
디자인을 중심으로 새로운 실험을 지속하고
있다. 작업 중 일부는 ADC, 커뮤니케이션아츠,
모리사와, 레드닷 및 TDC 뉴욕에서 수상했다.

막카이항(Mak Kai Hang, 麥棨桁,
막카이항디자인, 홍콩)
막카이항은 HKICC 리샤우키창의학교를
졸업하고 출판사의 디자이너로 북 디자인을
시작했다. 2018년 막카이항디자인을 설립했다.
실험적인 관점으로 디자인과 타이포그래피에
초점을 맞춘 그의 북 디자인은 강하고 인상적인
미학을 가지고 있다. 2019년 골든핀 디자인
어워드에서 '올해의 베스트 디자인'을 수상했고,
2020년 더원클럽 뉴욕, D&AD, TDC 도쿄,
TDC 뉴욕 등에서 수상했다. 베이징, 모스크바,
노르웨이, 대만, 미국 등에서 작품을 전시했다.

문상현(스튜디오문, 서울)
미국 로드아일랜드스쿨오브디자인을 졸업하고
워커아트센터 디자인 펠로우와 현대자동차
크리에이티브웍스실에서 근무했다. 구글
디자인, CNN, 『와이어드』 등에 작업과 인터뷰가
실렸으며, 2012년에는 『프린트』의 '20 Under
30: New Visual Artists'로 선정되었다.
샌프란시스코 현대미술관, 필라델피아 미술관,
파리 장식미술관에 다수의 작품이 영구 소장
되었고 현재 서울대학교 석사과정 중이다.

박신우(페이퍼프레스, 서울)
페이퍼프레스는 성수동에 위치한 그래픽 디자인
스튜디오이다. 문화예술 분야부터 다양한
브랜드와의 협업까지, 페이퍼프레스는 그래픽이
개입할 수 있는 모든 가능성을 수행한다.

박영신(이안디자인, 서울)
이안디자인 아트 디렉터이며, 북 아티스트이자
그림책 작가이다. 1983년 『어머니책』
『샘이깊은물』을 시작으로 세밀화 도감, 국어사전,
그림책 등을 디자인했으며, 자연과 생명, 이미지를
주제로 시각 표현을 병행해왔다. 새소리를

한국타이포그라피학회 편집부

민본(홍익대학교, 서울)

홍익대학교 시각디자인과 조교수. 레딩대학교
타입페이스 디자인 석사. 바르셀로나대학교
타이포그래피 석사. 서울대학교 시각 디자인 학사.
전 미국 애플 본사 수석 디자인팀 디자이너.
전 미국 애플 본사 폰트팀 서체 디자이너.
전 한겨레신문사 기자직 디자이너.

심우진 (산돌, 서울)

책과 활자의 디자인 방법론에 중점을 둔 교육과
출판에 집중하고 있다. 저서로『찾아보는 본문
조판 참고서』, 타이포그래피 교양지『히읗』
6호·7호,『찾기 쉬운 인디자인 사전』, 공저로
『마이크로 타이포그래피』『타이포그래피
사전』이 있으며, 역서로『하라 히로무와 근대
타이포그래피:1930년대 일본의 활자·사진·
인쇄』가 있다. 2017년부터 타입 디렉터로서
산돌을 대표하는 본문 활자인「정체」를 개발하고
있으며, 현재 산돌연구소장을 맡고 있다.

유현선 (워크룸, 서울)

워크룸 디자이너이자 파일드 운영자이다.
쉽고, 강하고, 빠른 작업을 추구하며 사진과
그래픽 디자인의 기묘한 만남을 탐구하고 있다.
《ORGD 2020: 최적 수행 지대》《만질 수 없는》
등의 전시에 참여했고,《PLAANTS》《파일드
SS 2020》을 기획·디자인했다.

이병학 (서울과학기술대학교, 서울)

인터페이스의 구조와 장식에 관심이 있다.
「표지 장식의 역사에 기반한 장식적 디자인
연구」라는 논문을『글짜씨』에 실었다. 현재는
웹퍼블리싱을 가르치고 있다.

저자

구자은(그래픽 디자이너, 서울)

그래픽 디자이너이자 번역가이다. 홍익대학교와
프랫인스티튜트에서 공부했다. 현재 디자인
스튜디오에서 근무하고 있다.

권준호 (일상의실천, 서울)

영국 왕립예술대학에서 시각 디자인을 공부했고,
이후 일 년 동안 왕립예술대학에서 그래픽
디자인을 강의했다. 2011년 졸업작업 〈Life〉가
영국『크리에이티브 리뷰』가 뽑은 '올해의

일러두기 본문의 외래어와 고유명사, 전문용어는
국립국어원 외래어 표기법과
『타이포그래피 사전』을 참고했다.
책·학위 논문·단행본·정기간행물·신문은
겹낫표(『 』)로, 글·학술지 논문·기사·개별
작품·글자체는 홑낫표(「 」)로 전시·앨범·
강연은 겹화살괄호(《 》)로 음악·미술·영화·
노래 저작물은 화살괄호(〈 〉)를 사용했다.

한국타이포그라피학회 안그라픽스, 2021
글짜씨 20

글짜씨 20 ISBN 978-89-7059-540-5(04600)
2021년 8월 13일 인쇄
2021년 8월 20일 발행

기획 한국타이포그라피학회 편집부
지은이 구자은, 권준호, 김영선, 김초롱, 김현진,
남선우, 마리아 도렐리, 막카이항,
문상현, 박신우, 박영신, 박진현, 박철희,
석재원, 신건모, 안마노, 양수현, 이재민,
이화영·황상준, 장수영, 포층, 피비쿵,
하형원, 한석진
옮긴이 김노을, 손현정, 홍기하
영문 감수 전재운, 아네카 코폴스
디자인 유현선

펴낸곳 (주)안그라픽스
10881 경기도 파주시 회동길 125-15
tel. 031-955-7766
fax. 031-955-7744
펴낸이 안미르
크리에이티브 디렉터 안마노
편집 김소원, 이연수
커뮤니케이터 김봄
영업관리 황아리

인쇄·제책 엔투디프린텍
종이 인버코트 G 260g/m²(표지),
링스 100g/m²(내지)
글자체 SM3 신신명조, 모코코, Rix 독립고딕 Pro

후원

안그라픽스

DOOSUNG PAPER

파트너
블랙
NAVER

kakao

+X

Yoondesign

RixFont

무이한
형제들

엑스트라볼드
VINYL C

볼드
motemote

하 디 자 인
ㅇ

레귤러
INNOIZ

한국타이포그라피학회
글짜씨 20